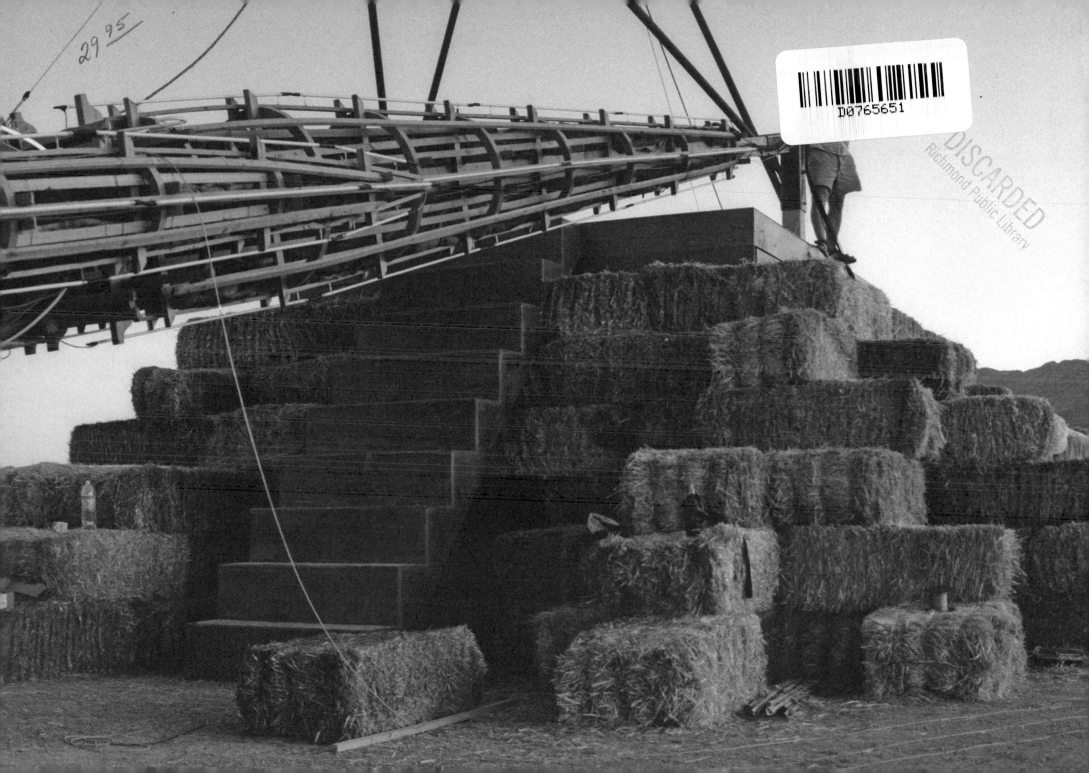

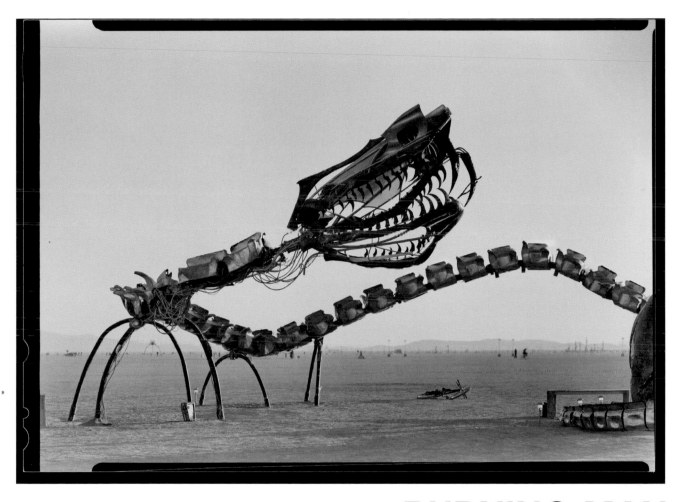

BURNING MAN

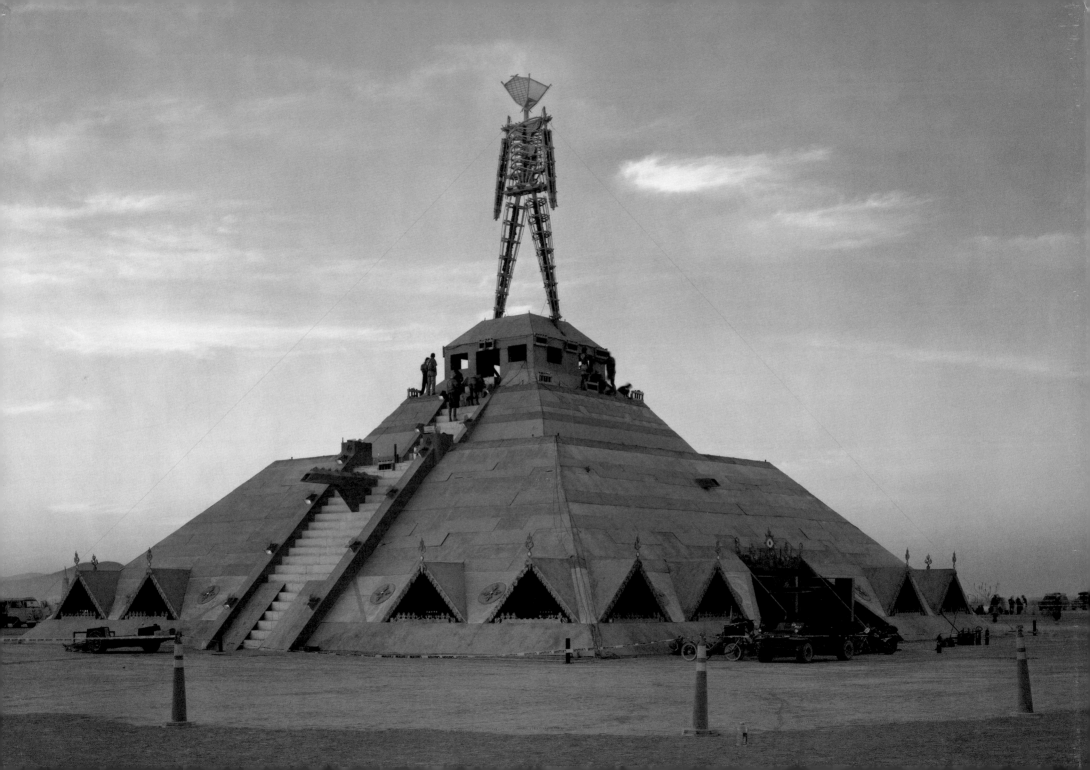

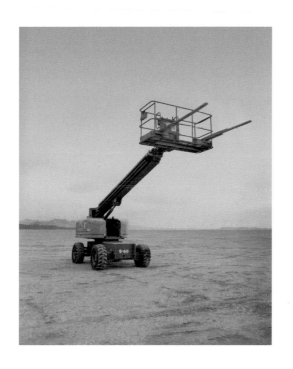

BURNING MAN

ART IN THE DESERT

PHOTOGRAPHS AND TEXT BY **A. LEO NASH**

INTRODUCTION BY **DANIEL PINCHBECK**

ABRAMS, NEW YORK

For the community,
the artists,
and my teachers

CONTENTS

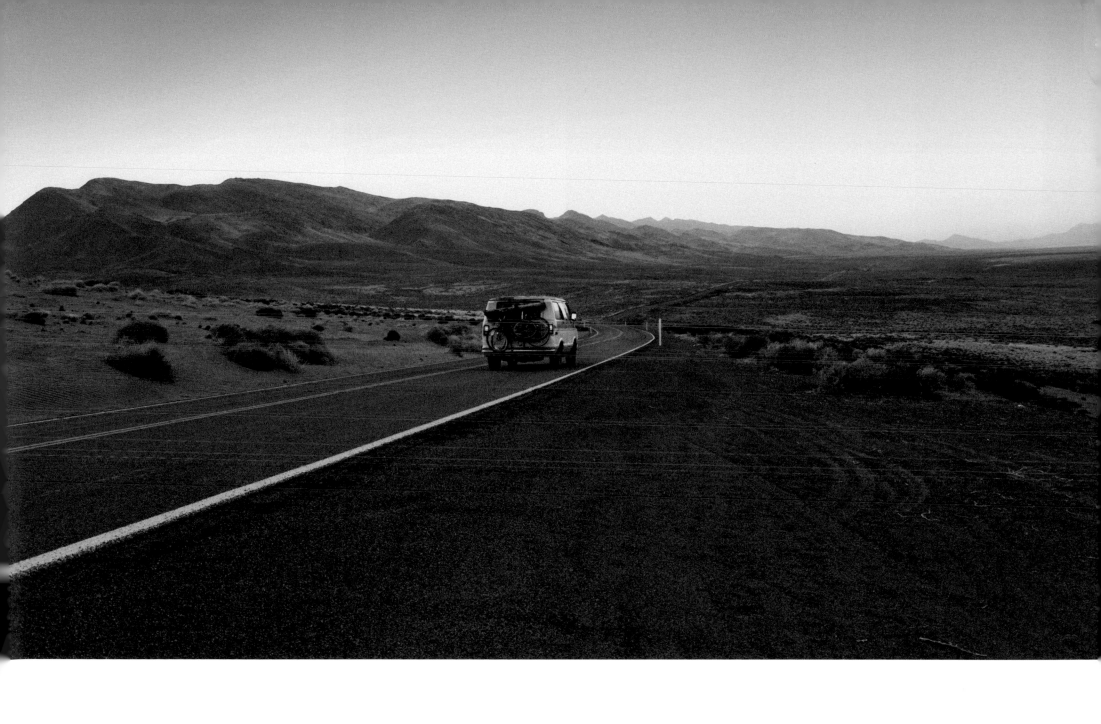

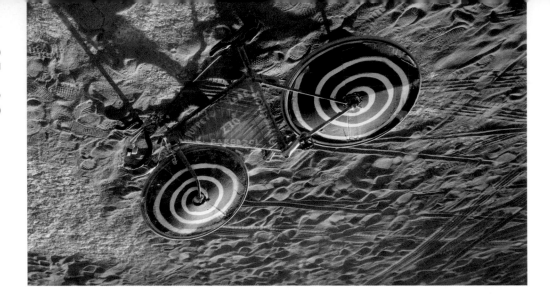

Barbazol Flying Circus (2002)
ARTIST: UNKNOWN

Opposite: *High Winds at Camp Before the Event* (2006)

INTRODUCTION by DANIEL PINCHBECK

When I recall my visits to Burning Man, my mind fills with arcing lasers and multicolored blinking lights, hallucinatory sunrises, hordes of costumed revelers dancing in the dust, and the enormous bonfires that consume the hand-built sculptures and structures at the end of the week. Burning Man is over-stimulation and cacophonous saturation, where the rhythm of your pulse syncs with the electronic beats that pound 24/7, and sleep is an enemy to be conquered. Who can bear to sleep when so much is happening at every moment, and the promise of so much more is forever held out? At the very instant that you finally lay your weary head down to rest, you can guarantee that somewhere on the Playa a Felliniesque marching band is leading a parade of anarchic booty-shakers into the void, the next great D.J. is spinning her first legendary set from a booth designed to evoke the fishtail curves of an alien spacecraft, an occult ritual is honoring Isis or Baphomet with opulent sincerity and evocative gestures, a Tesla coil is firing lightning bolts at the stars, while a gorgeously tattooed and wickedly grinning couple display their pole-dancing prowess, and an absinthe bar is just opening its doors.

Burning Man gives Attention Deficit Disorder a good name. And yet, along with its madcap circus swirls and dazzling displays of human invention, there are other layers and dimensions to the Burning Man experience—moments when the vast silence of the Black Rock Desert (a prehistoric dry lake bed with no natural plant or animal life) and its majestic harshness sweep over you; moments of Zenlike stillness and existential purity; moments when there is nothing but you and the dust. Every year, some of my best times are my quietest ones—bicycling past some spindly sculptural artifact designed to jangle softly as the wind blows through it, or passing a sleeping couple in fuzzy rave clothes, tangled together on a sofa left at the periphery fence, facing a vast expanse of emptiness.

Revealing that unexpected underside of Black Rock City, A. Leo Nash's photographs use the subtle tones of black and white to capture the silence and stillness that hides within the noise. They also isolate elements of a new formal vocabulary—jagged, raggedy, Krazy Kat meets Mad Max in a post-Duchamp Pepperland—that has emerged from fifteen years of experiment in the Nevada wasteland. This aesthetic collages natural forms

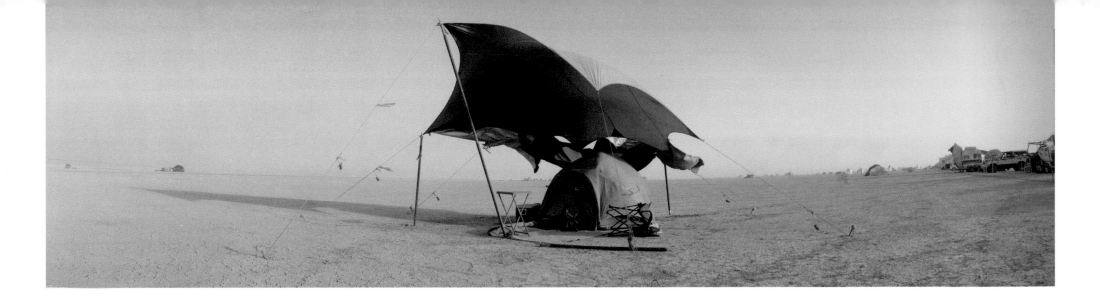

with fragments of the old industrial culture, welded and repurposed into sinuous and scaled expressions of what the psychedelic philosopher Terence McKenna liked to call "the Archaic Revival," the melding of our post-modern techno-culture with ancient myth and tribal ceremony.

In an age when handicraft has been exiled to the margins, Burning Man revives something akin to the lost craft traditions and guilds of the Middle Ages—its art collectives, dreadlocked welders, sculptors, and technical experts have apprenticed themselves in the use of fire, steel, plastic, concrete, EL wire, electricity, and wind to create extraordinary spectacles. These artisans return year after year to hone their skills and push the envelope a little further. As a repeat visitor, it is a privilege to witness the evolution of groups like the Flaming Lotus Girls. A women's art collective, they upstage their own creations annually, from vertical flamethrowers to crashed steel phoenixes, to 2005's giant serpent coiled around its egg, breathing fire and swiveling its endearingly menacing head via hydraulics.

The photographs collected in *Burning Man: Art In the Desert* wed the aesthetic of Bernd and Hilla Becher, the German photographer couple who found an accidental aesthetic wonderland of theme and variation in rusted water towers and other relics of industrial consciousness that reveal a peculiar and startling poignancy when isolated from the surrounding landscape, to the imagination of Dr. Seuss, spewing ever-new creative possibilities. In Nash's images, one also catches wisps of Robert Frank, whose secretive portraits of lyrical desolation revealed the cruel illusion of the American Dream. Nash has taken a minimalist approach to a maximalist event, isolating a tonal poetry of sculptural forms in a vast, open landscape. His book is a loving tribute to the art of Burning Man, the central focus of the festival, though the deliciously hedonistic decadence often gets more ink.

There are subcategories of images in Nash's work, such as those that focus on vehicles, from mobile piano bars to transmuted bicycles and rocket cars, to ineffable creations such as the one built by Michael Christian, memorialized in *Nebulous Entity* (1998). As Carl Jung has discussed, the vehicles that carry dreamers through their dreams indicate the different levels of velocity and self-confidence with which they traverse the collective unconscious. The "art cars" constructed for Burning Man open new realms of possibility for

Neverwas Haul at the Shipyard: Berkeley (2006)
ARTISTS: SHANNON O'HARE AND CREW

future dreamers. Christian's tentacled, semi-reptilian *Entity* appears in Nash's image ready to rove toward new vistas of imaginative crossover.

What Burning Man calls for, above all, is openness to transformation and wonder. My first visit to the festival permanently changed my idea of art, as well as expanding my belief in human possibility. Although I had written about contemporary art for years, I felt distanced from it, uneasily following the increasingly academic extension of movements such as pop and conceptual art that had once seemed radical and subversive. Burning Man gave me a wider context for considering creativity—in a sense, the greatest work of art at Black Rock City is the entire metropolis, the container of the event, with its circular urban plan and centralized avenues and zany street names, plus the self-organizing support structures, from volunteer rangers to lamplighters. The sculptural aesthetic of Burning Man mixes late-1960s land art, pop, surrealism, and conceptualism into a new form, adding, as well, an extraordinary sense of scale that creates a unique context for experiencing the work that appears there.

Many of Nash's images—which are both "art about art" and works of art in themselves—do a wonderful job of capturing that sense of scale. Part of what makes the event feel explicitly American is its pioneering optimism and faith in the human imagination to match any natural wonder. A picture such as *Anno Domino 2000 AD2K* contrasts a blown-up version of a modest game against distant mountains and far-flung clouds. Other images play with representation in classic deconstructive fashion—in one, a puppet-stage window opens onto a vast dusty expanse; in another, a billboard of photographs of the ocean conceal the desert just behind them.

It may be that the art of Burning Man is the new "movement" that European and American contemporary art cognoscenti always pretend they are looking for, changing the rules of creativity for a new generation, but happening under their noses. Post-Burning Man, I find I am less enthusiastic about art as the ego expression of the individual genius, but more fascinated in art as the juncture between the individual and the larger group. On the Playa, art serves as an instrument for meshing together the community, offering them a medium for discovery, for playing and praying, as well as a lens for seeing themselves. It extends the notion of conceptual and performance art to a wider field of human activity, recalling the surrealist doctrine that there should, truly, be no distinction between art and life. When this

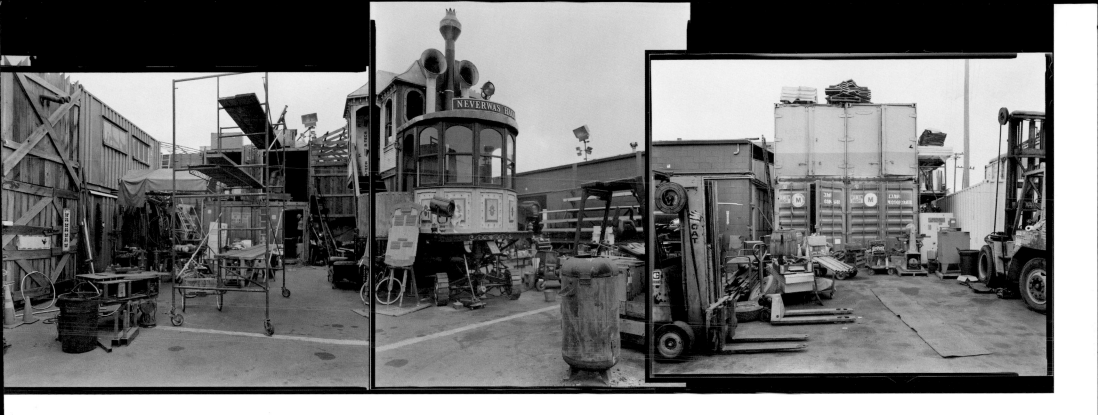

distinction disappears, product becomes process—and, appropriately, Nash takes a special pleasure in photographing artworks under construction or deconstruction, or hovering somewhere inbetween.

When art and life merge, clock time disappears and we plunge into the ecstatic atemporality of the Archaic Revival, recovering an original relationship to the cosmos. Before history and culture, before bureaucracy and work, before cell phones and laptops, time was cyclical and circular. Aboriginals in Australia believe that every day is the "first day," the primordial beginning of time and being, and their art and ceremonies help to maintain the creation in its proper order. For such tribal nomadic peoples, there never was a "fall of man" into a degraded state. Their initiatory culture is a means of accessing the higher vibrational frequencies of the Dreamtime, the ever-present origin of the Gods and the Ancestors, which is hidden within the illusory density of the physical world.

The tens of thousands who make the annual pilgrimage to the Black Rock Desert are seeking initiation into the perpetual present, utilizing the rusting and groaning artifacts of our over-reaching industrial civilization to access what is beyond time and the machine. According

to prophecy, some Native American cultures believe this era to be the time of "dreaming the world awake," when our post-modern secular world steps through the veil of matter, fusing modalities of science and spirit to discover the infinite other worlds that lie within and without. Eventually, Burning Man may reveal itself as more than an eccentric expression of an old and new counterculture, but a harbinger of a new way of being. Only time will tell. At the moment, it is—as we are—a work in progress.

Nash's images offer an open-sky poetry of forms and fragments, a set of secretive hints that reveal by concealing. Naturally, they have a different valence for Burning Man veterans, who view them through the context of their own experiences and perceptions, than for the art world spectator, who can appreciate their formal elegance from a safer aesthetic distance. Nash has made his own thirteen-year desert pilgrimage and come back with talismans that will help to bridge the cultural divide between the art world cognoscenti, with their studied ironies, and those who are compelled to unlock "the doors of perception" in their pursuit of a new iconic order.

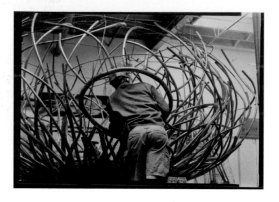

*Michael Christian Working on I.T.
in His Berkeley Studio* (2006)

THE BEGINNING

I came to Burning Man at an interesting time in its development, after seeing slides of the festival in 1993 on photographer George Post's light table. I first attended the following year.

Burning Man began in 1986 as a lark when Larry Harvey approached his friend Jerry James and asked him to join in the building of a wooden figure of a man to burn on the summer solstice on San Francisco's Baker Beach. Once they lit it up, they instantly decided to make the building and the burning an annual event, the tradition growing in size and attendance each year. It quickly included the involvement of the San Francisco Cacophony Society, "a randomly gathered network of free spirits united in the pursuit of experiences beyond the pale of mainstream society"; and a few former members of the Suicide Club, named after a short story by Robert Louis Stevenson that was populated by characters who lived each day as if it were their last (who in this incarnation consisted of an unending series of urban adventurers exploring old bunkers, bridges, and long-forgotten subway tunnels, all in pursuit of the inscrutable feeling of being alive). After the burning of a forty-foot-tall wooden structure became too much for park officials to dismiss as a simple "bonfire on the beach," the event now known as Burning Man moved in 1990 to the Black Rock Desert, a remote dry lake bed a couple of hours outside of Reno, Nevada. And it's been there, near the town of Gerlach, ever since.

The Man has grown from its humble stature—standing on the beach at eight feet—to a construct of forty feet on top of a thirty-foot base. Over the years, this platform has taken on the shape of a lighthouse, a Mayan style pyramid, and a geodesic dome (to name just a few of its incarnations).

At the time, I was in the midst of resurrecting a project on alternative communities and gatherings, which were, more often than not, in remote parts of the lower forty-eight states. I had started this venture in 1986 at the Oregon Country Fair, and days after I was done shooting, my car was stolen along with all of my film. It had taken me five years to get back to where I could pursue this project again with the voracity that it required. But after I started going out into the Nevada desert, it took only a few years before I realized that the original project I had begun no longer engaged me the way that the desert now did. In 1997 I abandoned my initial concept and focused exclusively on photographing this desert environment.

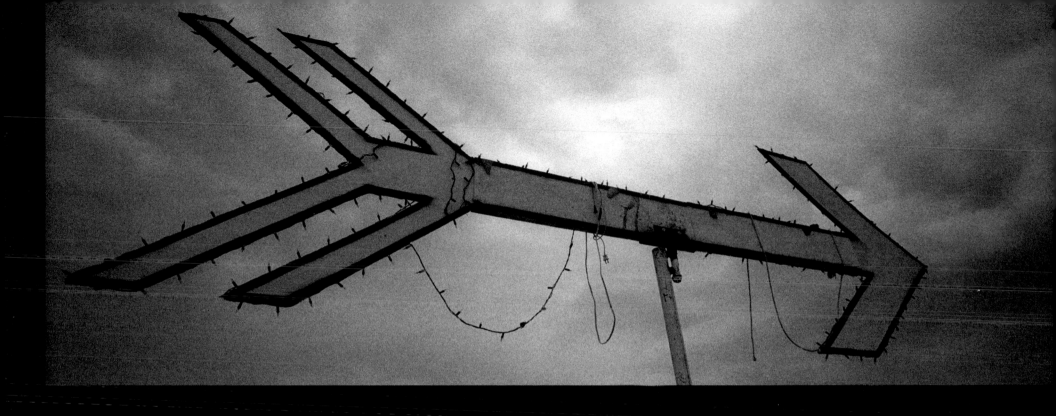

In those days Burning Man was different than it is now. It was focused much more on a *Mad Max*-like expression of freedom and danger, and less on the *artistic* aspects of the event. In the evenings, tracer fire would arc into the night sky above Militia Camp. Over the course of three to four days, there was an ever-present reminder that you were beyond the permissible edges of society. Even though societies appear to function given their accepted rules and structures, they seem to have lost something in the process. By being there in the Nevada desert, on a 400-square-mile prehistoric dry lake bed referred to by its Spanish name, Playa, which literally means "beach," we'd somehow regained that which we had lost.

With nothing on the Playa except the detritus of fifty years of post-war culture dragged out as props for the event, people reveled in the ability to stand back, get a good look at their surroundings, indulge themselves, and kick some ass. As a photographer with a contemplative nature, it was all a breath of fresh air—and Burning Man gave me something truly beautiful to aim my camera at. It took me three to four years to figure out how to

translate what I saw, and how I felt, into a visual representation that communicated what it was like to be there. This book is the culmination of that experience.

Burning Man is essentially a temporary city that regenerates itself annually for a week of art, performance, and human experience, then disappears, leaving behind little or no trace. When Burning Man is in existence, it coalesces into a city of thirty-five to forty-thousand people, complete with its own law enforcement, fire, and emergency services departments; an airport; a Department of Public Works (DPW); a Department of Motor Vehicles (DMV) chartered with keeping tabs on unconventional automobiles, all of which require registration; and a café in the center of the camp, complete with streets and avenues delineated by names on sign posts in a horseshoe shape—all contained within a seven-mile-long perimeter fence that completely encircles the site. This fence merely defines the circumference of the area and catches whatever stray trash blows into it.

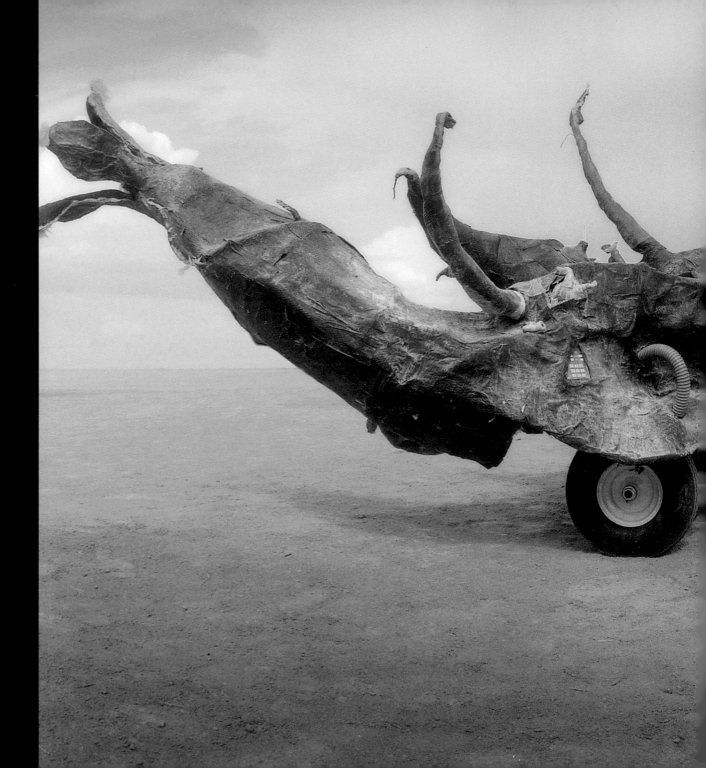

Art is what saved Burning Man, enabling the organizers to move beyond anarchy. The event's success and where it's situated allowed anyone with a vehicle and the inclination to drive out to the desert the ability to attend. And many of those who did participate weren't able to reel themselves back in—once they had let themselves out farther than they had ever gone before.

In 1996 Burning Man went beyond dangerous to reckless, and there was no way to bring it back into focus except to wait until those aspects dissipated. By that time a few people had gotten permanently hurt through careless accidents involving drugs, alcohol, and vehicles—in two instances fatally (one when a motorcycle and a van played "chicken" and another when a car ran over a couple asleep in a tent).

Burning Man, however, wasn't just a small band of lunatics having a ball at the Edge of Nowhere. The camp grew organically. There were no streets or roads initially. In fact, in 1996 you had to drive twenty-plus miles out into the desert, and couldn't even see the site until you were a few miles out. The encampment coalesced out of a mirage simmering off of the lake bed. You just pulled up, found an empty spot, and set up camp. People drove where and when they liked, went into town for supplies, zipped over to the local hot springs (now off limits), went to the drive-by shooting range hard against the nearby hills at Trego, or zoomed off across the desert at high speed—a cloudy vector stretching off to the vanishing point.

Until recently, 1996 was considered the best year for the event in terms of the collective joy everyone felt with the project—one of involvement and community. There was a palpable feeling then that this was, in fact, the Next Big Thing. That there was an energetic link to what we were doing, along the lines of what had occurred in San Francisco during the Beat Era of the 1950s up until, but not including, the media's announcement of the Summer of Love in 1967—once that concept was pronounced, every wing nut and misfit had been drawn to San Francisco to somehow be a part of the scene, and that scene had been altered by the attention and subsequent commercialization. Burning Man has been able to prevent that from occurring.

Nebulous Entity (1998)
ARTISTS: MICHAEL CHRISTIAN AND CREW

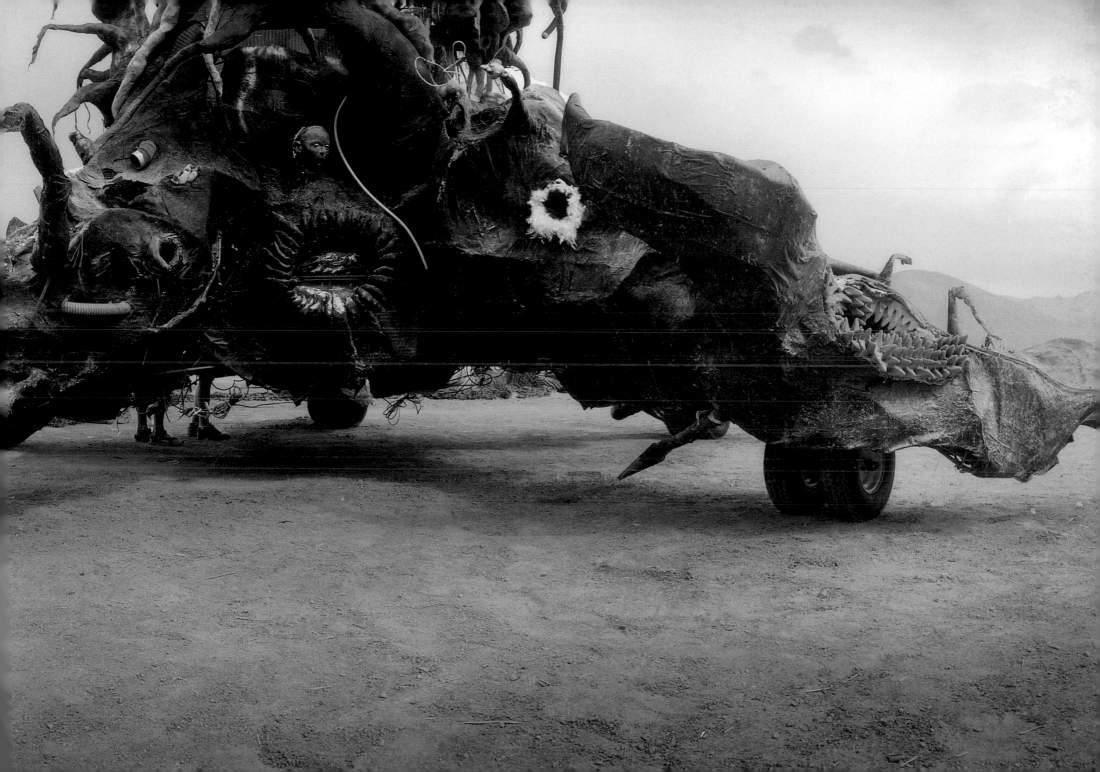

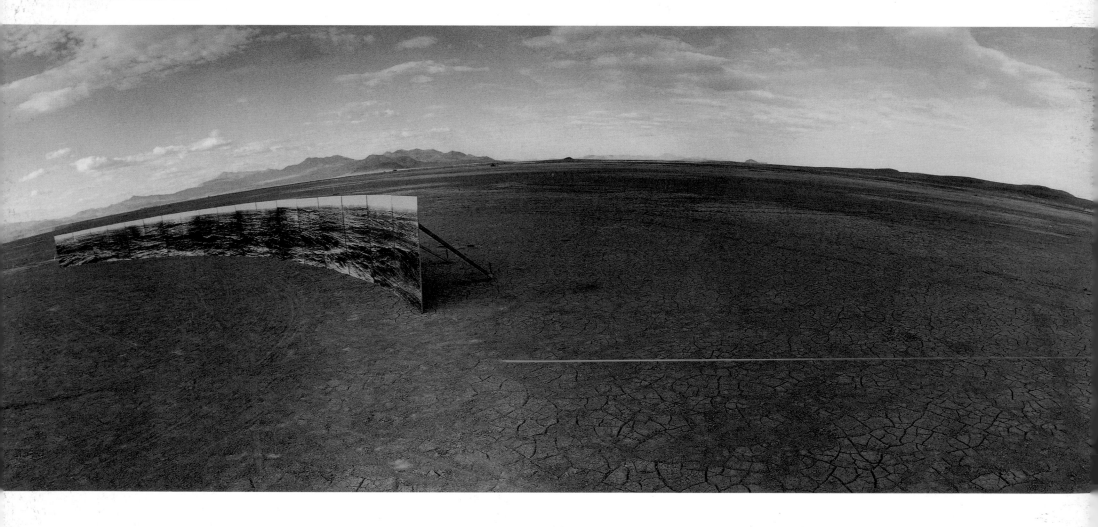

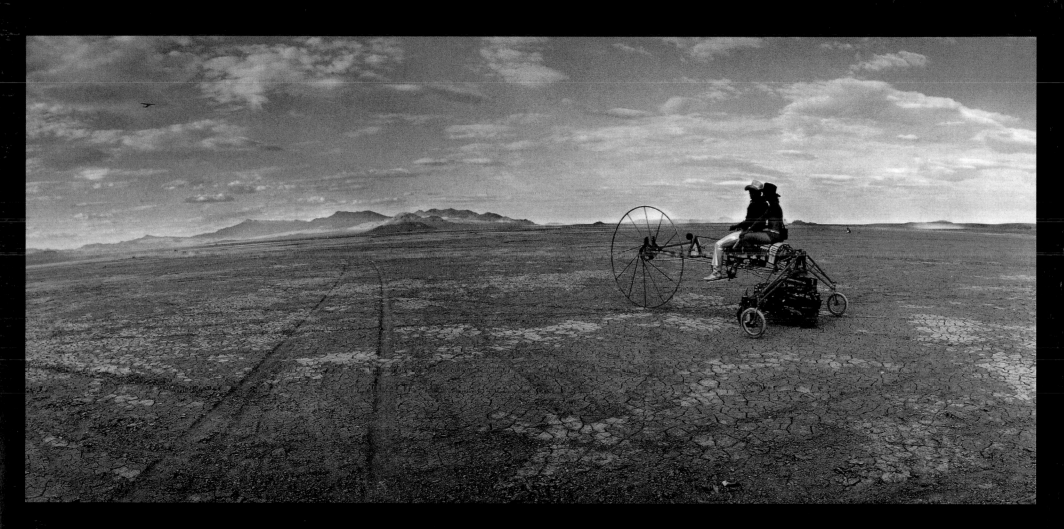

Tricycle Cowpokes (1997)
ARTIST: UNKNOWN

Burning Man is run by a six-person board organized under a limited liability company named the Burning Man LLC. They deserve high marks for keeping the community alive, nurturing it, and *not* succumbing to a very real need to generate cash through commercialism. Sure it costs a couple of hundred dollars to attend, but the price of the tickets provides attendees with a lot of value for the week above and beyond clean Porta-Potties. And at $225.00 it is similar in cost to other events lasting a fraction of that time.

Without explicitly stating it, you are guaranteed a unique experience, whether you desire one or not. You are not paying to be one of 50,000 people watching a concert from an eighth of a mile away, with ten-dollar parking spaces, seven-dollar cups of beer, and thirty-dollar T-shirts. Burning Man respects you enough to demand more from you. And it's not enough to just come up with the money. If you're going to attend the event, you're also going to have to take care of your own basic needs for survival. But beyond that, you have to let your guard down and become part of the community. That can be daunting, but you'll be richly rewarded for it. You'll meet people whose paths you may never have crossed before, and help one another deal with unforeseen challenges, some small and some not.

The price of a ticket covers the costs of putting on a sizable event in the middle of nowhere, provides bathroom facilities, and partially pays for many of the large art projects that are created there each year. Invariably the artists kick in a lot of their own money to cover the complete costs involved (if you are working on your own piece, you will still have to buy a ticket to the event). After all, creating an art project is something that everyone is encouraged to do, and some of those are done by artists who have been doing it for years; others are created by those who just decided to contribute something for the first time.

After fallout from the event in 1996, the organization went through some changes. People who had been with Burning Man through the heady transition years from Baker Beach to the Black Rock Desert in 1990 were doing some soul searching.

The experience of 1996 had been intense for everyone. It was clear that the event was either going to have to pack it in, or take some major steps, especially in terms of costs, in order to fulfill the demands being made on it from local law enforcement, fire officials, and government.

There was also the issue of which county was going to host the event. The Black Rock Desert may be on BLM land (the Bureau of Land Management, an agency within the U.S. Department of the Interior that administers 262 million surface acres of America's public lands, located primarily in twelve Western States), but it falls under the jurisdiction of two counties (Washoe and Pershing). As a result, Burning Man 1997 took place on private land—a mud flat just to the west of the main Playa. After *that* it made peace with Washoe County and the BLM, and after agreeing to pay for a new turn-off onto the Playa, an access road, and a daily fee per participant, the event has used the same basic site since 1998, and benefited from the regularity of that.

The Two Leos (1999)
ARTISTS: A. LEO NASH AND LEO VILLAREAL

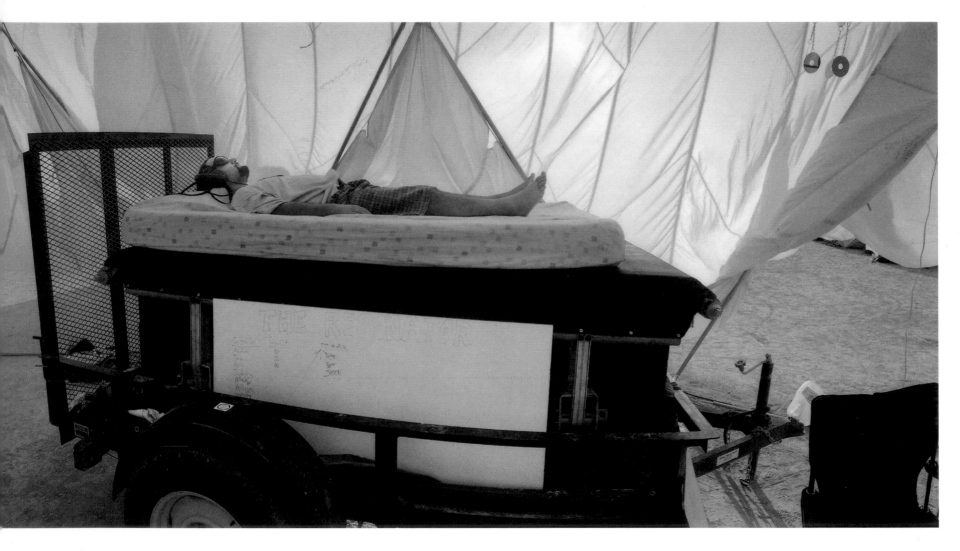

The Resonator (1998)
ARTIST: LIKKY

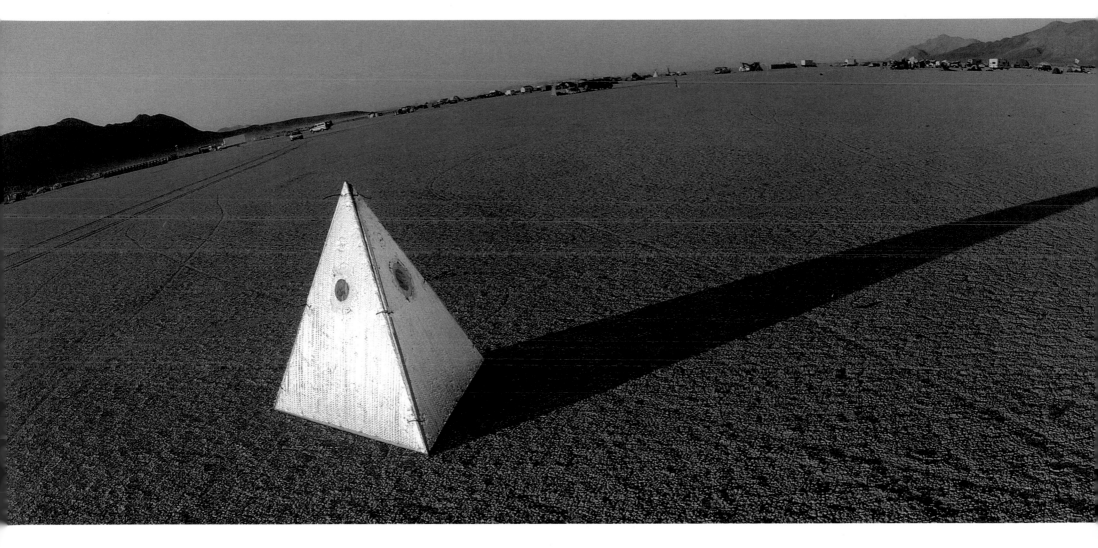

Silver Pyramid (1998)
ARTIST: UNKNOWN

Johnny on the Spot (2003)
ARTISTS: SAUL MELMAN AND ANI WEINSTEIN

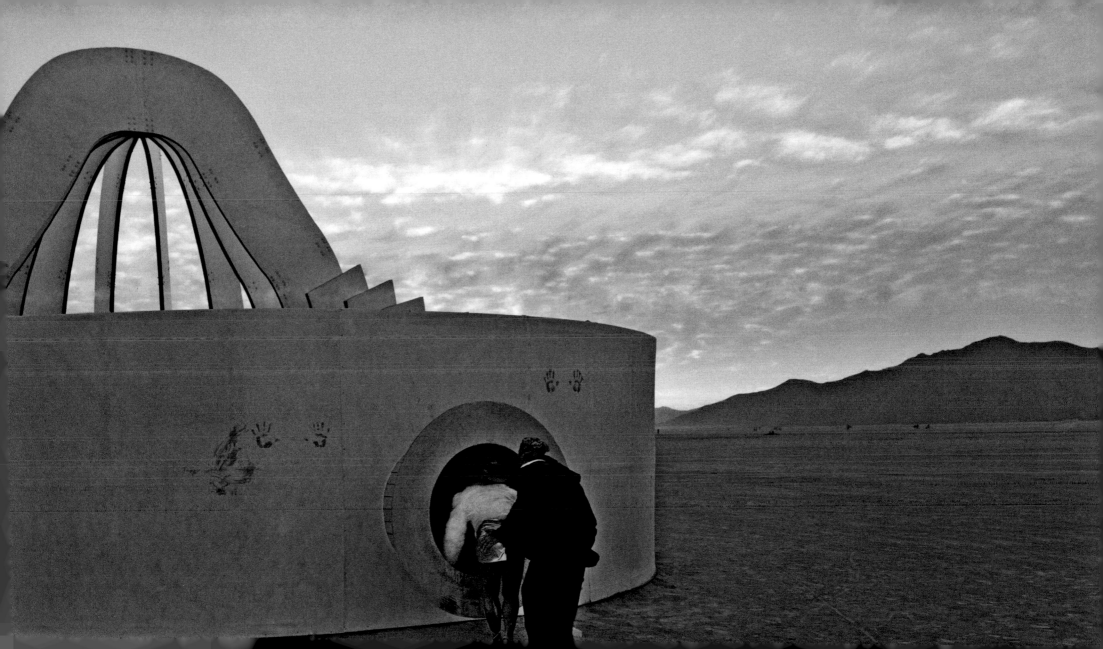

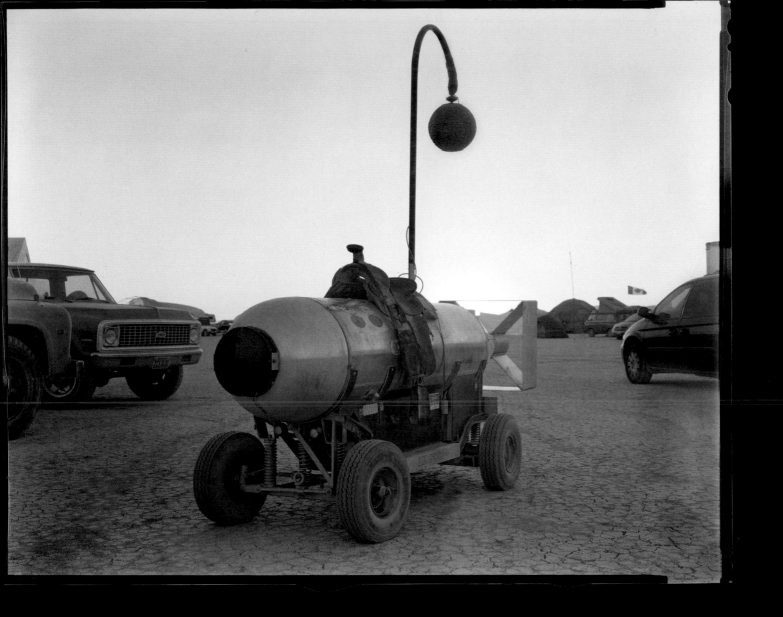

Slim Pickins' Ride (2005)
ARTIST: UNKNOWN

INSPIRATION

You're taking a shower early one morning, trying to wake up before going to work, and an idea comes to mind that stays with you out the door and down the street. You're energized by it, but also daunted. It's going to take a lot to pull it off. Not only are you going to have to build this massive thing, buy the materials, get a space big enough to work on it, *and* get lots of help, but you're also going to have to drag your creation—and everything you're going to need to assemble it—a hundred-plus miles out into the Nevada desert.

And the desert isn't necessarily going to welcome you with open arms either. You may arrive in a dust storm, you'll almost certainly leave in one, and in between the sun and the heat are just the start of the elements working against you. Wind, rain, and isolation from unforeseen equipment and resource needs will hinder your progress and undermine your resolve. Never mind the fact that you're going to have to bring all your own food, water, and *everything* you'll need to survive.

You'll sleep for a week when you get back, and have one hell of a credit card bill in your mailbox weeks later, accrued from the weeks of building whatever piece or contraption you dragged out there, not to mention time off from work if you can swing it. However, it's inspiration that's driving you now, and it's only just the beginning. Is your idea worth it? (Yes, in those initial moments. And later, when your vision stands before you completed, and you're able to bask in the appreciation of others, it most certainly is.) But after it's all over, when you're paying off the bills and still living in a windowless hovel in some warehouse district, you may begin to wonder. You may even begin to resent the idea and wish you had never entertained the initial thought that had crossed your mind months earlier in the comfort of that morning shower.

It's costing you a lot of time and, in the end, some serious money. And after it's all said and done and the Man is burned, it'll all have existed for really only a short time and for a limited audience. Your contribution will take from you more than it gives back in return monetarily—but if you're successful, it will have all been worth it.

Inevitably you'll do it again next year. And while you're in the midst of it you'll wonder why you didn't remember how difficult it all could be. And if you're lucky, the good years will make up for and exceed the bad. For most of us they do, and that's why Burning Man persists. It's as much the pursuit of a challenging and an authentic experience as the art objects that result from it.

The event is not prepackaged or even *that* predictable. However, the basics are the same. There have been years where grants had been given, the money spent, and the finished piece just didn't come together as planned. The enormity of the project, or the logistics involved, or the weather, or a host of other reasons stopped it from being fully realized.

The irony is that there's so much going on out there in the desert that except for people in the know, or a handful of those paying strict attention, hardly anyone ever really notices the shortcomings of any given project besides the artists themselves and their friends. It's that kind of event. You'd better be doing your "art" for yourself because even the biggest projects out there can get lost.

Burning Man covers three and a half square miles. Though its flat and relatively wide open, only the largest objects are imperceptible dots when viewed from a mile away. It's also a bit of a pilgrimage getting there, not unlike finding the more famous of U.S. land art works such as Smithson's *Spiral Jetty* (a large gravel and dirt spiral on Utah's Great

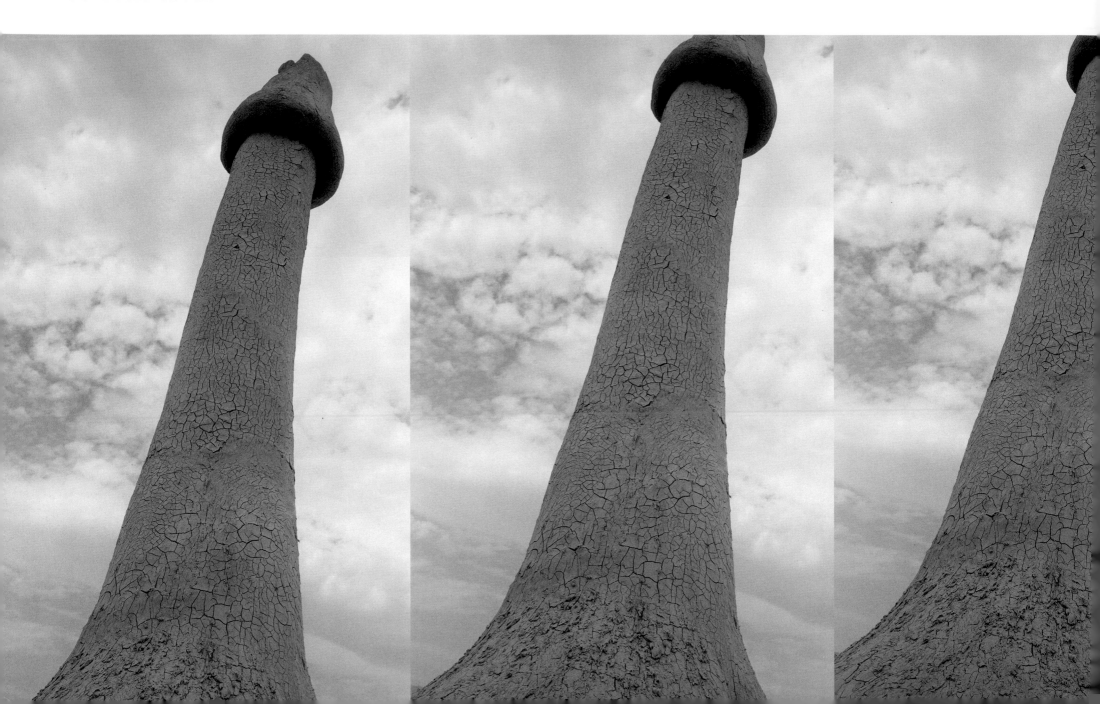

Phallus of the Man, detail (1998)
ARTISTS: PEPE OZAN AND CREW

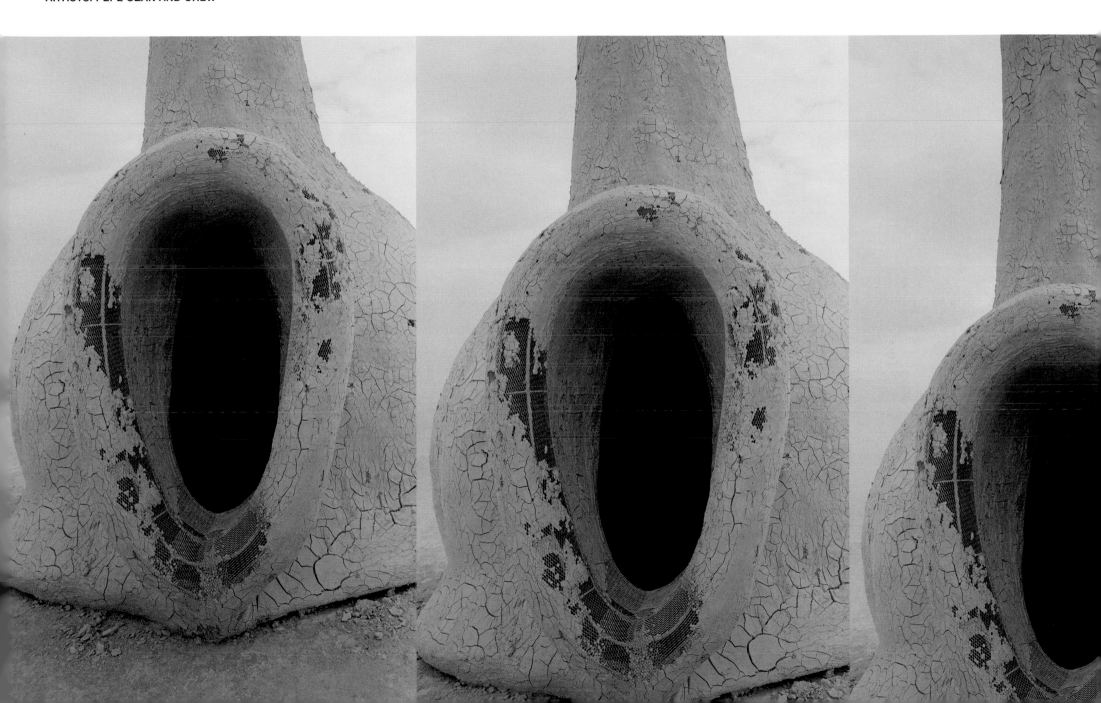

"THE MOMENT YOU PACK UP AND WALK AWAY FROM THE CREATIVE PROCESS, A STATE OF ENTROPY INSTANTANEOUSLY OCCURS. I FOUND THAT WHEN I TRULY 'FINISH' PIECES THEY TOO OFTEN BECOME CLOSED STRUCTURES WITH NO ROOM FOR OTHERS TO ENTER INTO IT. FOR ME, THE TRUE MAGIC OF THE PIECE COMES OUT IN THE IMAGINATION AND ENERGY OTHERS BRING TO IT. THEIR INTERACTION CONTINUALLY TRANSFORMS THE PIECE AND GIVES IT LIFE." —MICHAEL CHRISTIAN

Salt Lake), or visiting De Maria's *Lightning Field* ("a one mile by one kilometer" grid of 400 polished stainless steel poles twenty-plus feet high that in addition to defining a high desert space also attracts lightning during summer months); or getting to see Turrel's *Roden Crater* (a natural cinder volcanic crater in Arizona that artist James Turrell has turned into a massive naked-eye observatory, designed specifically for the viewing of celestial phenomena); or *Heizer's City* (a project in a county that is remote even for Nevada, consisting of huge mile-plus long concrete and earth structures organized into complexes that are meant to "represent all the civilization to this point"), the latter two having been under construction for decades.

These works employ a shared sense of maverick visioning, but utilize the isolation of the individual in order to experience their grandeur. All of these endeavors require a significant investment of both time and money, and that commitment by the participant creates a safety net for the experience to occur as it was designed.

Each of these projects is the work of an individual's vision, made real and lacking any sort of levity in the expression. At Burning Man, a community event of thousands of people, levity is an integral aspect of the art that's produced. Humor is not often present in the art world. Here, however, it is both posture and mirror, reflecting back the culture that has been left behind, albeit temporarily.

Sometimes this humor is overt, as with Kal Spelletich's interactive robotic contraptions. His *Hugging Machine* features a large cushion that folds around you with a pneumatic *whap*, almost knocking you off balance in the process, as the large cushion envelops you in its wooden embrace. *The Lie Detector Halo* gives you some sort of quasi "benefit of the doubt" with a burning halo situated above your head, acknowledging your saintly divinity and questionable truthfulness while quietly toasting your hair. More often the humor is subtle, of the "you had to be there" variety.

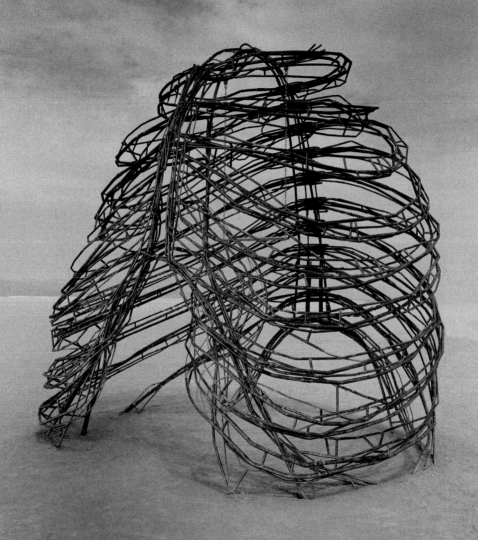

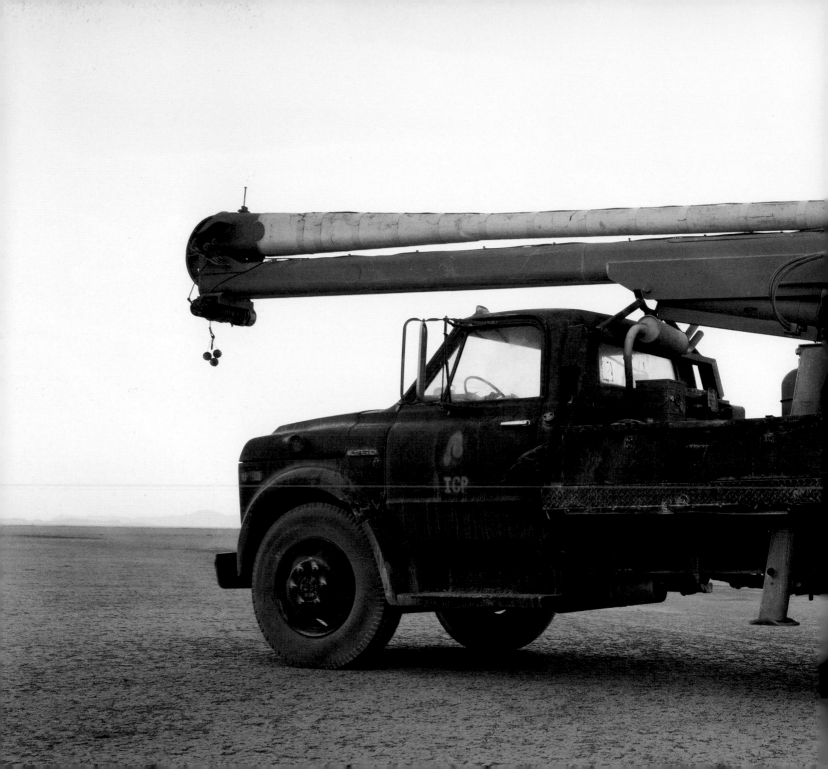

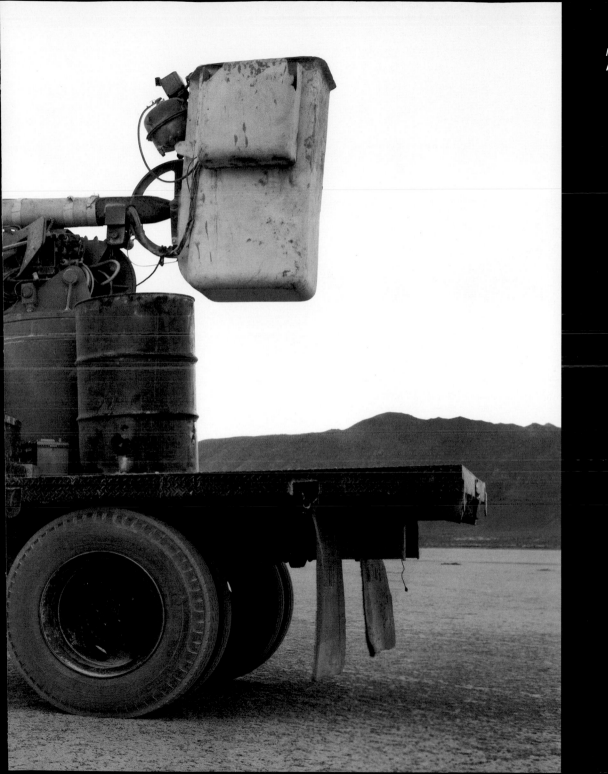

Impotence Compensation Project/Support Vehicle
ARTIST: JIM MASON

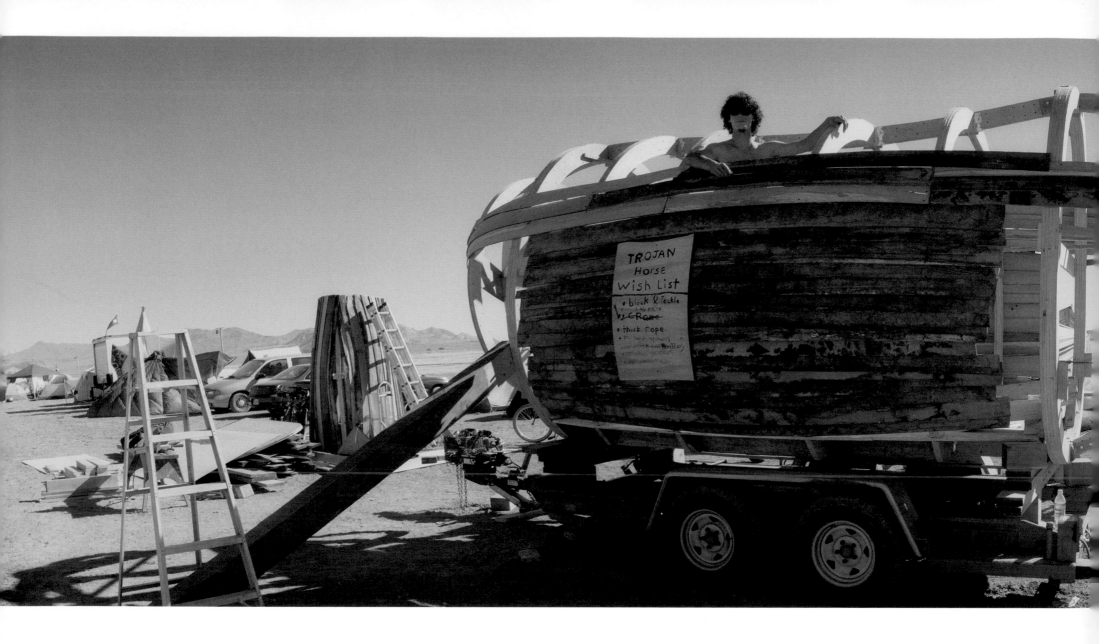

Trojan Horse (1997)
ARTISTS: BILL WALKER [pictured] AND CREW

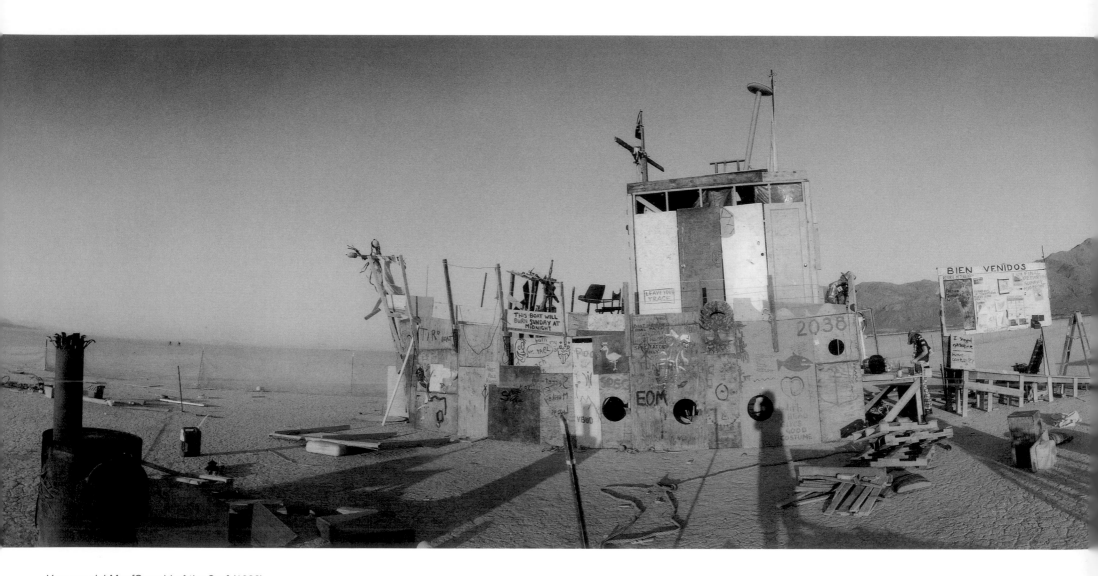

Vaquera del Mar [Cowgirl of the Sea] (1998)
ARTIST: JENNY CARDEN [pictured]

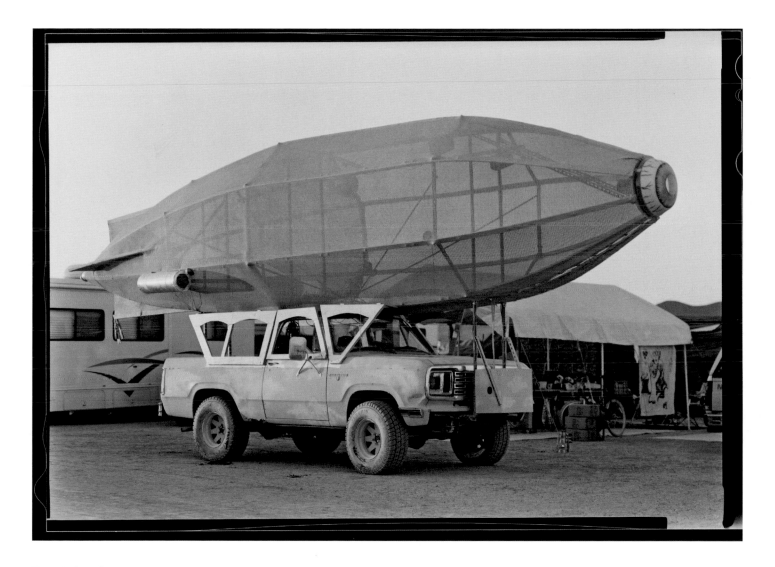

Zepplin (2006)
ARTIST: UNKNOWN

Overleaf: *Building the Rocket Ship* (1999)
ARTIST: UNKNOWN

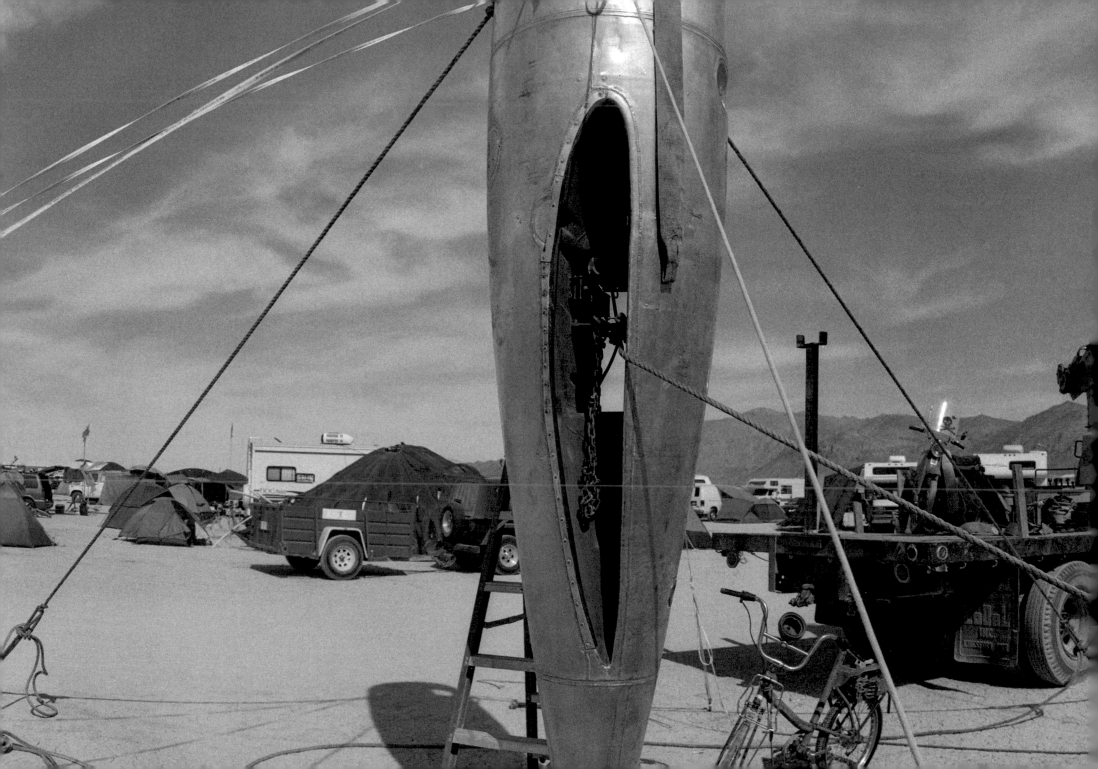

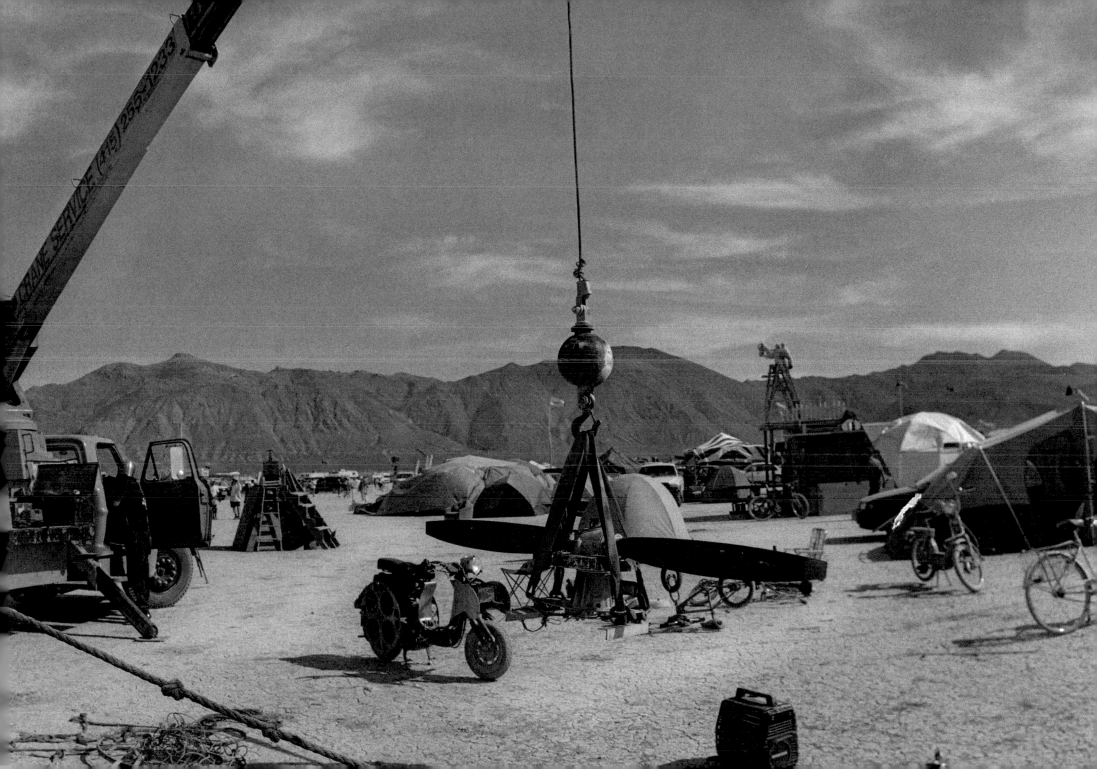

Building the Hamock Car (2001)
ARTIST: DAN DAS MANN [pictured]

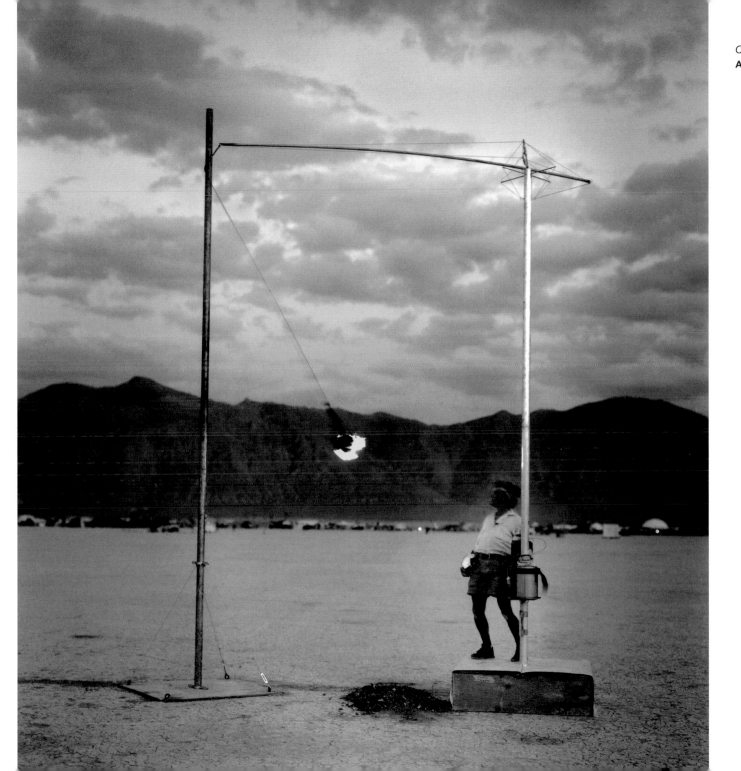

Temple of Rudra Approach (1998)
ARTISTS: PEPE OZAN AND CREW

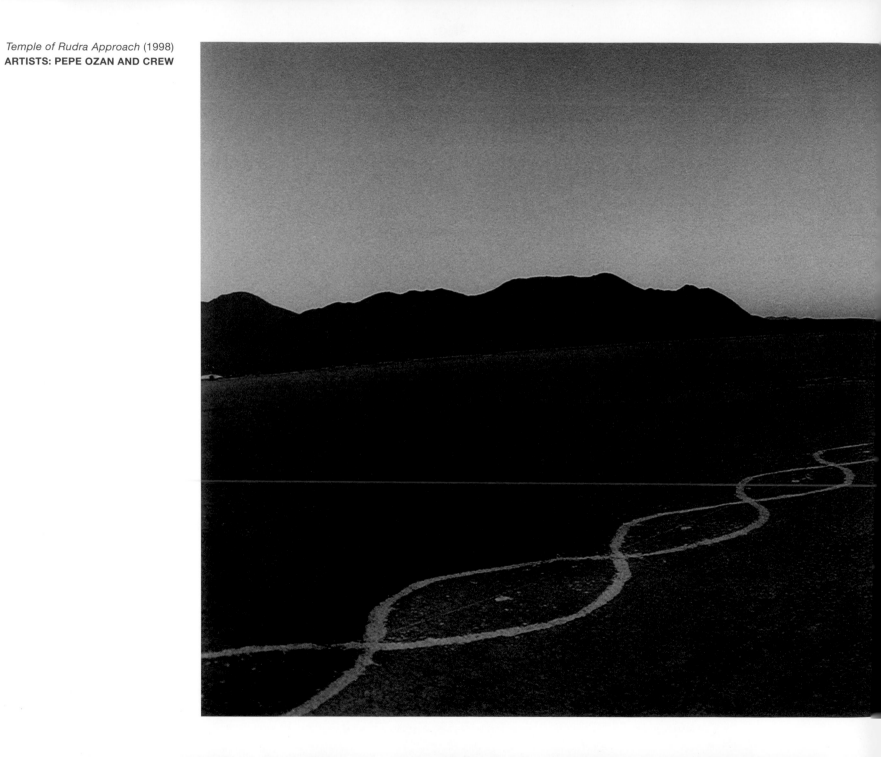

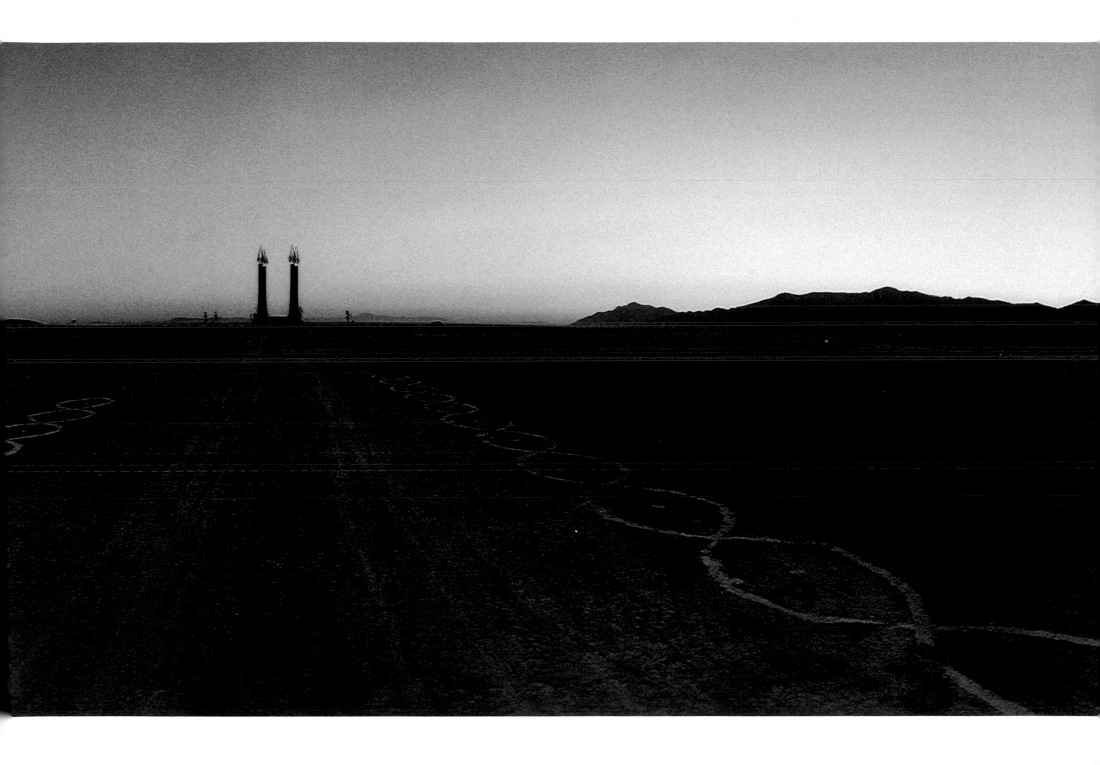

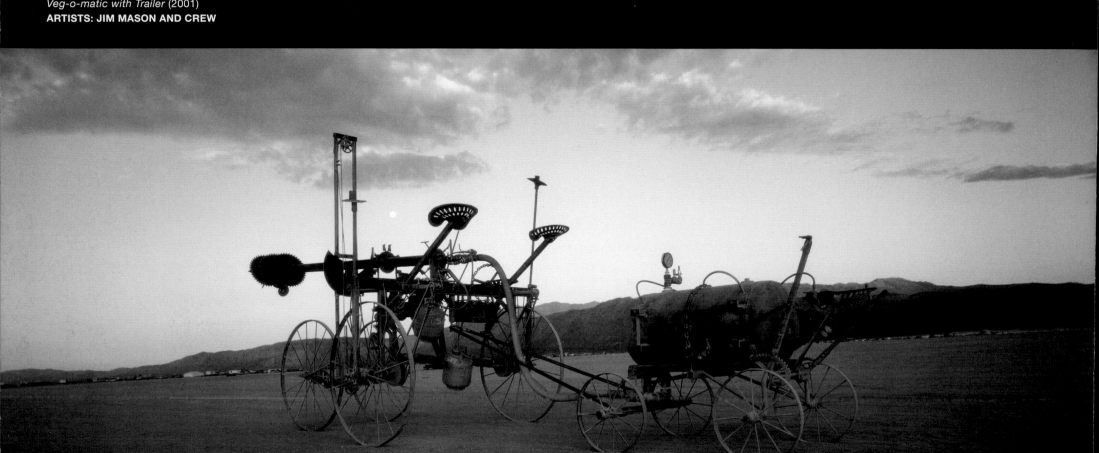

Veg-o-matic with Trailer (2001)
ARTISTS: JIM MASON AND CREW

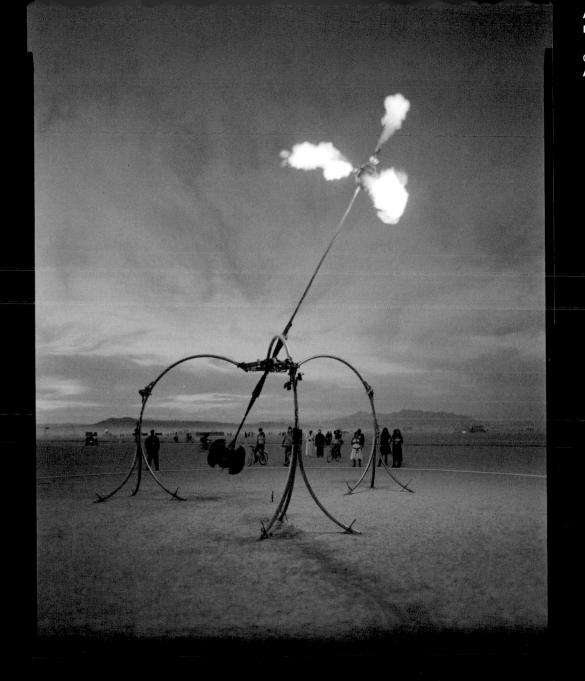

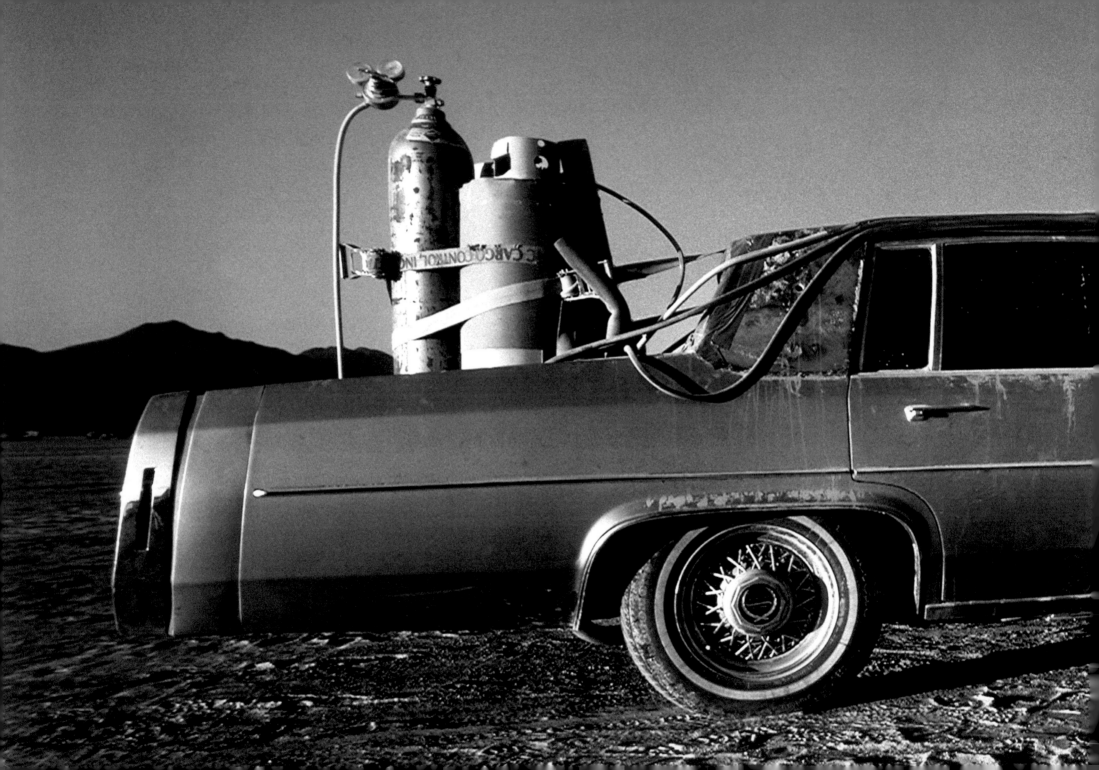

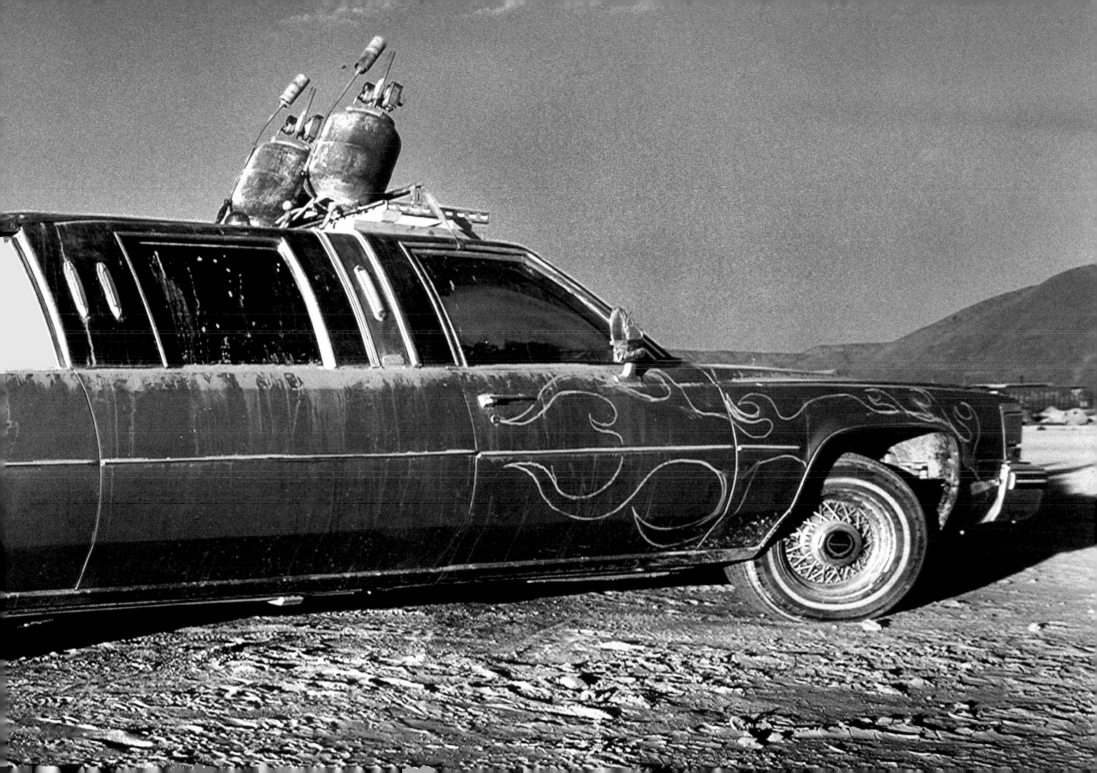

Unloading Wood (1999)
ARTISTS: PEPE OZAN [pictured with white hat] AND CREW

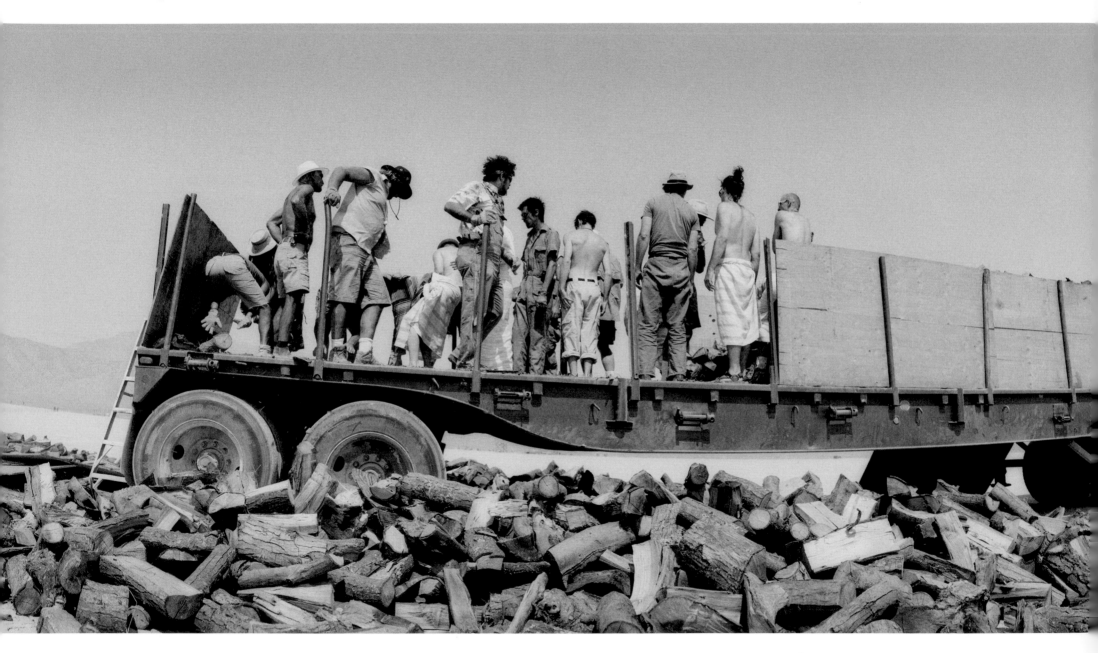

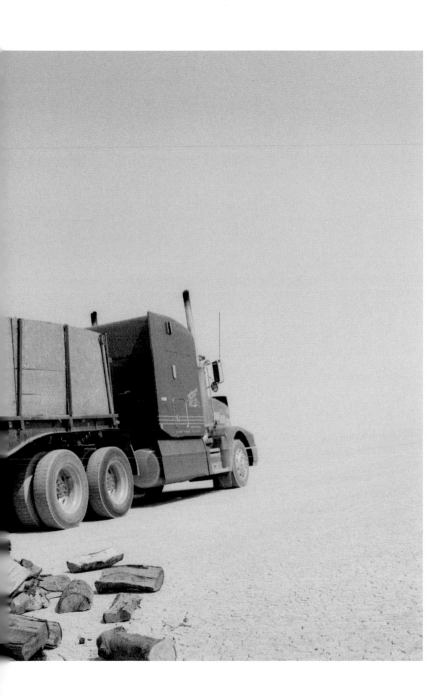

PREPARATION

The relentless demands of my life often made it difficult to adequately prepare for Burning Man. Whether it be (currently) family life, the demands of a job, or multiple jobs, there are a week's worth of details to deal with in order to live and then work in a high desert environment. Long hours as a gaffer in the San Francisco Bay area film industry keep pushing back my prep time to the point that I would often end up getting ready only days before I had to leave, having numerous boxes shipped to the post office in Gerlach, Nevada (the small three-bar/no-church town at the edge of the desert). Even then my departure would, more often than not, get pushed back a day or two due to unforeseen problems, or just plain exhaustion. This is more the norm than the exception for most of the artists and attendees involved in Burning Man.

There are so many details leading up to your departure that the days often turn into all-nighters, only to be followed by hours and hours on the road fraught with breakdowns and all manner of mishaps. I worked for a few years with David Best and his crew on the large temples that were built in the desert beyond the Burning Man itself. Inevitably, I would meet them at the site, guaranteed to hear numerous stories of duress, such as tires coming off of trailers and buses that would only reach top speeds of ten miles per hour.

"I'M NOT REALLY SURE I BELIEVED THE EVENT COULD WORK ON THIS SCALE. THAT 40,000-PLUS PEOPLE COULD ASSEMBLE OVER A WELL-WORN FORM YEAR AFTER YEAR AND STILL STIR THE CREATIVE STEW SO IMPRESSIVELY, AND ODDLY, AND STILL SO INTIMATELY. THAT BURNING MAN COULD BE SO STRONGLY FELT AND CREATIVELY SMART AT THE LEVEL OF THE SINGLE INDIVIDUAL, WHILE ALSO REALIZING ITSELF AS BEING SO MUCH MORE AT THE SCALE OF THE MASSIVE WHOLE. THAT MAYHEM AND WONDER COULD BE OFFERED WITH SUCH BREADTH AND DEPTH IN ALL DIRECTIONS, AT ALL TIMES, IN ALL FORMS, TOWARD ALL ENDS. THE HYSTERICAL SUBLIME, RENDERED AT LARGE, FOR EVERYONE IN LINE TO DRINK." —JIM MASON

One year a couple from Ohio made it all the way to Empire, the US Gypsum company town seven miles before Gerlach. They swerved to avoid a rabbit and one of them was killed when their vehicle, towing a trailer, flipped over. This is the most common of accidents leading to and from the Burning Man event: a lack of experience in driving and towing heavy, often poorly organized loads. In some instances the load weighs equal to, or close to, that of the vehicle that's towing it. The trailer starts to push the car or truck down an incline in the road, whereupon the driver's natural instinct is to hit the brakes rather than easing off the accelerator or even hitting the gas as the trailer begins to jackknife, ending in disaster.

Poor planning, unforeseen holdups, and the gravitational pull of the life you're leaving can make the transition to the desert thick and heavy. I often leave in the late afternoon, and arrive during the night.

In the early years, a solo car trying to find the small encampment days before the event, a dozen miles out on the open Playa, would have trouble. The curvature of the earth and no landmarks in close proximity combined to create a loss in perception. In 1995, I was the nineteenth person out there. I was trying to find Pepe Ozan and his crew of builders, which I was a part of. I hit the Playa at dawn and tried to follow Michael Michael's directions to the site. They were something on the order of: leave the main road, drive sixteen miles north on the west track, then turn right and go 5.3 miles to the site. At that hour, without the sun and shadows to define objects, I was unable to find anyone. Ultimately, I gave up and headed back into town for breakfast.

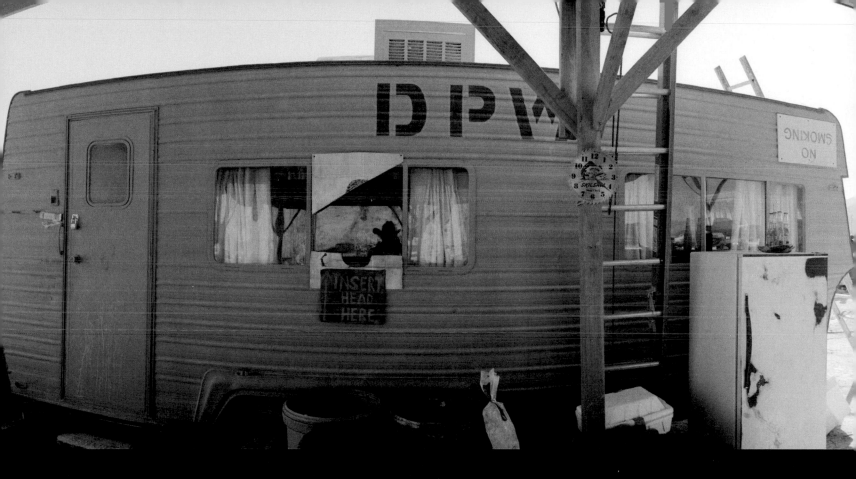

Insert Head Here/DPW Depot (2001

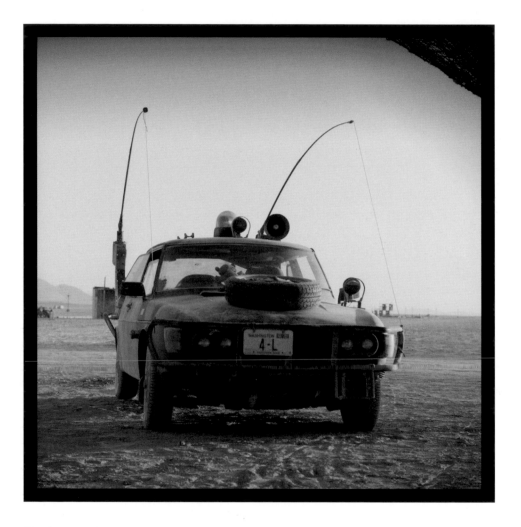

The Observer (2001)
ARTIST: ELI LYON

Opposite: *Temple of Honor Dome* (2003)
ARTISTS: DAVID BEST AND THE TEMPLE CREW

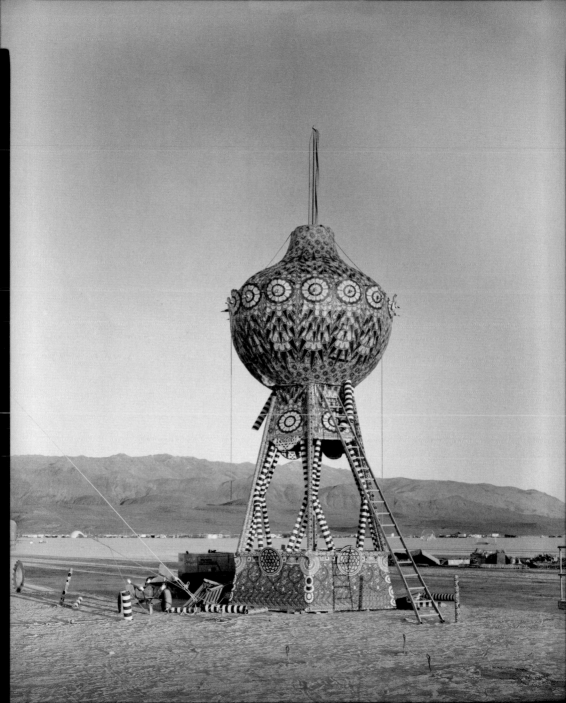

Steve Heck's Piano Bar/I Am Sickened by Your Weakness (1998)
ARTISTS: STEVE HECK, WITH HELP FROM JAY BROMMEL [pictured] AND OTHERS

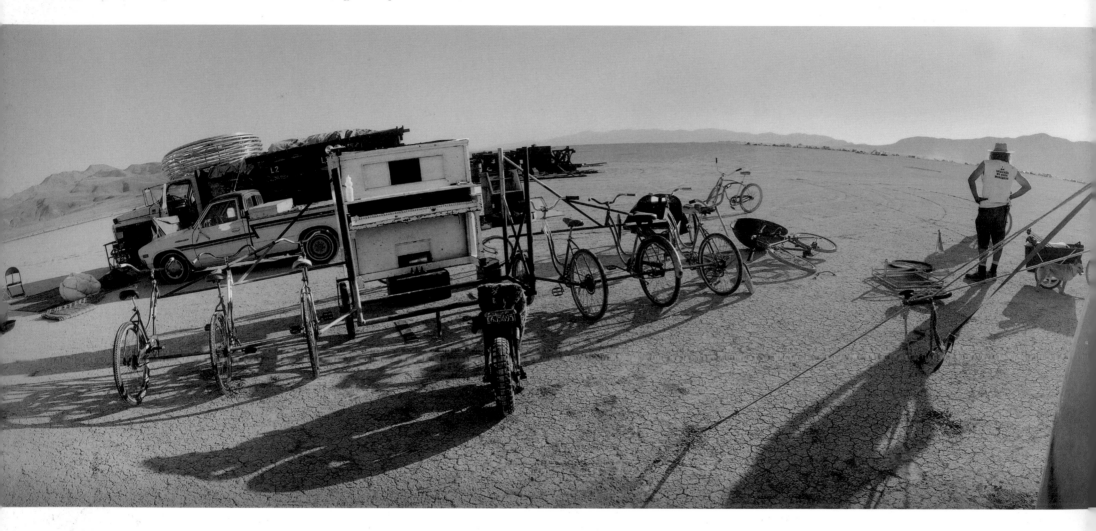

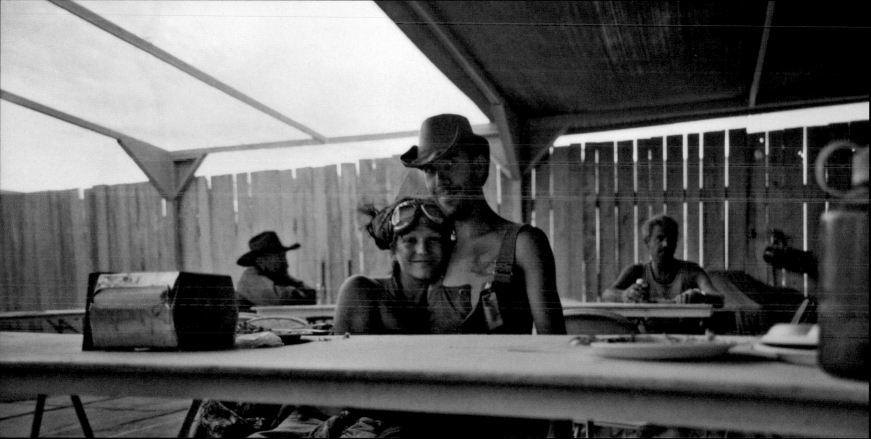

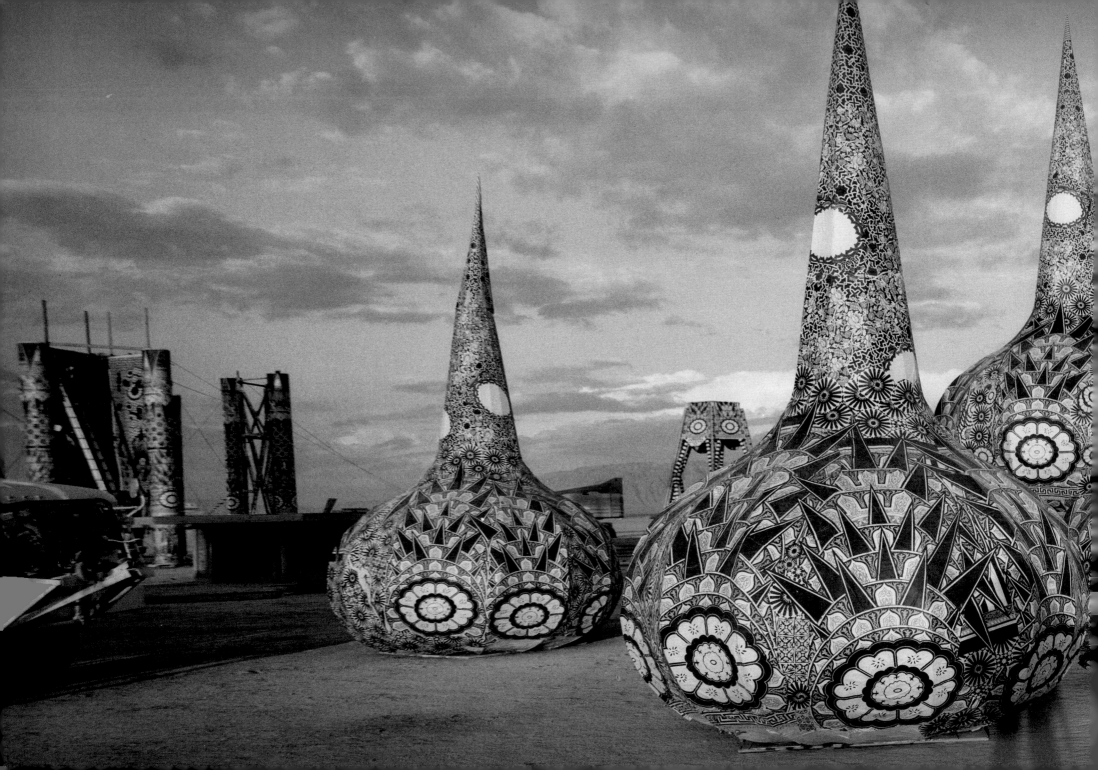

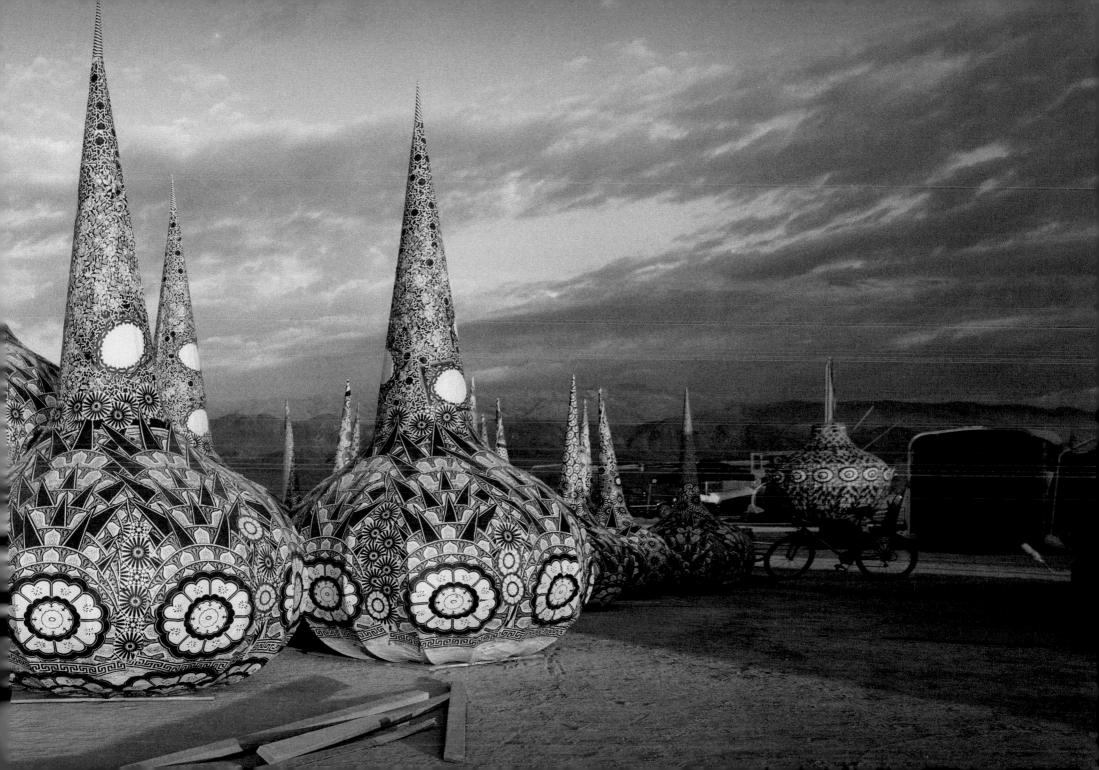

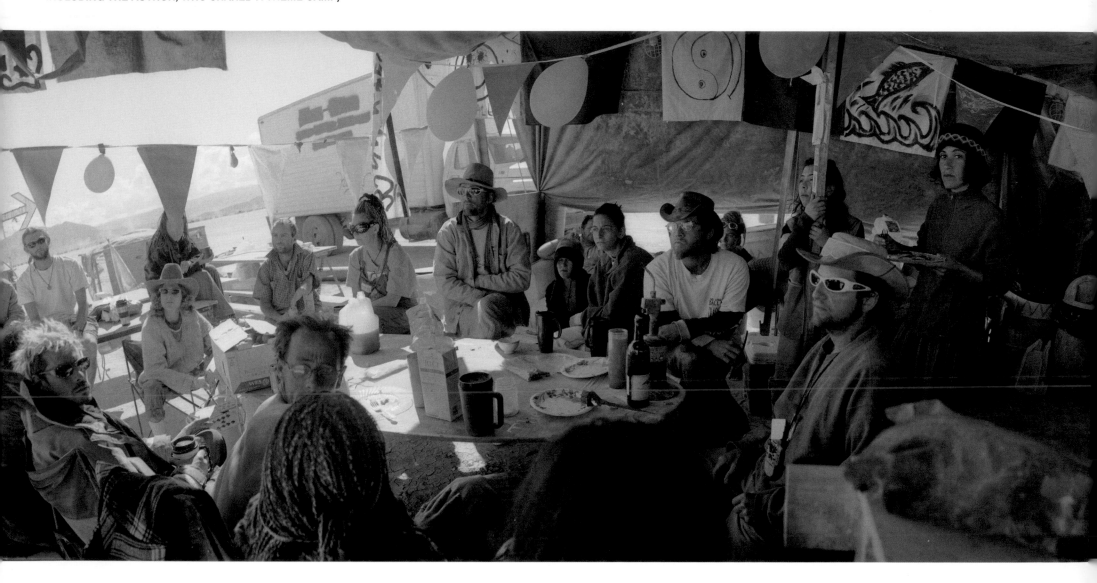

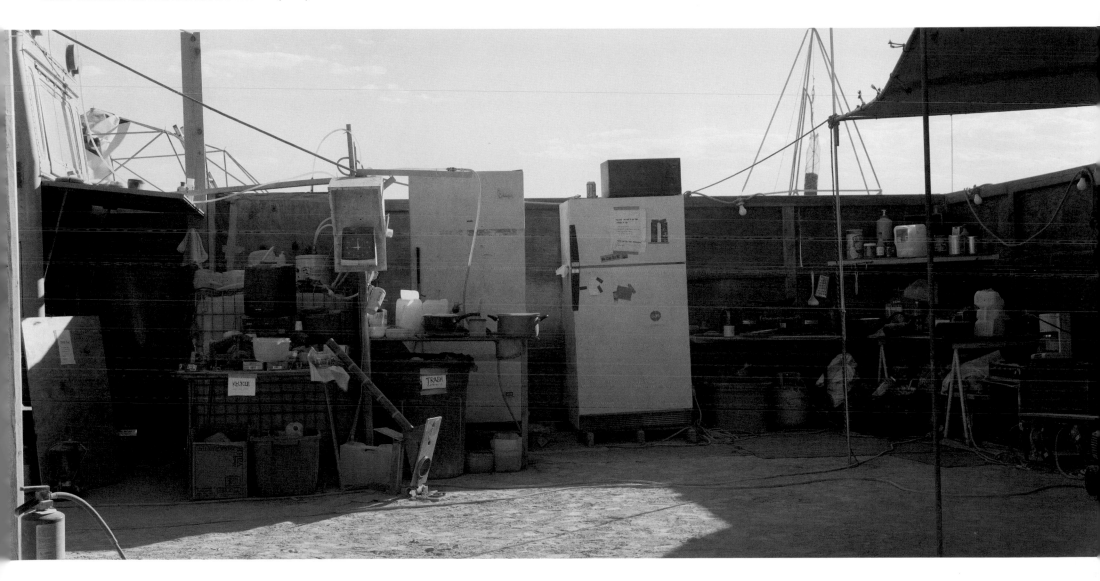

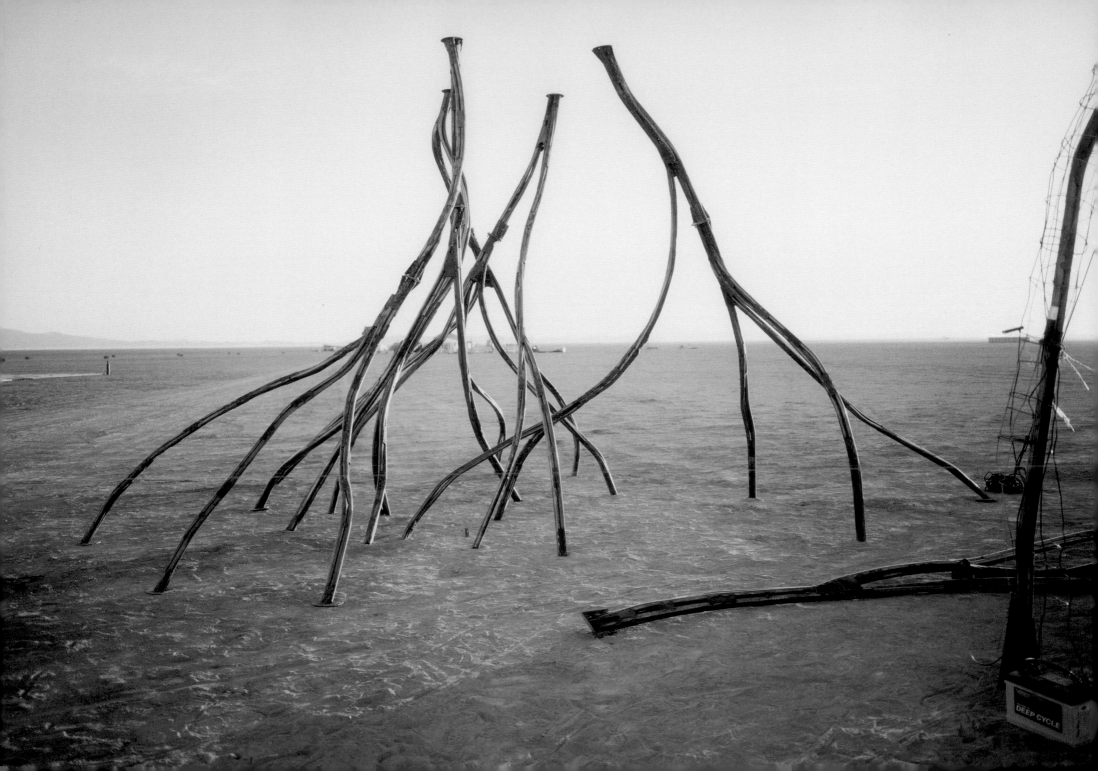

Opposite: *Flock's Legs* (2001)
ARTISTS: MICHAEL CHRISTIAN AND CREW

Scissor-Lift Couch in Dave's Berkeley Glass Shop (2006)
ARTISTS: DAVE WILSON, VICKI BURNHAM, AND PHIL SADOW

ROAD TRIP

When I finally get into the car and head out, having planned to leave at 9:00 AM but, if I'm lucky, leaving by 5:00 PM, I'm stuck in the midst of rush hour traffic. I've been as much as six days late, like the year I decided to do my own art project separate from photographing those of others. One day led into the next and before I knew it, it was the day before the event was starting and I had missed an entire week.

When one arrives early, the city is sparse. That has its own comforting quality to it. Being back, it's not too different from when I last saw it, though the tracks are gone, the lake that forms each winter has wiped the Playa clean, and the city is freshly laid out with new street names reflecting the year's theme.

I drive to an approximation of where I'm going to camp, get out of the car, go for a short walk, or just have a beer and lay down next to my car and go to sleep. After years of doing this it's an embedded ritual. I lie down on the side away from where the sun will soon be shining, against the side of the car so I don't get run over in the middle of the night by a stray vehicle, and wake to the sound of people working around me and vehicles moving as the DPW crews head off to the depot a mile or so away for the morning meeting.

I start my day by drinking a quart of water and search my pockets and car for the things I'm used to just reaching for. I try to get up to desert speed as fast as possible. It takes about a week to acclimate. Even when I think I hit the ground running, it isn't so. One year I arrived and had just enough energy to put up my tent and crawl in and go to sleep, almost shaking. If you're not accustomed to the high desert climate, and the dryness and how to adjust for it so you can work, you can mess yourself up. Peel an orange and lay the rinds down somewhere out of the sun; by the time you come back in the evening you'll be able to snap the peel in half like a cracker.

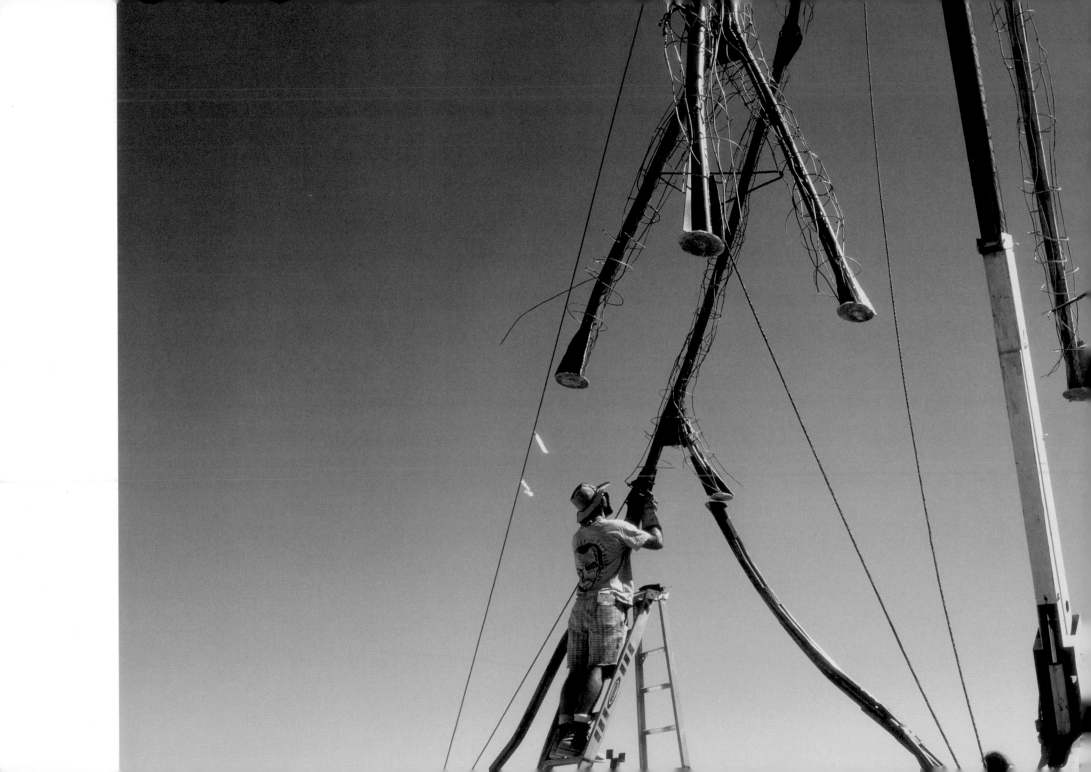

Building Flock (2001)
ARTISTS: MICHAEL CHRISTIAN [pictured] AND CREW

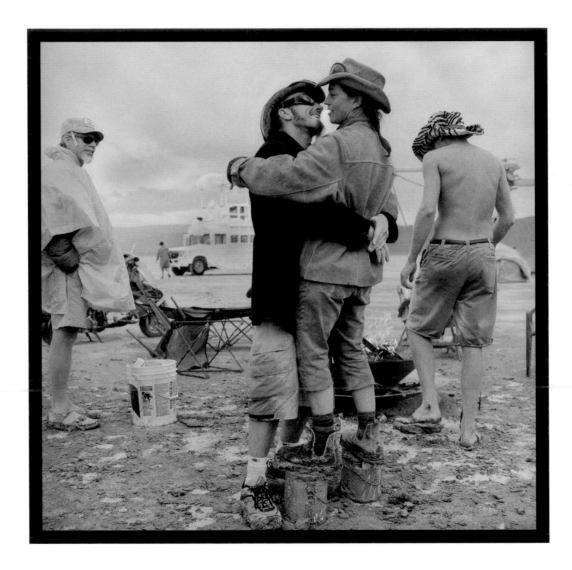

Zac Carroll and Jody Lyman (Temple Crew)
after the Rainstorm (2003)

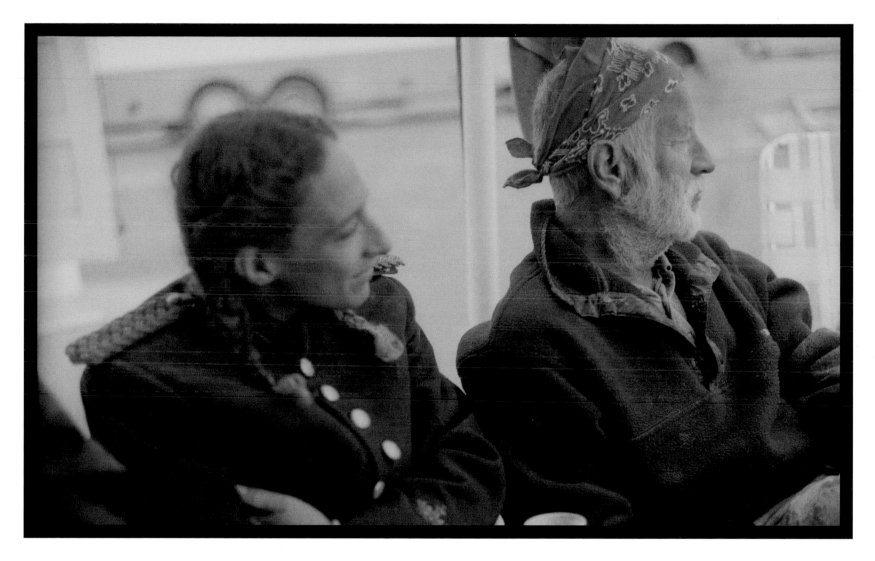

Amy (Temple Crew) and David Best Waiting for the Playa to Dry (2003)

Overleaf: *Building the Man Base* (2003)
ARTISTS: ROD GARRETT AND LARRY HARVEY
BUILDERS: ANDREW SANO, D'ANDRE TEETER, ELI LYON, AND CREW

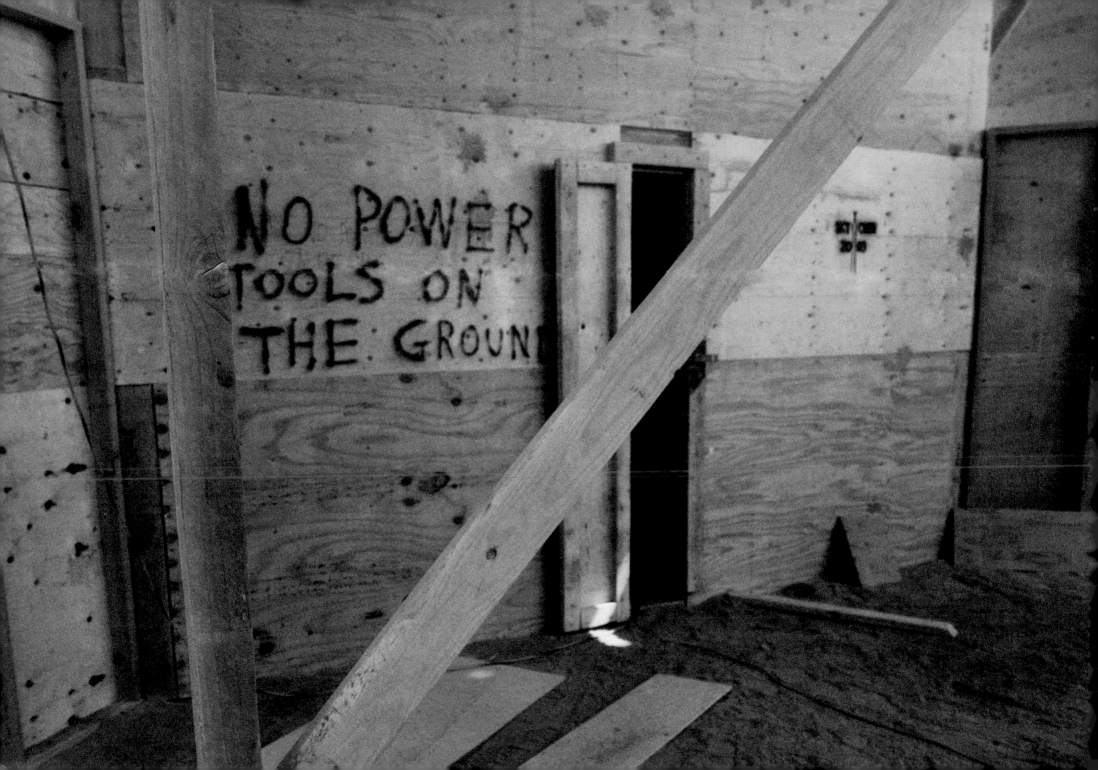

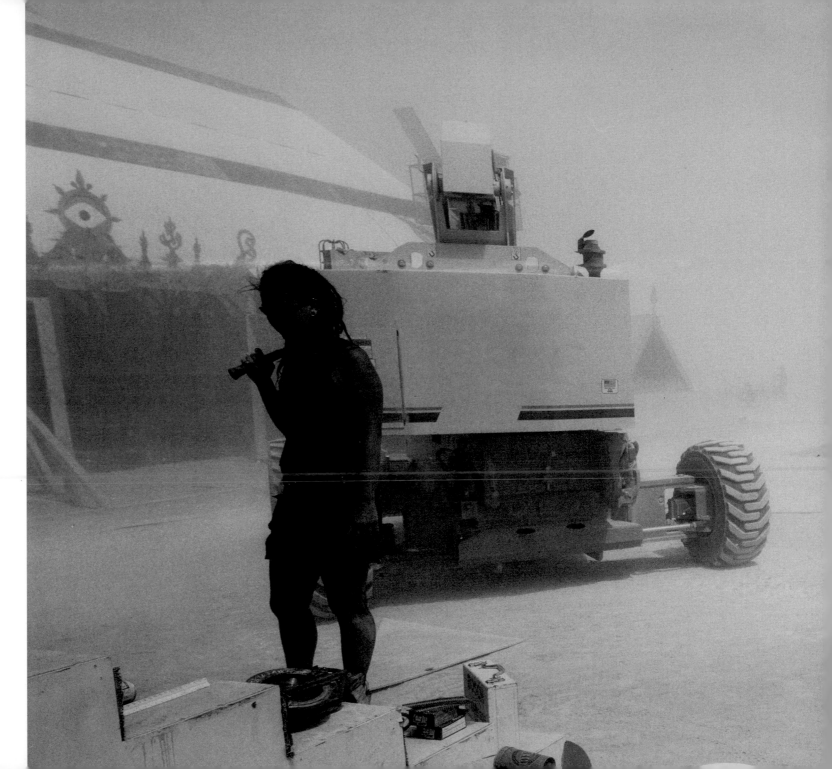

Building the Man Base as a Dust Storm Passes Through (2003)
BUILDERS: ANDREW SANO, D'ANDRE TEETER, ELI LYON, AND CREW [pictured, unknown]

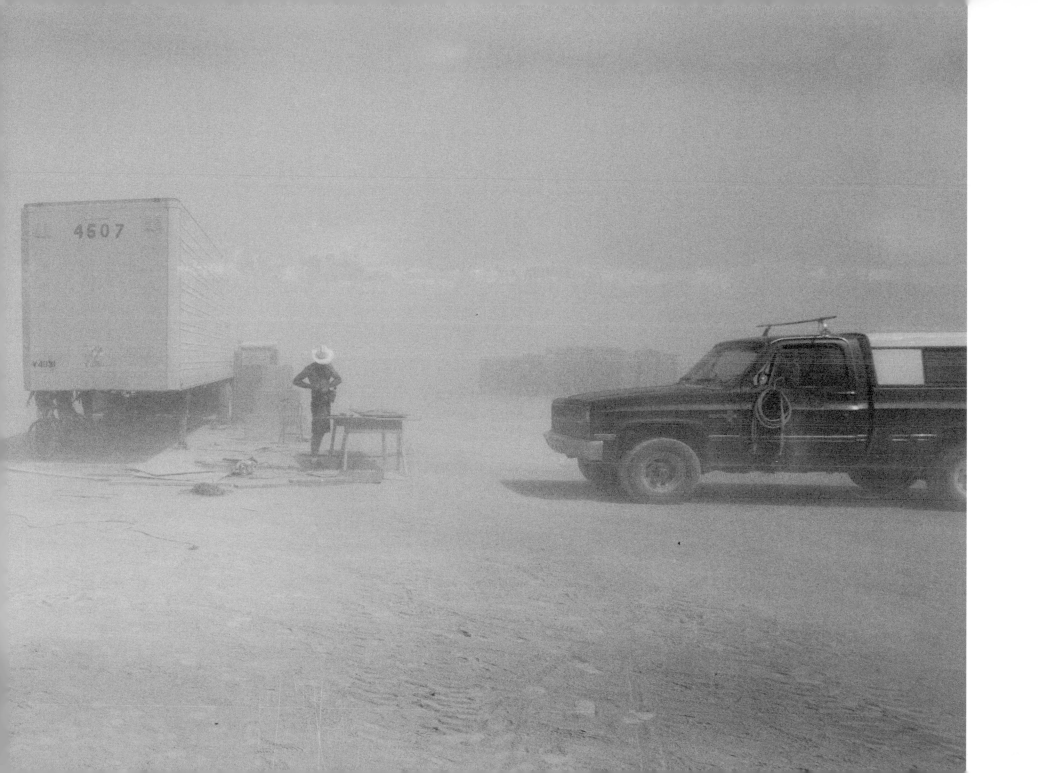

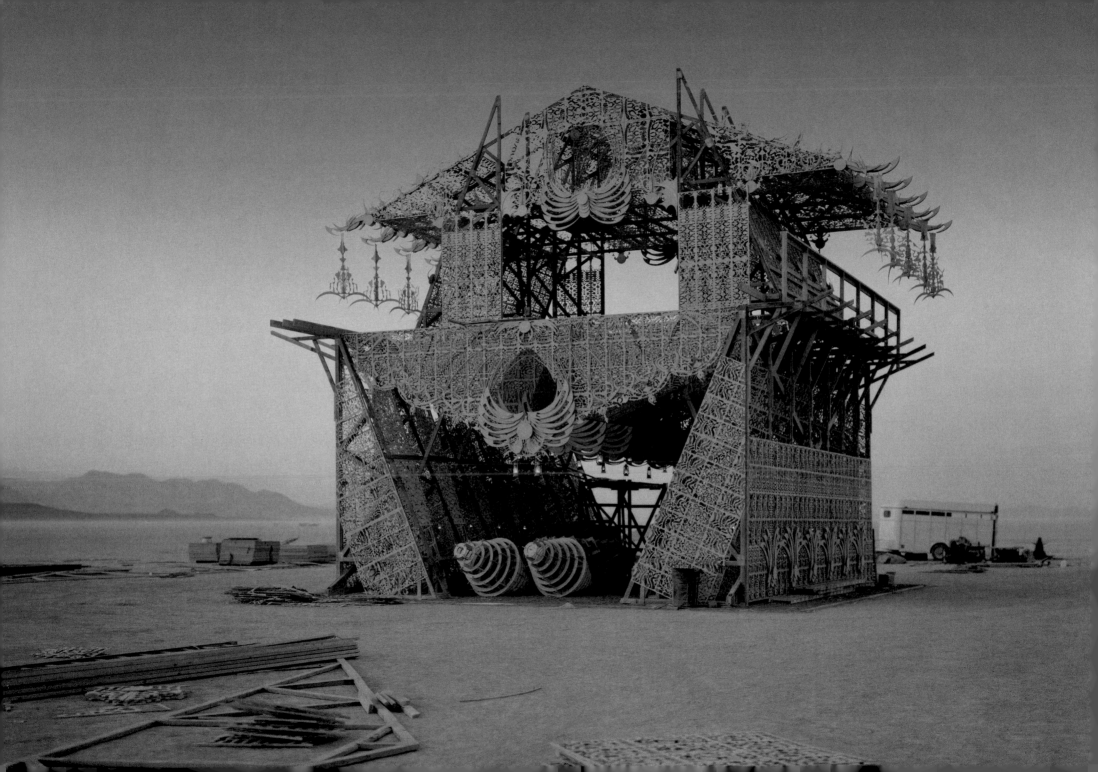

Opposite: *Temple of Joy under Construction* (2002)
ARTISTS: DAVID BEST AND THE TEMPLE CREW

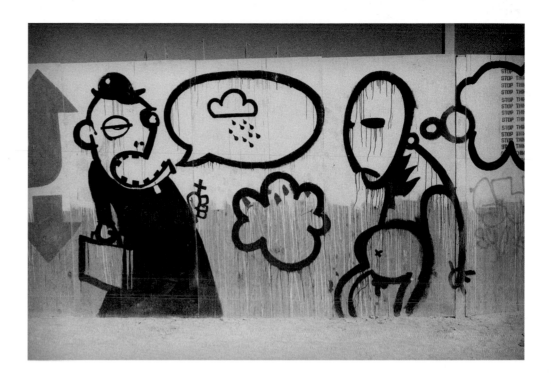

Banksy's Center Camp Café Wall (2001)
ARTIST: BANKSY

A lot of artists with time on the Playa under their belts bring work lights and do what they can at night. If there's a full moon it's even easier. As you ride along in your car you pass people working. You can see lights all over the Playa and hear the sound of drills and saws, and see sparks flying. There's always a sense of mystery. Often you can't tell what people are working on until they're finished. A pile of scrap becomes a forest, or in Robert Burke's case, a pile of chrome bumpers becomes a DNA helix rising above his car, its roof cut off. If you're lucky you see magic. It's the reason we all go out there in the first place: to witness something sublime. A call from grace.

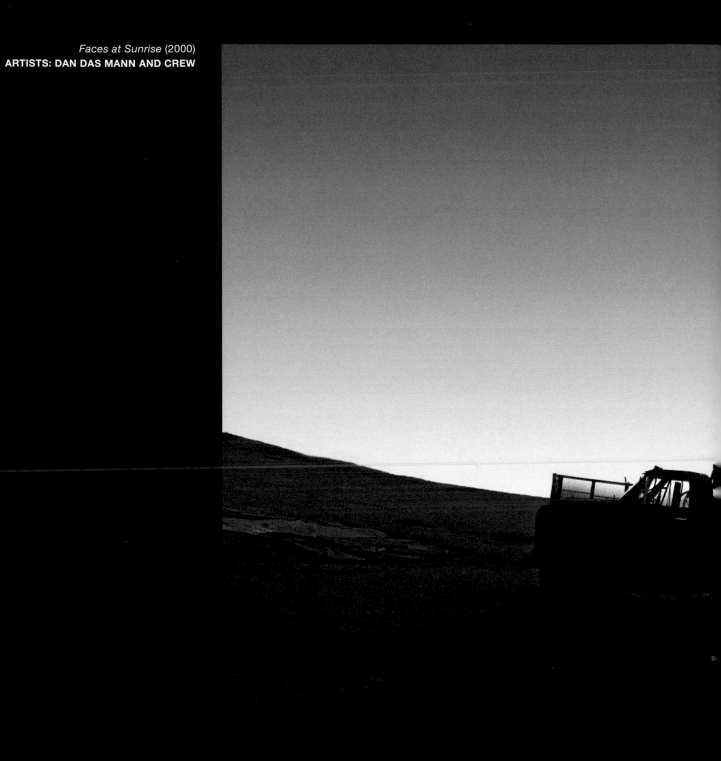

Faces at Sunrise (2000)
ARTISTS: DAN DAS MANN AND CREW

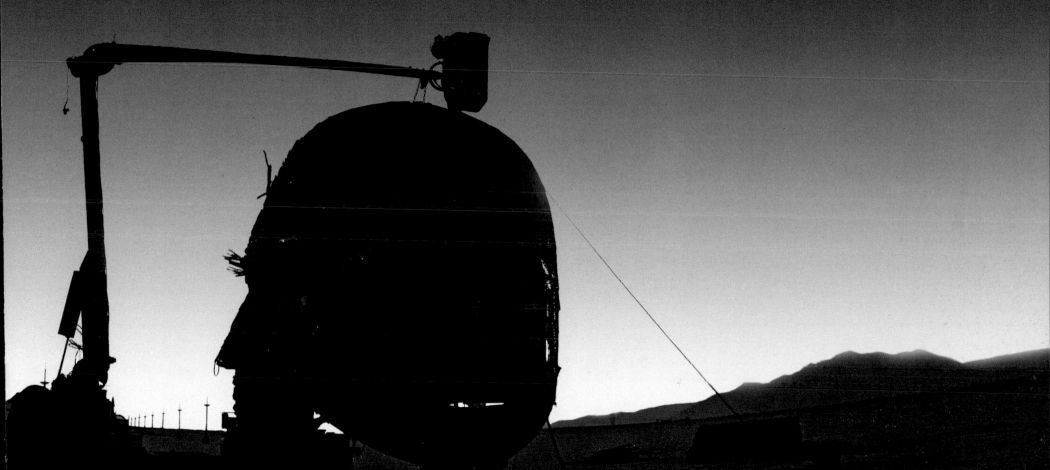

A CITY EMERGES

As an artist working on a large project, you may have been out in the desert for two weeks; on the weekend before the event starts, cars begin to arrive. The buzz of activity increases, adding to the energy, but changing it as well. No longer are there only a core group of workers from the Burning Man DPW, artists, and staff around. Now there are people with theme camps where F-U-N is the main objective and it's no longer just you and a series of large installations scattered throughout the desert. It's all good and part of the same event, but the surrounding area begins to shrink. It no longer feels like the wide-open space it was before. There are now Burning Man's own Black Rock rangers patrolling, telling you to slow down. Whatever sense of anarchy or freedom that had existed begins to change to make a city of this size workable for all.

The Black Rock rangers are great. They act as a buffer between the BLM rangers (who are basically park rangers—these days cops with green uniforms) and the attendees. There are only so many BLM rangers, and by having their own, Burning Man is able to provide a level of security that maintains law and order without people feeling as if the government is invading their space. The rangers also keep a safety perimeter around large artworks that are burned until they've had a chance to collapse and no longer present a physical hazard beyond the fire itself. There is a largely unspoken agreement between the artists and the rangers and the crowd, that once a structure has fallen and lays burning in a heap, they can run in and dance around it.

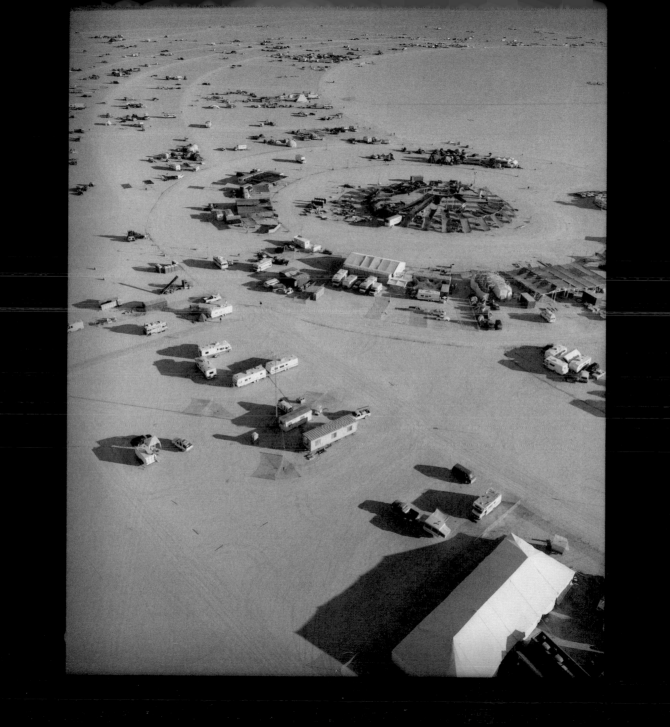

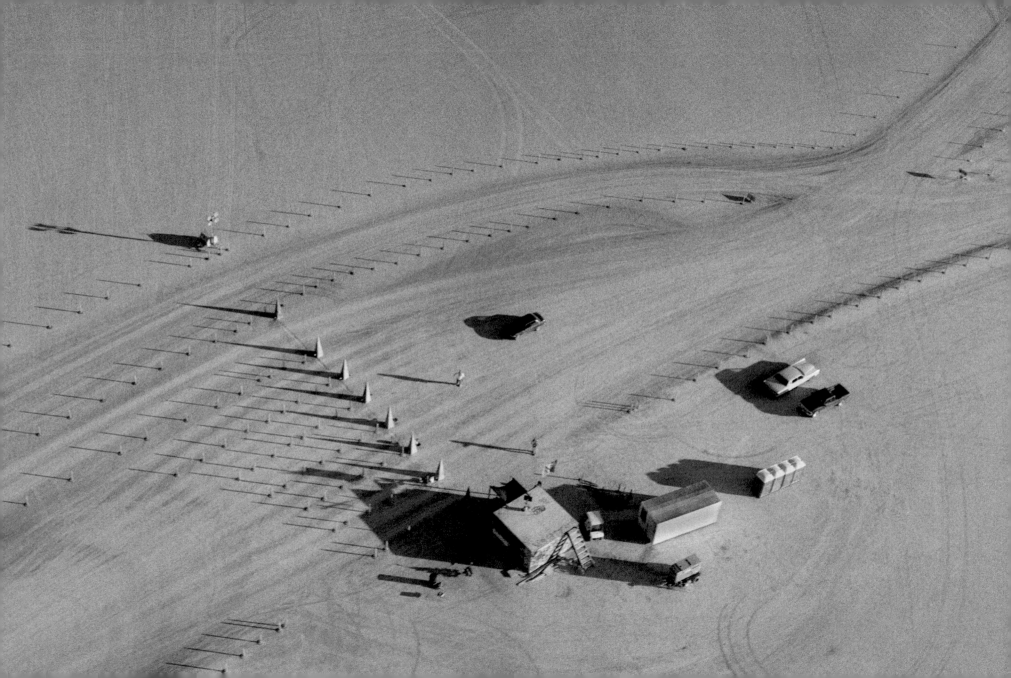

"I CONSIDER BURNING MAN TO BE A FULCRUM FOR THE EVOLUTION OF CONSCIOUSNESS ON THE PLANET, WHERE CUTTING-EDGE SCIENTISTS CONSORT WITH NEO-PAGAN WARLOCKS, AND ARCANE BITS OF KNOWLEDGE ARE EXCHANGED AT HYPERSPEED." —DANIEL PINCHBECK

As Burning Man comes together, no longer is it hard work for work's sake, but there's a feeling of a city gathering itself. It has a bit of a weekend warrior feel to it, real or imagined, and it takes some adjustment. Having the Playa to yourself was fun. There were few reminders that there's a world beyond what you've focused your attention on and it felt good. Now, all of a sudden, you are reminded of what life is like with a lot of other people around you—the way it was before you came out to the desert. And it's not that the people are bad or obnoxious (it's actually the opposite), it's just that you've worked hard out there to get to this point, and all of a sudden there are fresh-faced people riding around half nude on bikes and you can resent their ease and the reminder that there is a world out there that you've had a break from, one you hadn't necessarily missed.

The creation of the city has formed a bond within the various groups of builders, and that is being diffused by the energy of others. For some that is a difficult transition. Except for the artists and their pieces, the infrastructure is mostly taken for granted. As one friend laments, "The poor hippies work for the rich ones." I think that's partially true, but there's always going to be those who do hard physical work and those that don't. In this community most people get it. They've had their own battles with getting their creations to the desert and respect the DPW's efforts.

I worked with Lance Hughston and his electrical crew for six to seven years, helping with the setup and breakdown of the electrical grid needed to run the event. I liked being part of the building of the city. I was able to use my skill set and have the week of the event to myself to photograph. For many of those years I also worked with one of the artist groups. It enabled me to have my feet in both worlds. Although there was often a tension between my time and the work I did for others, it allowed me to have a well-rounded experience. I didn't just come and take my photographs and leave. My time spent was satisfying in a way that what I did the rest of the year often wasn't. It was work for the community, and it made me part of the social fabric that makes this society function.

The morning meeting out at the DPW depot is a daily ritual as crews are put together, tasks completed, and problems solved. It's a constant drama of craziness that seems to fuel everyone and make the work meaningful. If shit wasn't going down, your time at Burning Man would be boring and nobody would want to work there on projects. It would be the same as any other job. But it isn't. You're working in trying conditions that cause stress in spite of the work. Nerves can get raw and the fur can fly.

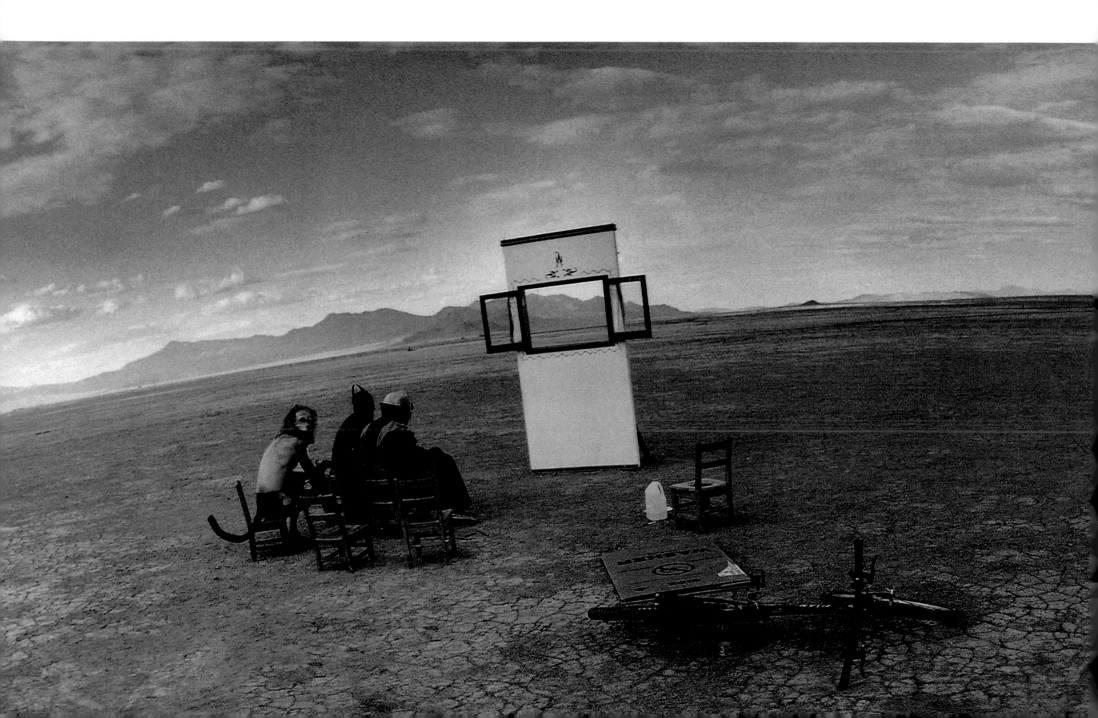

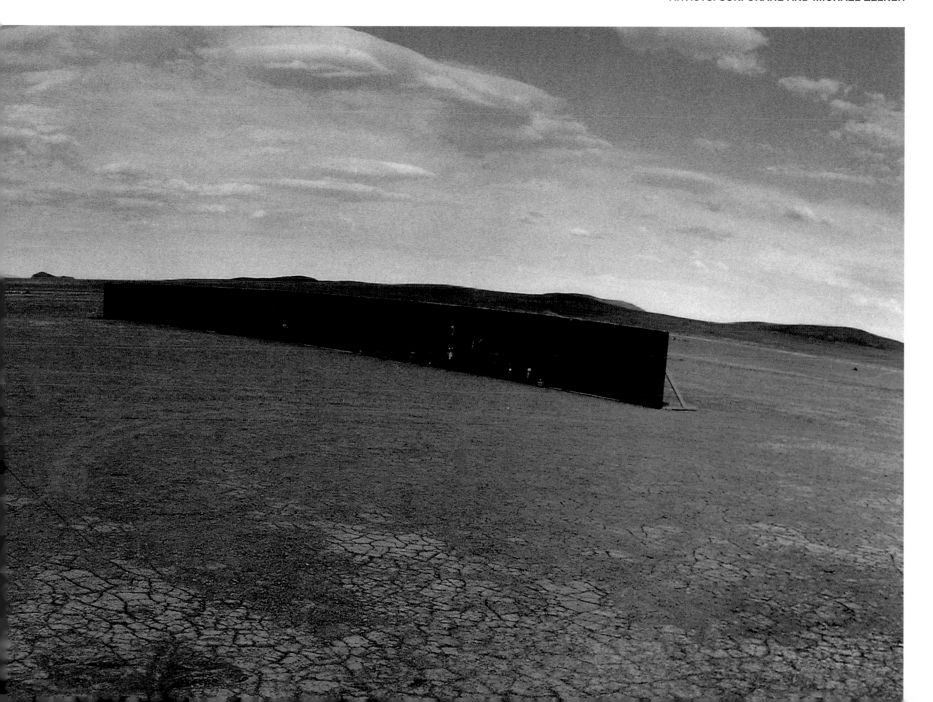

Laughing Scorpion Puppet Theater (1997)
ARTISTS: SUKI OKANE AND MICHAEL ZELNER

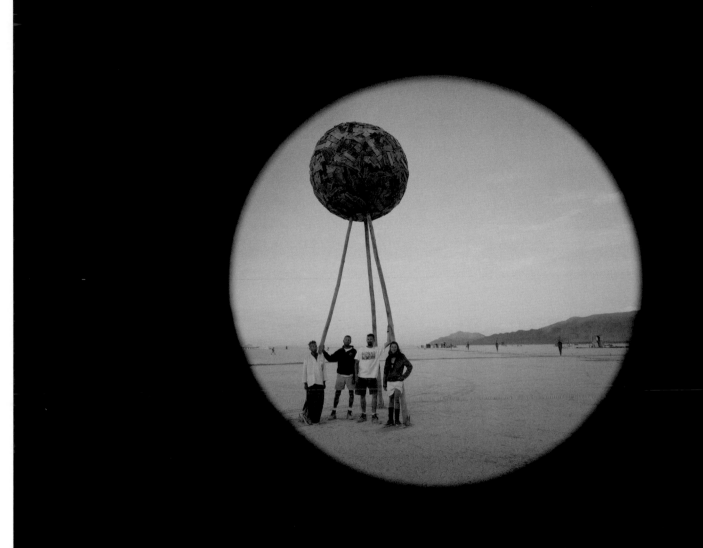

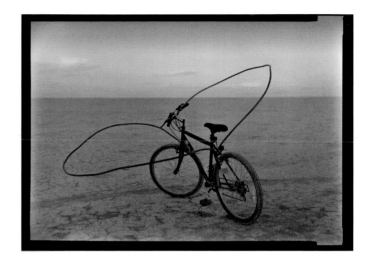

Carroll Moore's Bike (2006)

Overleaf: *Orbicular Affect under
Construction* (1999)
ARTISTS: CHRIS CAMPBELL AND CREW

Early on, the event attracted a punk vibe that helped set it apart from other social groups. Working on the staff as an adjunct to the DPW, we became part of a team with a separate code born of the language and humor that comes with working in such a harsh, isolated environment for weeks on end. I remember sitting with Michael Michael during dinner at the work ranch one night, and commenting to each other that it was one of the best environments and moments we had ever seen or been part of. A group of containers stacked at angles formed an outdoor shaded eating area, 140 miles out in the middle of nowhere. And the best thing about our time there was that it was all about the work and the community. In fact, no matter how trying day-to-day life is, I know I can always go back out to the desert and it's as if I've been re-tuned to the frequency most in harmony with who I am. Much of it is the absence of the white noise of our culture. Gone are the distractions we'll never miss: the jarring, yet necessary interruption of the phone, mail, e-mail, and the inanities of mainstream culture.

It should be noted that even though the crowd is mostly white, the cultures that you would expect to be attracted to such an event are all represented: gays, seniors, nudists, art enthusiasts, a huge high-tech crowd from Silicon Valley, among others. It is a city made up of those who enjoy being part of a community that is open and free thinking. Some would consider themselves New Age, others might detest the label but would be able and willing to see how it could fit. They just wouldn't want to be misrepresented as a fruitcake.

We all bitch and moan about something; as much as the arrival of thousands of "Burners" can be a bit dissonant after weeks of near solitary work, it's still a great venue in which to create and just be. The crowd is bonded by wonderment, with enough naysayers to keep the place grounded. Having said that, I find I take the most from the experience (which functions as a retreat for the majority of us), when I stay away from negativity and soak up being in a community where, for at least a week, we agree to let our minds expand into unchartered territory.

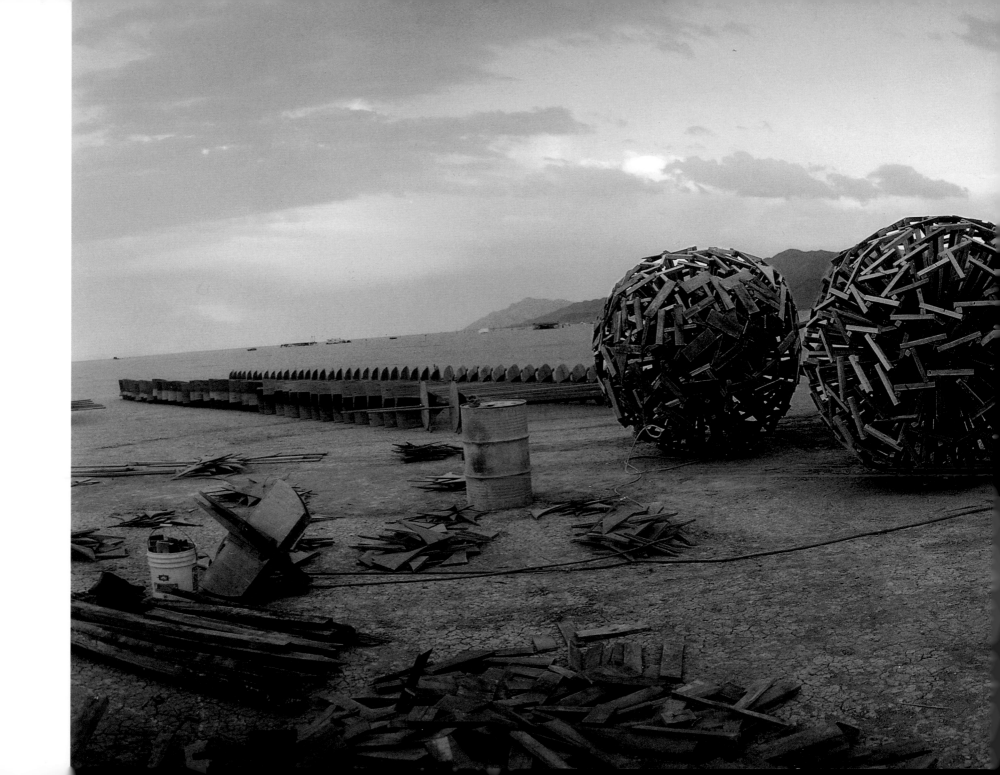

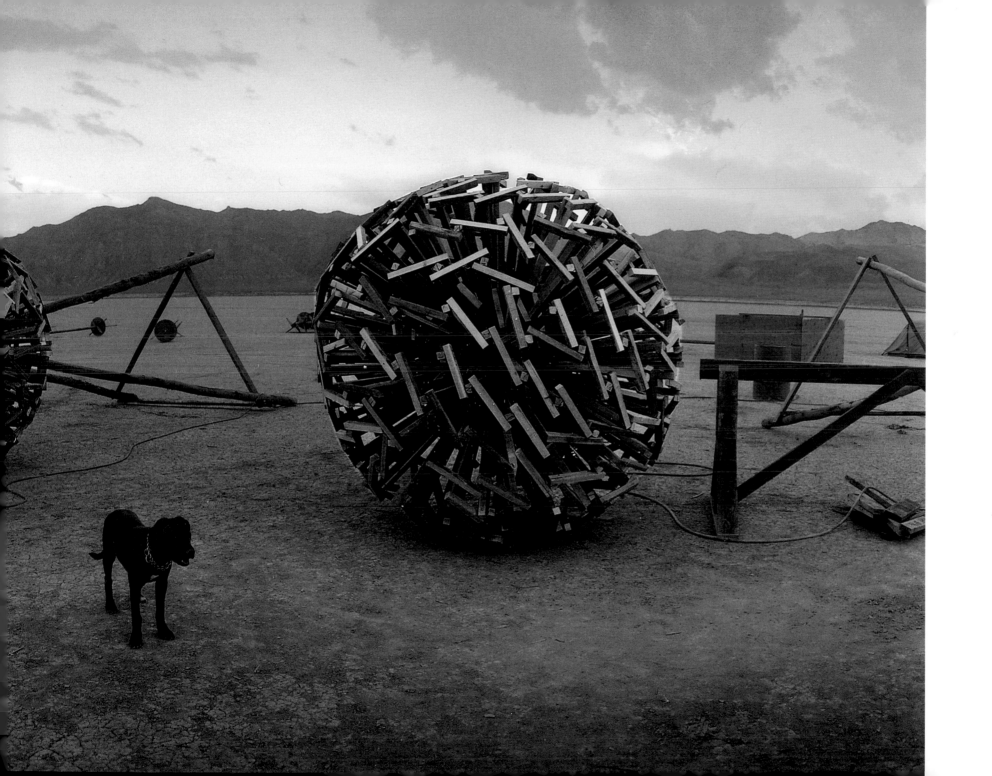

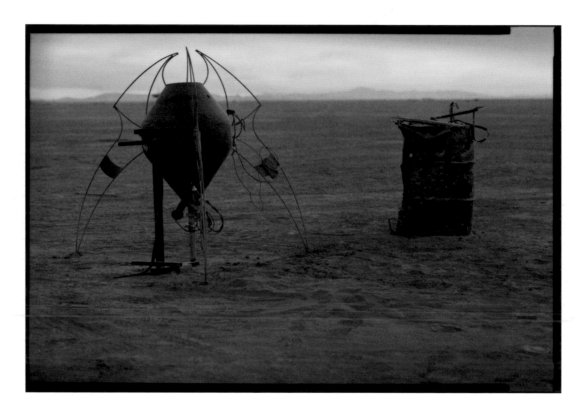

Pressure (2004)
ARTIST: JUSTIN GRAY

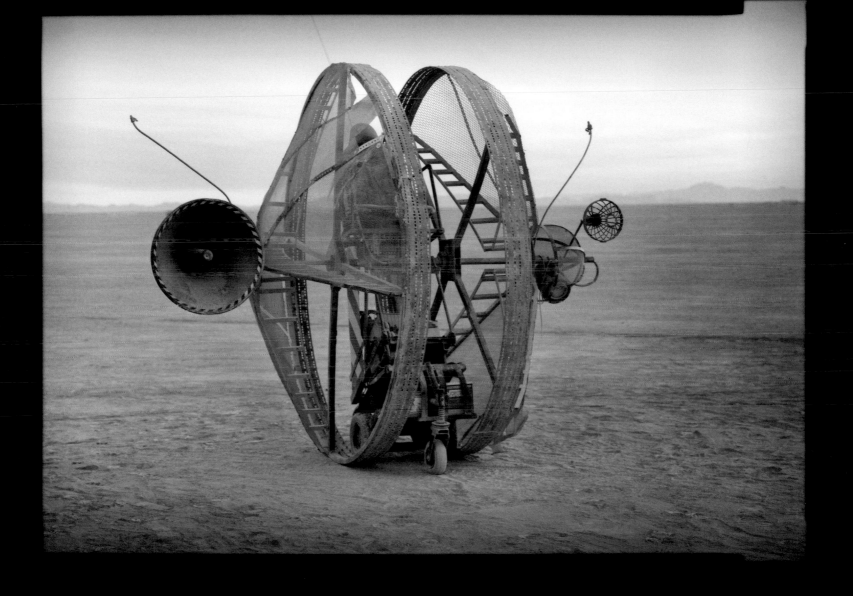

Th'Fuck Machine (2004)
ARTIST: RYON GESINK

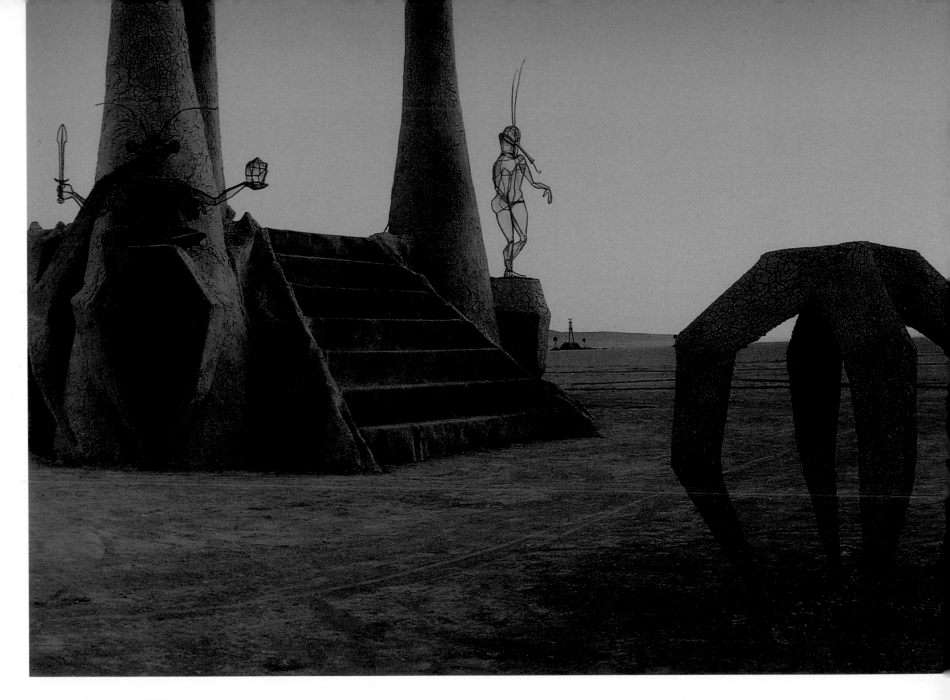

Rudra Sunrise Dance (1999)
ARTISTS: PEPE OZAN AND CREW

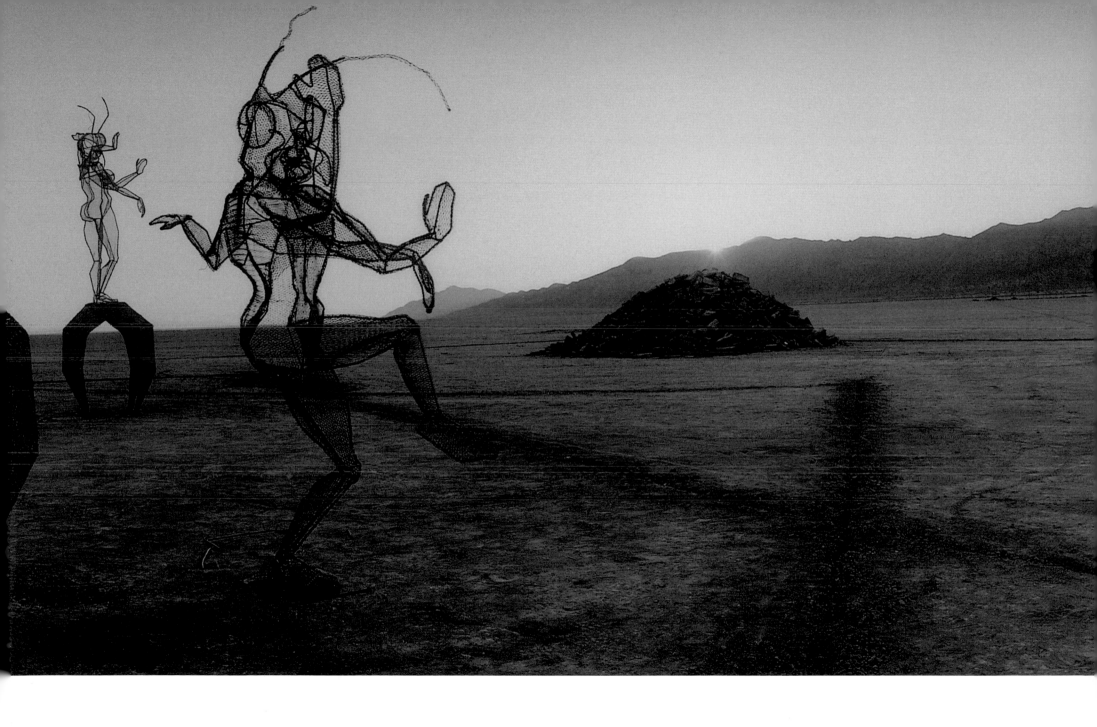

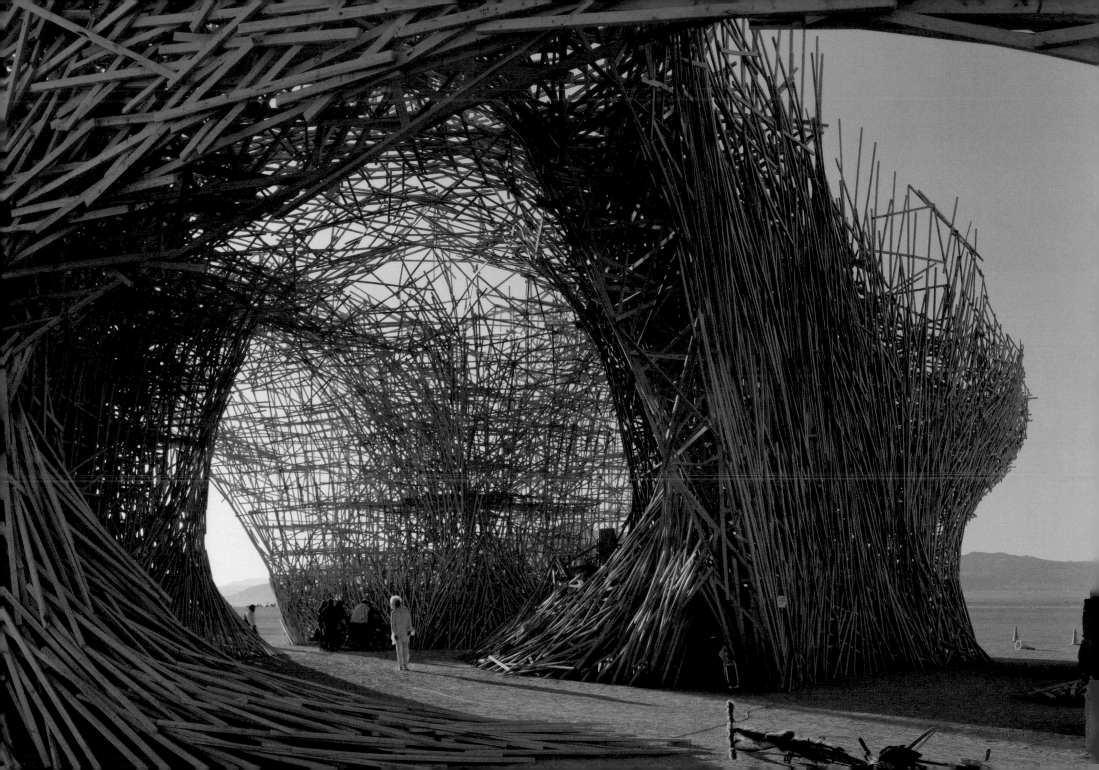

Uchronian Trance (2006)
ARTISTS: JAN KRIEKELS, ARNE QUINZE, AND CREW

DESERT RHYTHMS

The mornings are my favorite time to photograph. The light is right, and the distractions are few. I have been rewarded time and time again, and always feel like I have the Black Rock Desert to myself—with the art of Burning Man there for me to discover. Serendipity is always present, and they are among the best mornings of my year.

The Playa is full of distractions. Between the nudity and everyone pushing the freak envelope, it's easy to get diverted by it all. It's why I switched to shooting in black and white and concentrated on the landscape. It seemed that what I needed to express was what I saw in the space—an area separate from the people who populated the event. I want the viewer to look at what was out there (at that moment in time) and project themselves into it. To feel themselves vibrating in harmony with the work, with little or no human presence.

In the weeks leading up to the event, I photograph the DPW's endeavors at dawn. They perform tasks that I have witnessed for almost a decade, since Will Roger formed the organization in 1998. They're a tough bunch and possess an irreverence born of the need to stay focused on the job at hand in an unforgiving environment. I find their humor and their way of solving mechanical problems sublime. I can live and work alongside them for weeks, photographing little, and then see something that makes my artistic inactivity worth it.

On the other hand, I have filing cabinets full of pictures born of the need to go through the motions, regardless of whether I thought I could actually use them (it gets very expensive, especially when you're funding it all out of your own pocket, but it's always worth it). As I began to lay out this book, I realized that pictures and images I hadn't thought to ever use might actually have a voice in the work. They are interspersed here throughout, adding links and transitions from one moment to the next.

An hour before sunrise, the Playa is scattered with people who've been up all night wandering from place to place. A few sound systems are still going, the music moving unimpeded across the desert, clear and distorted at the same time. I usually have an idea where I'm going to start shooting, but not always. Things have changed, objects are no longer where they used to be, or they're gone altogether. It takes me a few minutes to ride my bike, trailer in tow, out to where I've decided to start. The trailer exerts a drag on my speed.

Even though I am fully acclimated, I can only go so fast. Until 2006, the trailer had been a hacked-together contraption made from two old bike frames with the front forks removed. After years of headaches I finally found a local bike welder and paid to have it rebuilt. It was worth every penny, and now the ride takes less of my energy away. The trailer no longer succumbs to broken welds, a lousy hitch mechanism, and last minute reconstruction. I once took a corner only to have one of the braces on my bike trailer fail, leaving me stranded a mile from my camp. As luck would have it, Charlie Smith was camped a couple of blocks away and awake that early in the morning. I was able to limp over to him, and he was able to zap it back together for me. A year earlier, Jim Mason had done almost the same thing, with nearly the same convenience. It's an easy place to get a weld fixed.

Everyone comes to the desert in a different state of readiness. One friend, Nesdon Booth, was unable to build anything before he came, but had a rough idea of what he wanted to build, and just loaded his truck up with what he had on hand: a bunch of seemingly random parts, such as an old canoe, a lawnmower engine, some tires, a light, a throttle, and other things. After a day and a half tinkering in a temporary shop he and Jim Mason set up (really just a couple of walls and a slight roof) Nesdon built himself a motorized canoe that would zip across the open Playa at a good clip (see pages 152 and 153). On Labor Day, after the event had ended, I borrowed it around sunset to go out to the Marching Band's near perfect replica of a Spanish galleon, and was able to circle the hulking presence of the ship as if in water off the coast of an ancient sea. It was exhilarating, and the high pitched whine of the lawn mower engine gave it the proper twist.

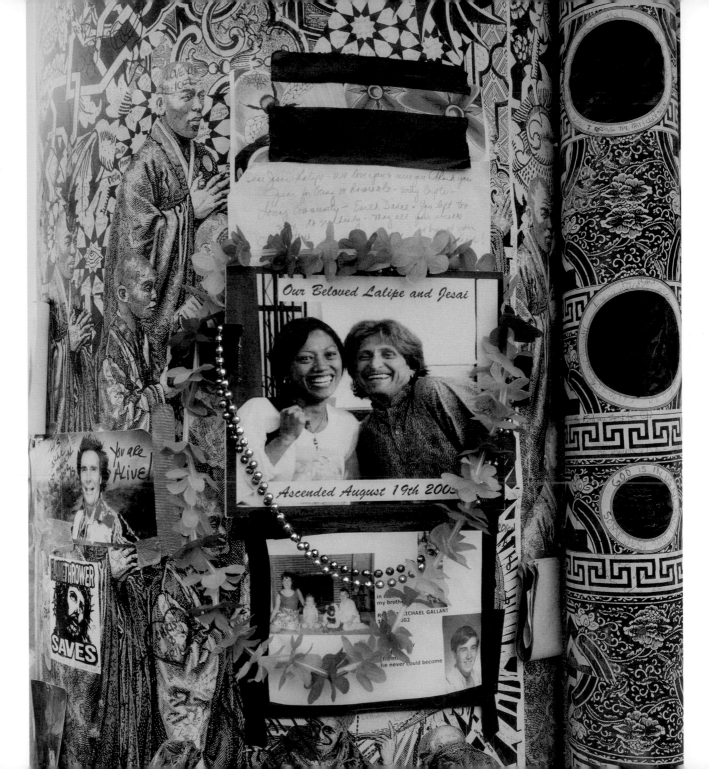

Temple of Honor:
Rememberance no. 2 (2003)
ARTIST: UNKNOWN

Opposite: *Temple of Tears:*
Rememberance no. 1 (2001)
ARTIST: UNKNOWN

Overleaf: *Kill Your Television* (1997)
ARTIST: TRIP ALLEN

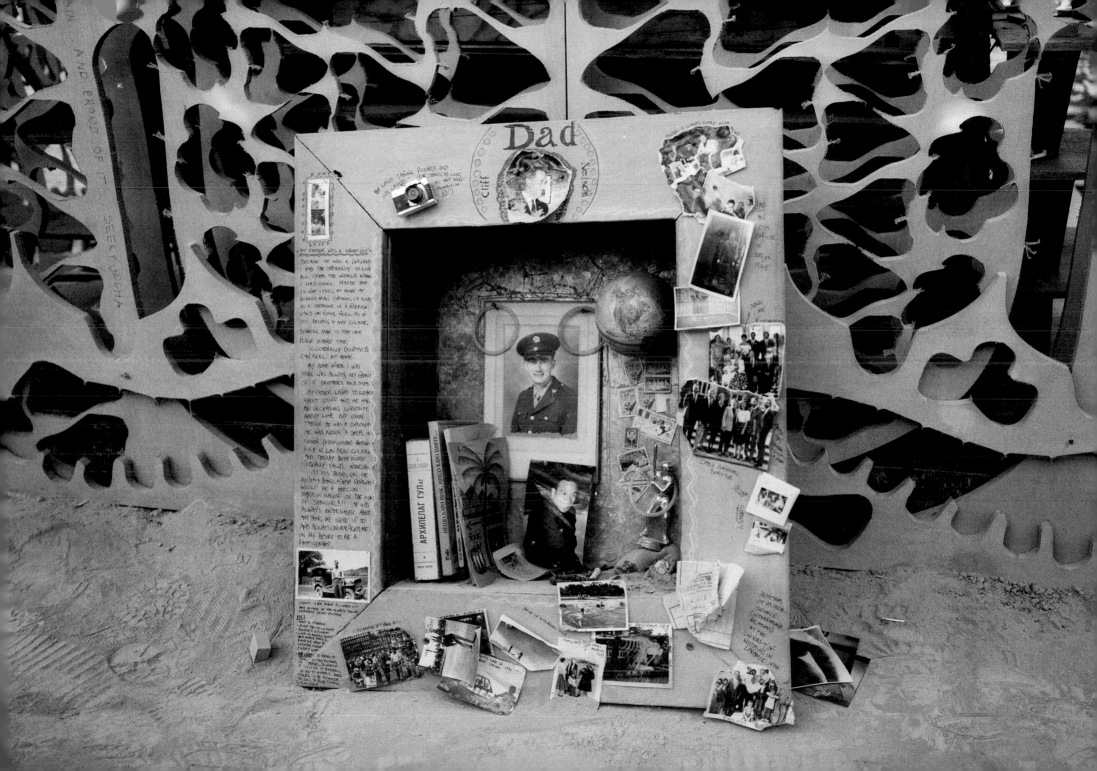

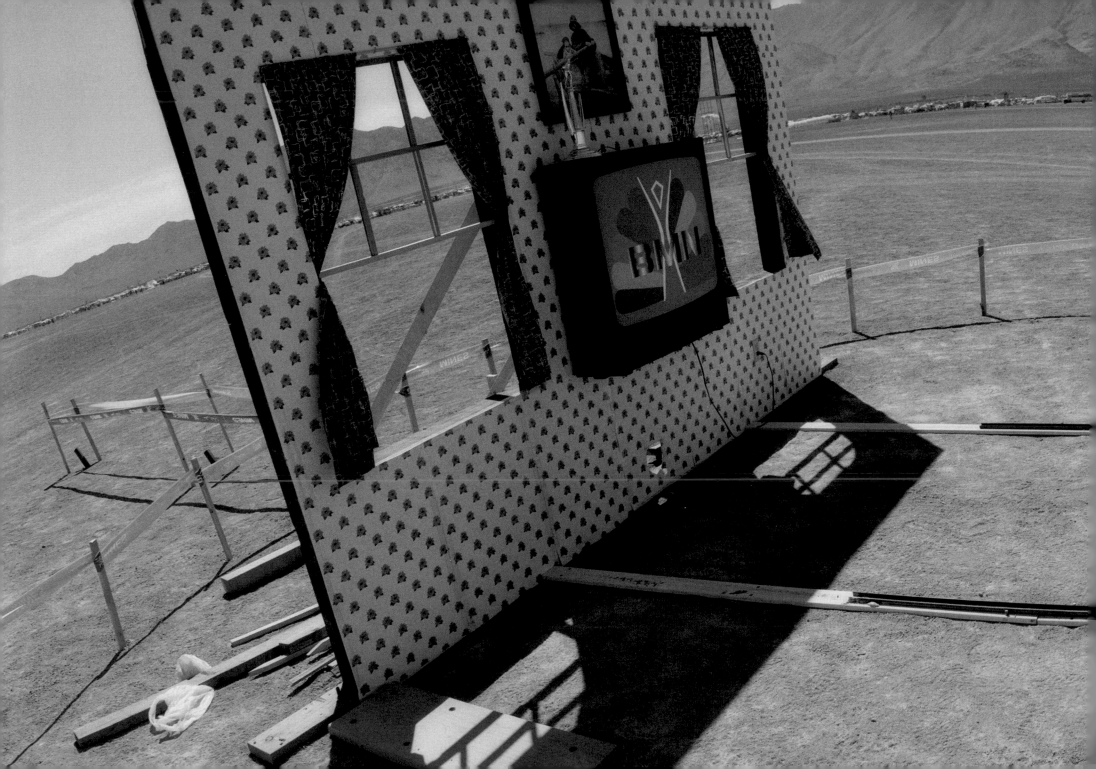

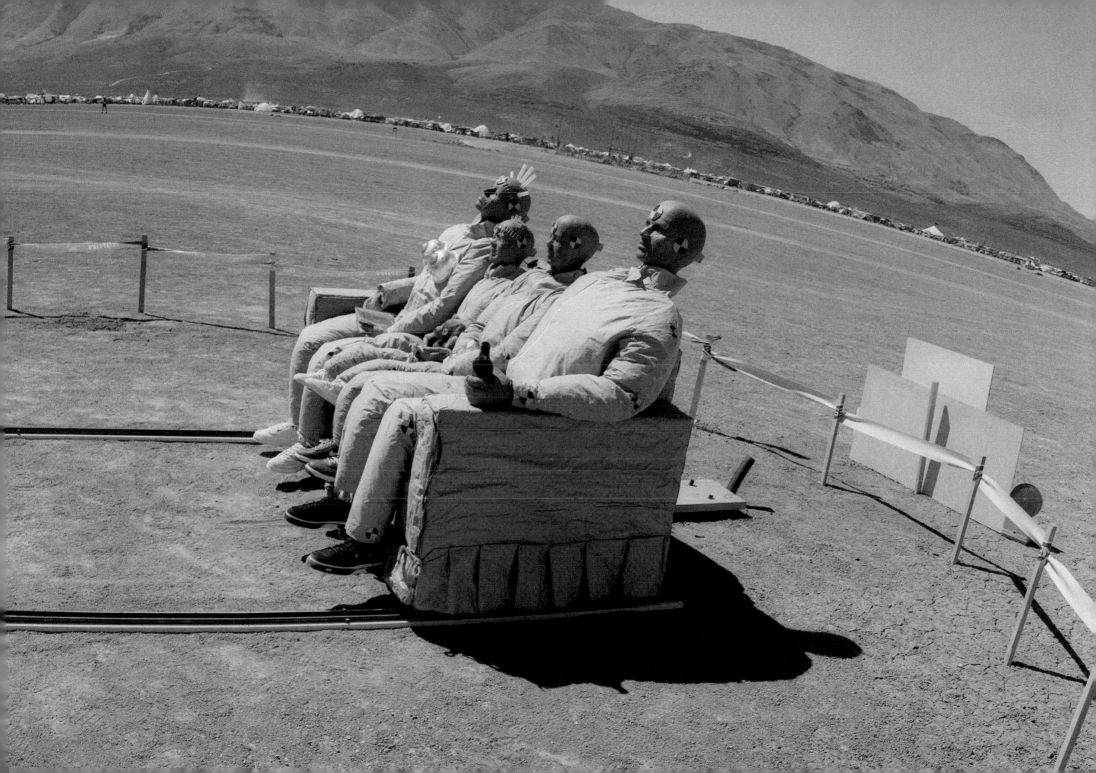

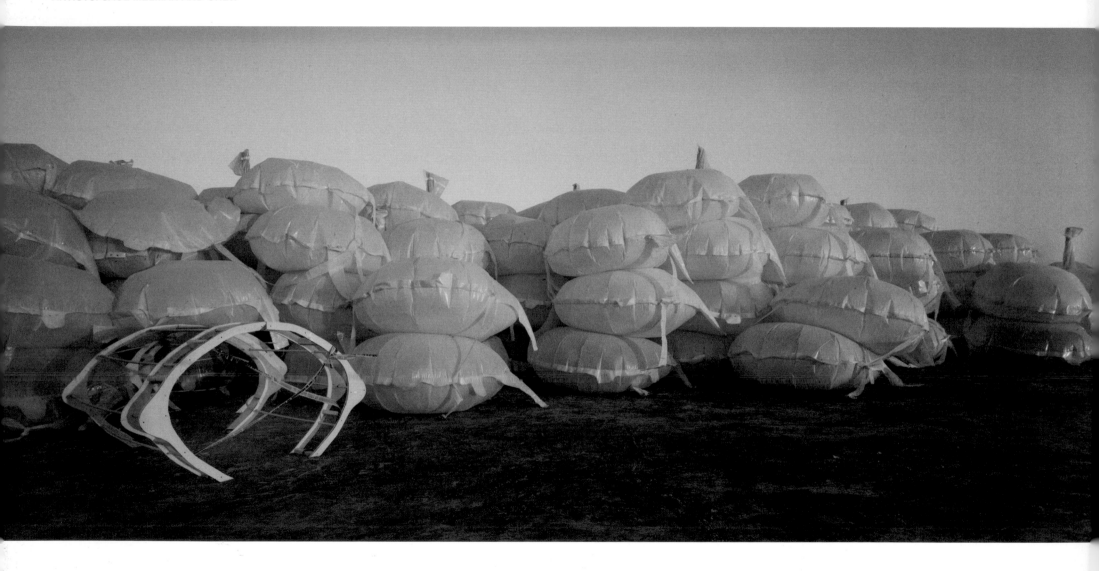

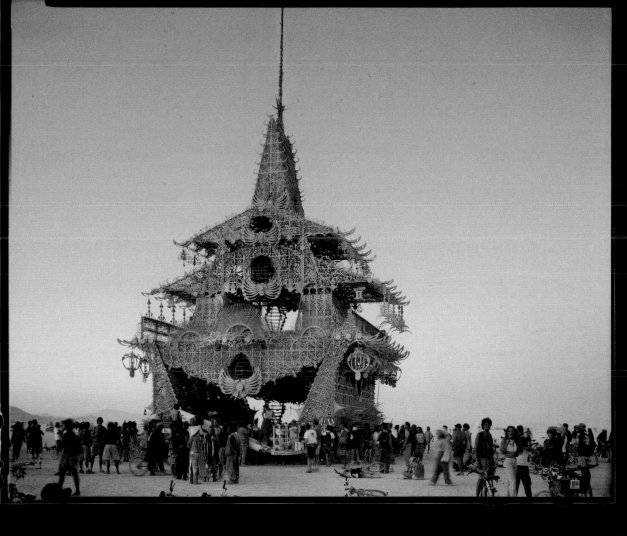

Temple of Joy: Afternoon of the Burn (2002)
ARTISTS: DAVID BEST AND THE TEMPLE CREW

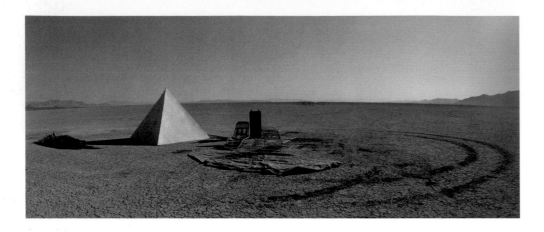

Lawnchair Pyramid (2000)
ARTIST: UNKNOWN

FREEDOM

Life is about experience . . . on the ground . . . being there. The Burning Man event gets lumped in along with the West Coast's groovy haze of the outsider art scene. Thousands of people running around with little or no clothing, doing lots of drugs, acting uninhibited. I think that's what kept the event sheltered for so long from the art world. It was hidden away behind this hippie fest exterior, and was easily dismissed. In a way, that's been good. The organization supports a lot of art every year, making it one of the largest non-foundation/civic grant givers in the United States. And the work is often *dangerous*. Jim Mason's fire canons (*The Impotence Compensation Project,* on pages 115 and 119) of which there are five, burn through $700 (now probably $2100) of fuel every time they are loaded, shooting columns of flame 100 feet into the air, each load typically lasting for twenty minutes. You can't witness those air bursts and not change the way you think about art.

I like museums and galleries as much as anybody, but when you're *part* of the experience of an art project, when you can hear unburned fuel falling to the ground around you and realize that you can get seriously hurt by all of this, you develop a respect and awe of the moment. There are no ushers to knock you back into line.

In 2006, Bill Codding built a piece called *Burninator II,* one of the few projects from the event that I don't have pictures of because it had to be experienced as much as seen: a 550 foot linear sequence of towers at fifty-foot intervals, with computer controlled patterns of flame. You could stand in the middle of them and the eruptions would come zooming down the line, past you and back again. Loud and immutable.

Years earlier, Jim Mason, again, created one of the most moving art pieces I have ever seen. In fact, I heard it way before I even saw it: the sound of an engine so loud it could only have come from a dragster, one being carried on a pall by a group dressed in saffron robes, with Jim sitting with his legs off to the side like a boy prince, pulling a rope attached to the throttle. I almost cried, it was so beautiful. In one motion, our society's love affair with the internal combustion engine was summed up with the utmost grace. Those are the moments

94

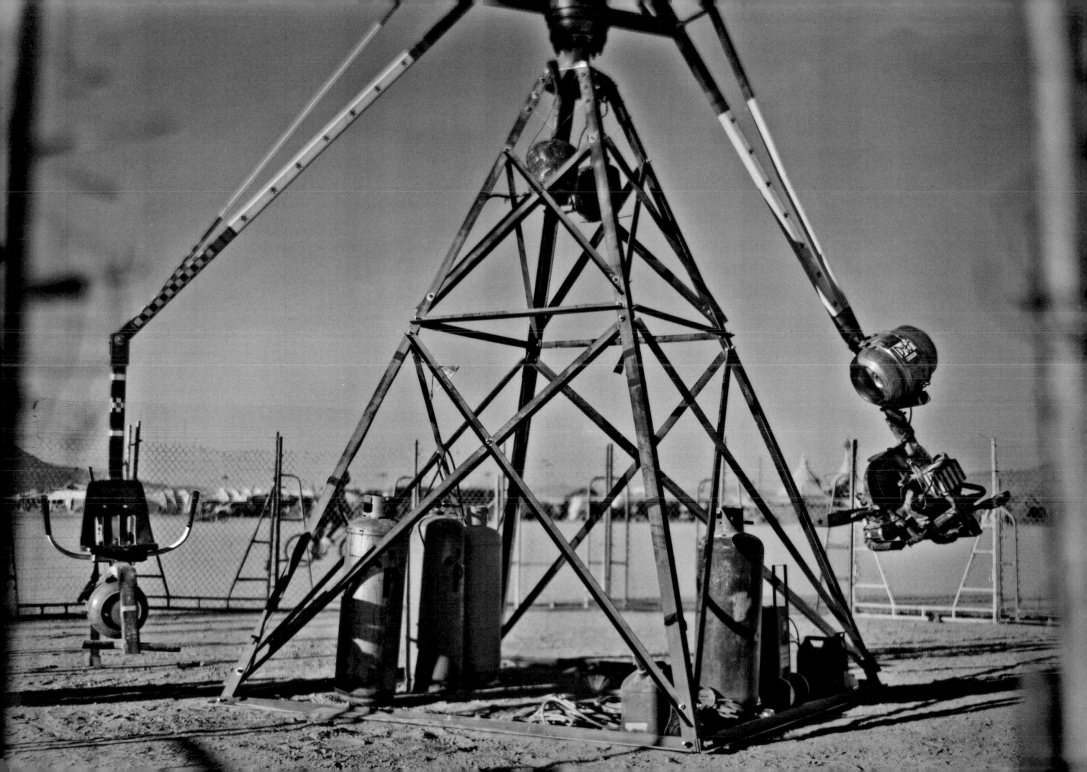

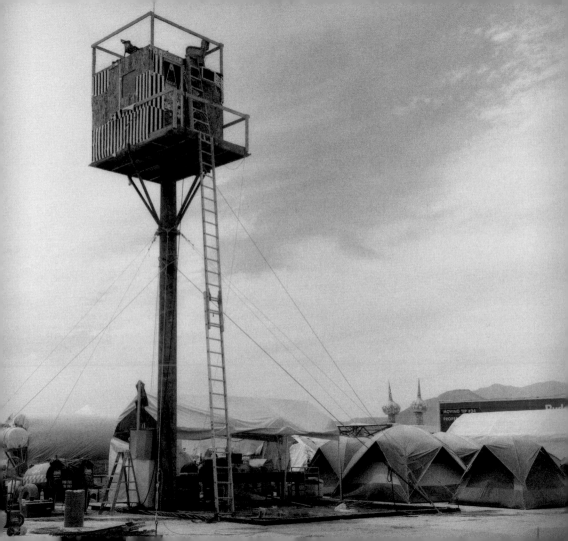

"WE GIVE OURSELVES IN IMAGINATION TO THE REALITY OF ANOTHER WORLD; WE TAKE JOY IN RESPECTING ITS INTEGRITY AND TREASURE ITS DIFFERENCE, AND THAT LIFTS US UP AS HUMAN BEINGS." —DAVID MILCH

we all live for. When the physical becomes poetry. The juxtaposition of disparate elements is such that new neural pathways are formed, and that formation transcends the patterns of your perceptions, free from mental and energetic blockages, and we are transported into a state of bliss. Moments like that you savor.

After all that work, the "burn" comes as a welcome milestone—the beginning of the end. After weeks of building, we have all gotten a bit lost in the event. Burning Man consumes a lot of your energy, and even the best-laid plans can drift away unfulfilled. Leading up to those weeks in the desert, and even once I'm there, I've made countless plans, brought along notebooks with ideas that I hoped to realize, lugged cameras and

film; however, once I was out there I just had to let those intentions go so I could stay in the moment. I had to change my approach to what I thought I was going to do, and what I was seeing before me. I used to resist it and get down on myself for not following through with what I set out to do, as if I had somehow failed myself. In reality it was really the difference between Newtonian thinking and Quantum thinking.

Newtonian thinking can best be described as linear. Ideas follow an inevitability that is logical, sequential, and left brained in its structure. Quantum thinking allows for a more philosophical and intuitive approach. Disparate ideas link themselves across gaps normally seen as separate or paradoxical—some people call this approach holographic.

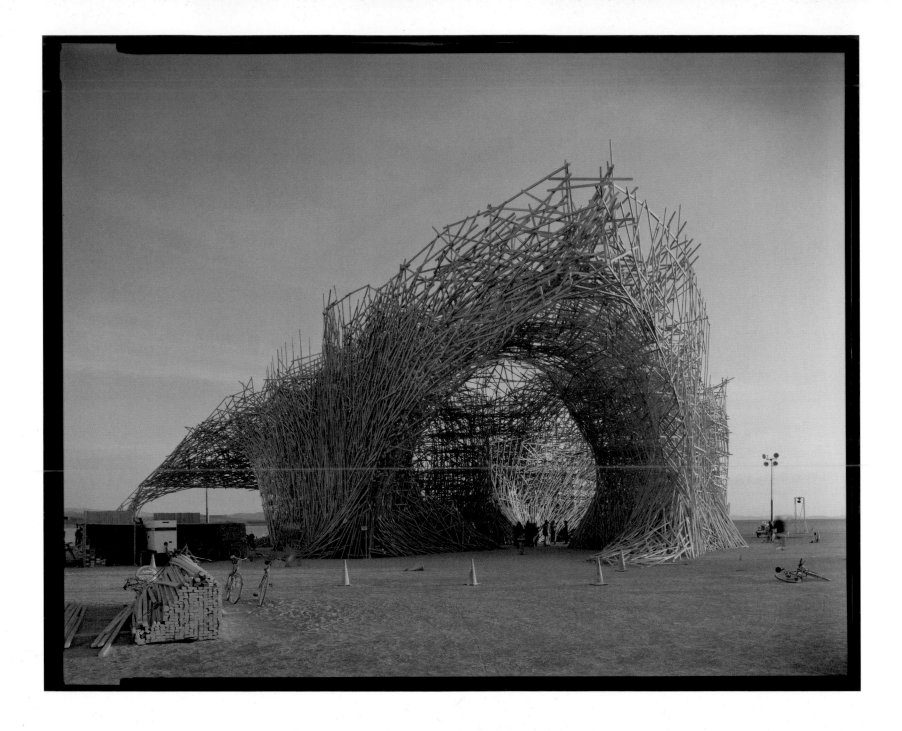

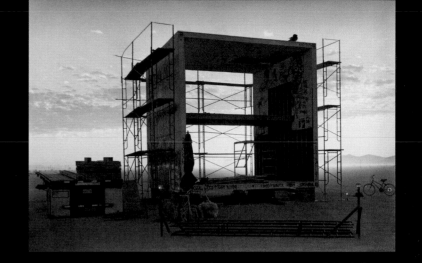

What has saved the community at Burning Man from the relentless trafficking in saccharin expressions of emotion and undeserved fame (the essence of our celebrity-based culture) are some basic strictures: no vending, except at the center camp café, which sells coffee and tea—the proceeds of which help fund the DPW's operating budget; and the conceit that, at the festival, there are no spectators—we are all participants and have the ability, through the inherent nature of the event, to pitch in and help out where needed.

I had thought about helping David Best and his crew build the Temple of Joy in 2002, having talked to him in passing at his wife's café in Petaluma. So when I arrived on the Playa, I went out to see how the construction was coming along. David remembered that I knew something about lighting, and within minutes I was crawling around inside the roof sections with John Horn, Bill Codding, and Brian Buckley, furiously trying to get the pre-built runs in place before the arrival of the crane that was coming out to lift all the sections onto the structure. It was one of the most beautiful pieces of architecture I ever had the privilege to climb on.

We spent hours tweaking the lights. I even took an afternoon to drive eighty miles to Fernley, where I spent seventy dollars of my own money buying every twenty-five watt bulb in town so that the Temple would have a subtle and contemplative glow at night. It took days and time away from my own work, but it was one of the more satisfying projects I had been a part of. I got so involved, I had trouble stopping work on it, wanting it to be as good as we could get it. And even though it's gone and was meant to be temporal, I still miss it. And that's better than if it still existed.

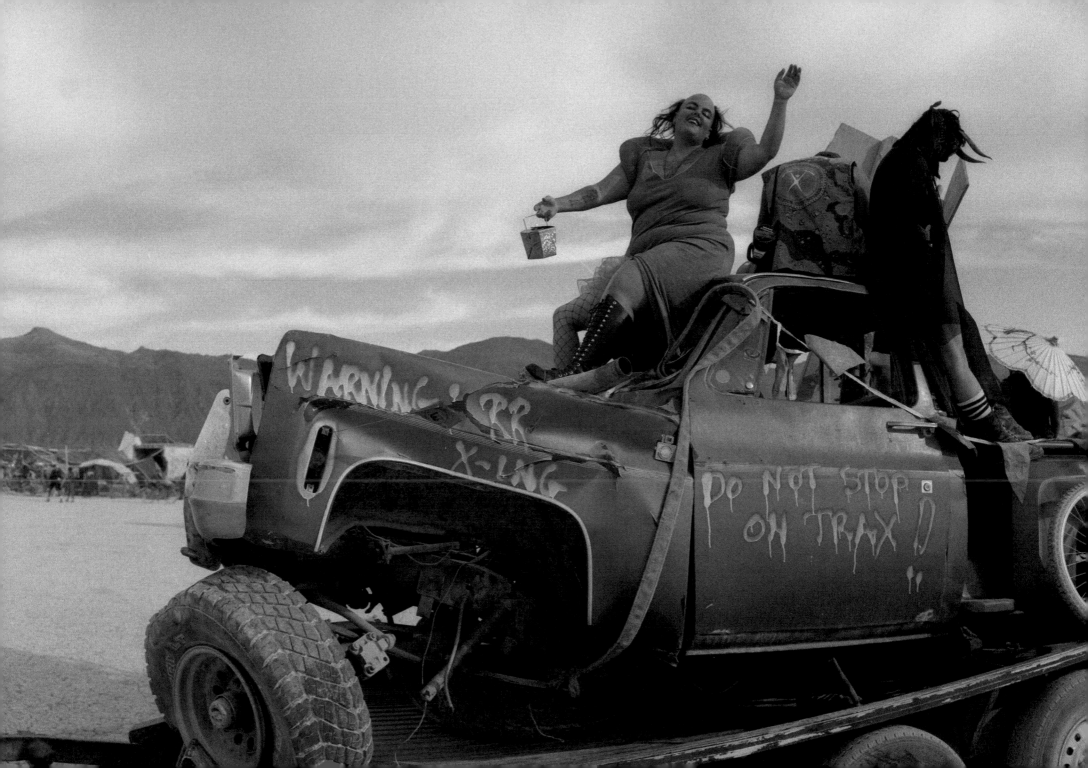

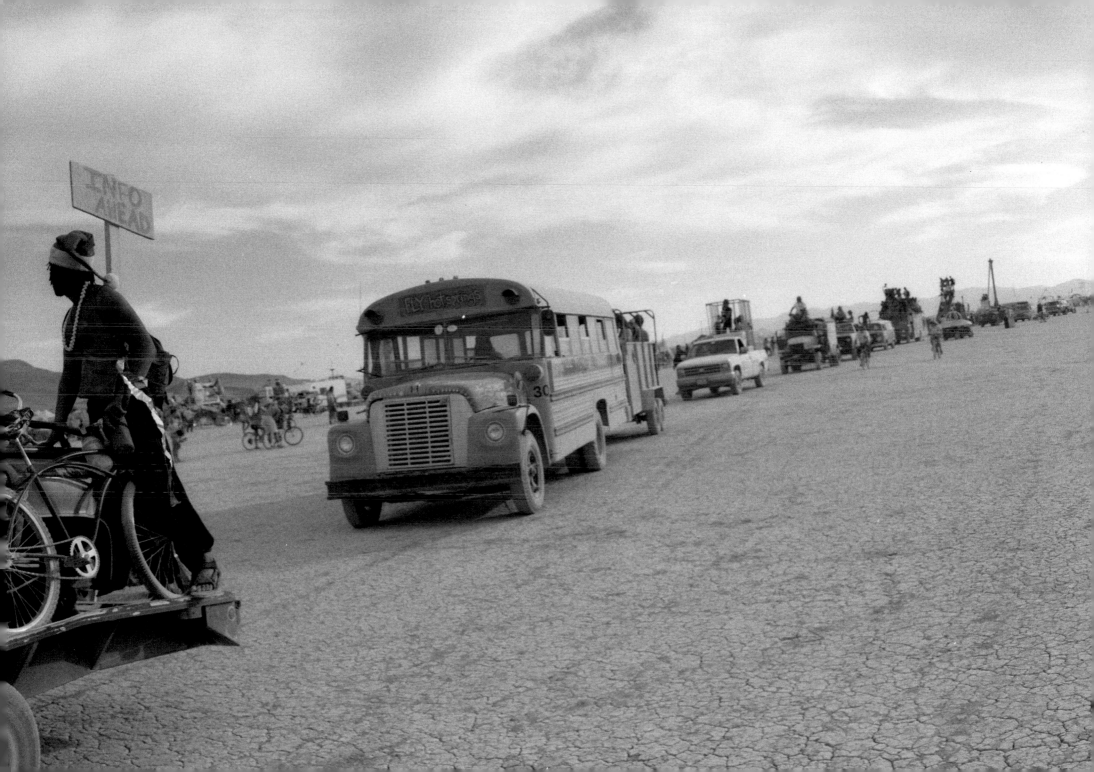

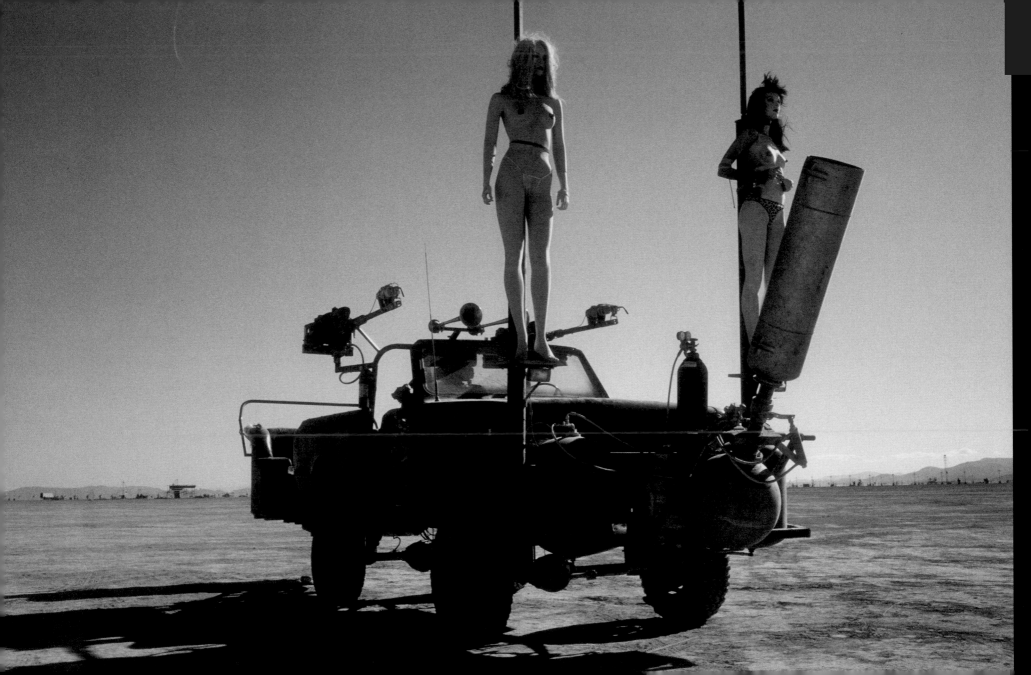

Opposite: *Christian Ristow's Truck* (2004)
ARTIST: CHRISTIAN RISTOW

The Seeman's Truck with Bosun's Chair (2001)
ARTISTS: KAL SPELLETICH AND THE SEEMEN

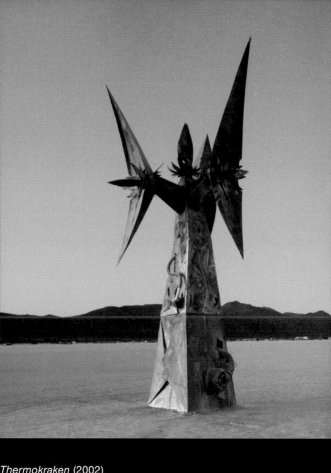

Thermokraken (2002)
ARTIST COLLECTIVE: THERM

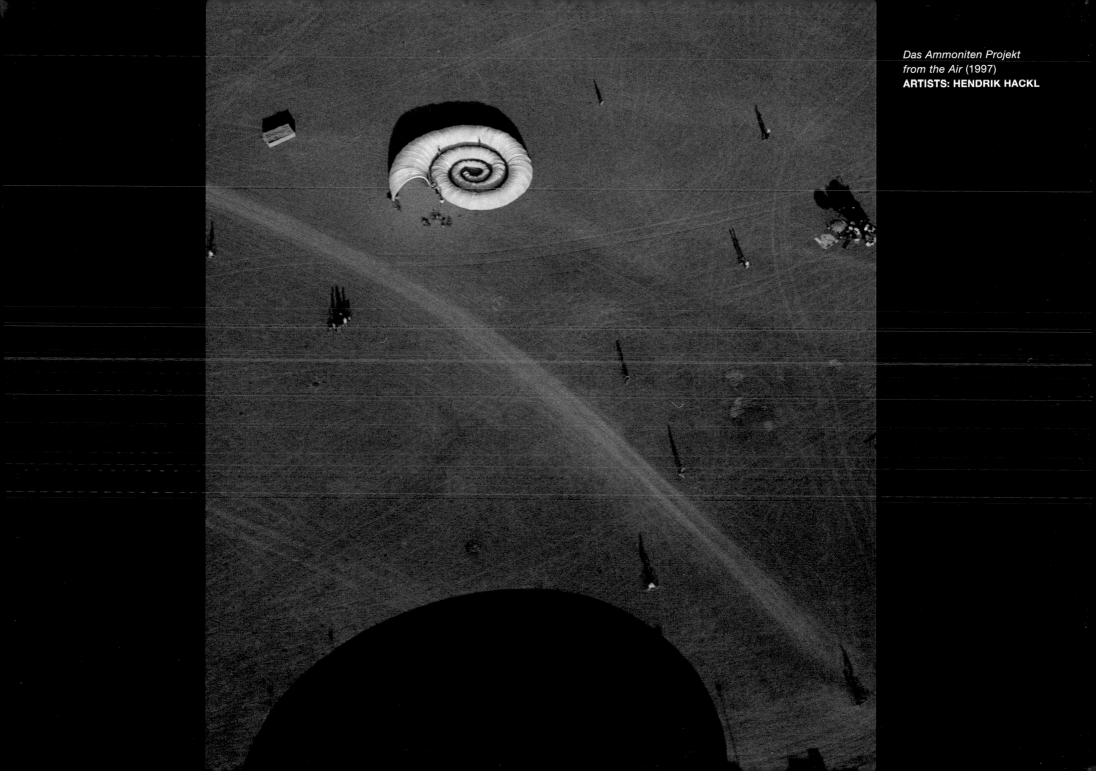

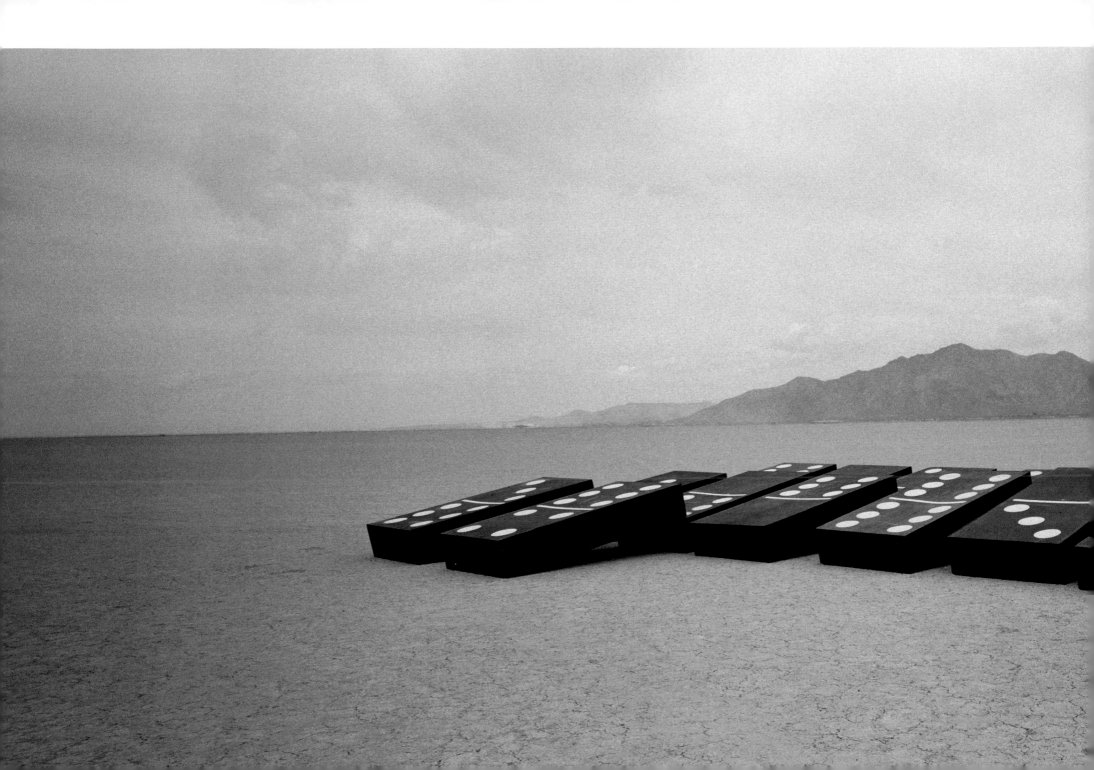

Anno Domino 2000 AD2K (2000)
ARTISTS: AARON MUSZALSKI AND CREW

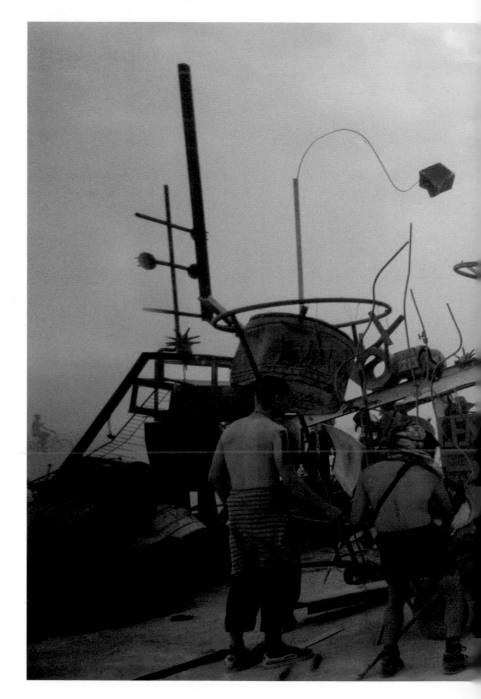

CONTRASTS

It's difficult to get to sleep early at Burning Man. In fact, most people are just heading out as I turn in for the night. I'm partly envious of that freedom—to just go out and bounce around from one groovy space to the next, seeing what people have created and enjoying the ride.

 I spend the time after dark reloading my film holders and preparing for the next day. Like any endeavor one may pursue, being a photographer involves a lot more than people realize. One of the things you have to overcome if you're going to persist at it, is to know you're going to spend hours alone processing and tweaking your images, organizing them, dealing with technical errors, going to sleep early rather than staying out late with your friends, and getting up an hour before sunrise so you can bicycle out to something that caught your eye the day before. You take your rewards in keeping up with the process as much as you do in the images that result.

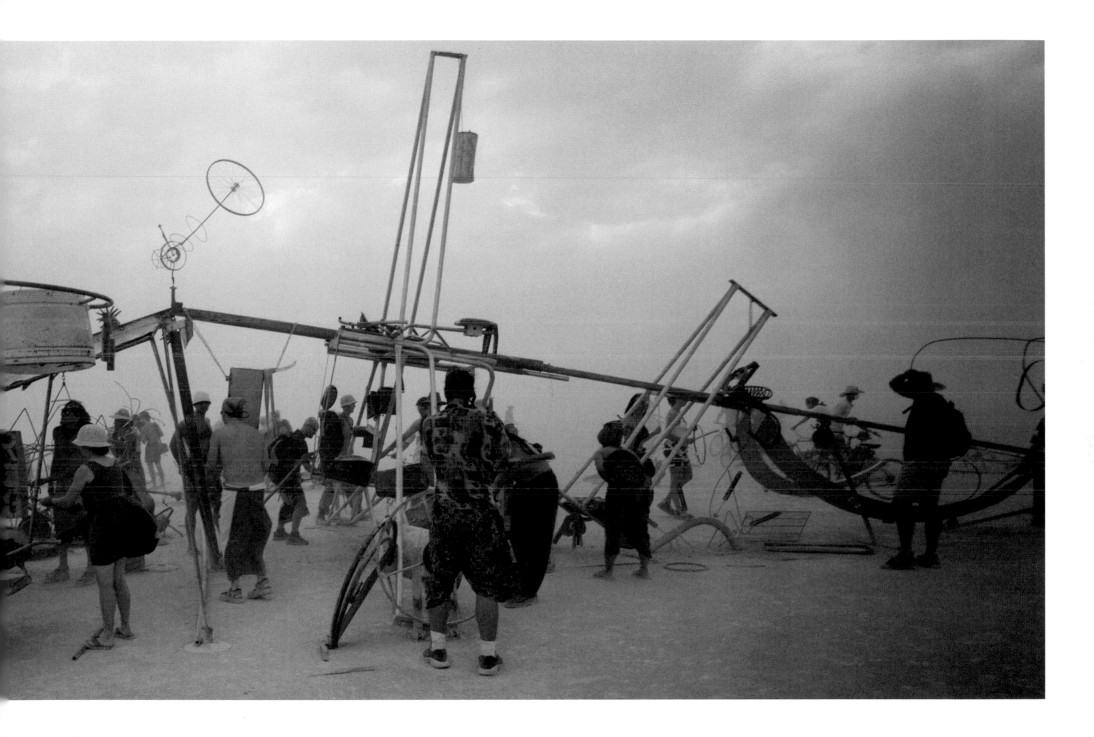

Icarus' Skeleton (1998)
ARTISTS: KAL SPELLETICH AND THE SEEMEN

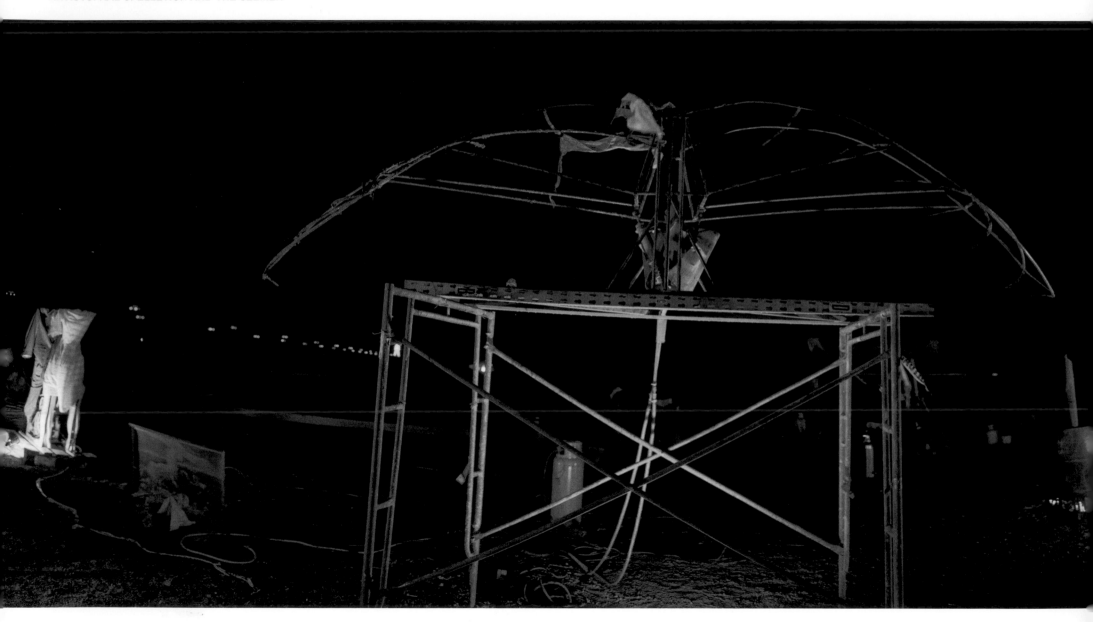

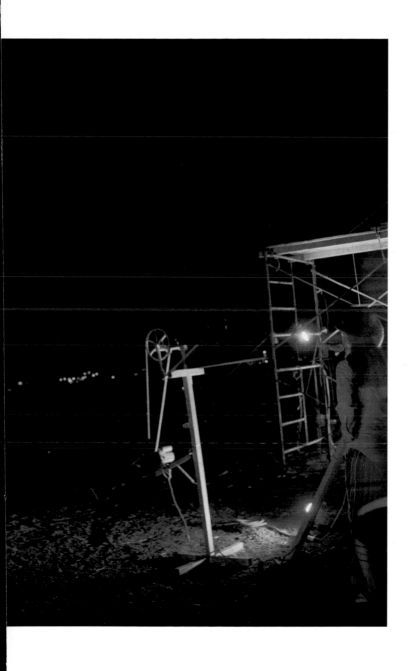

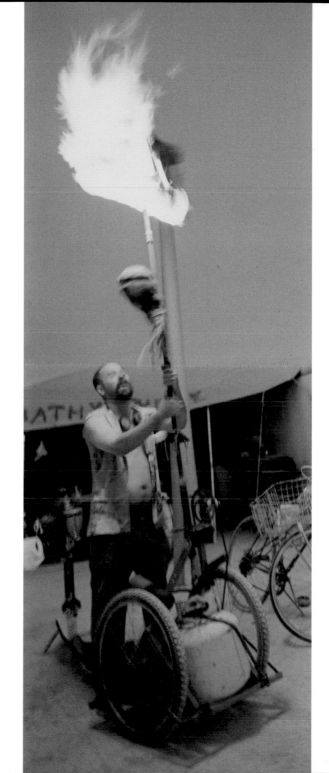

113

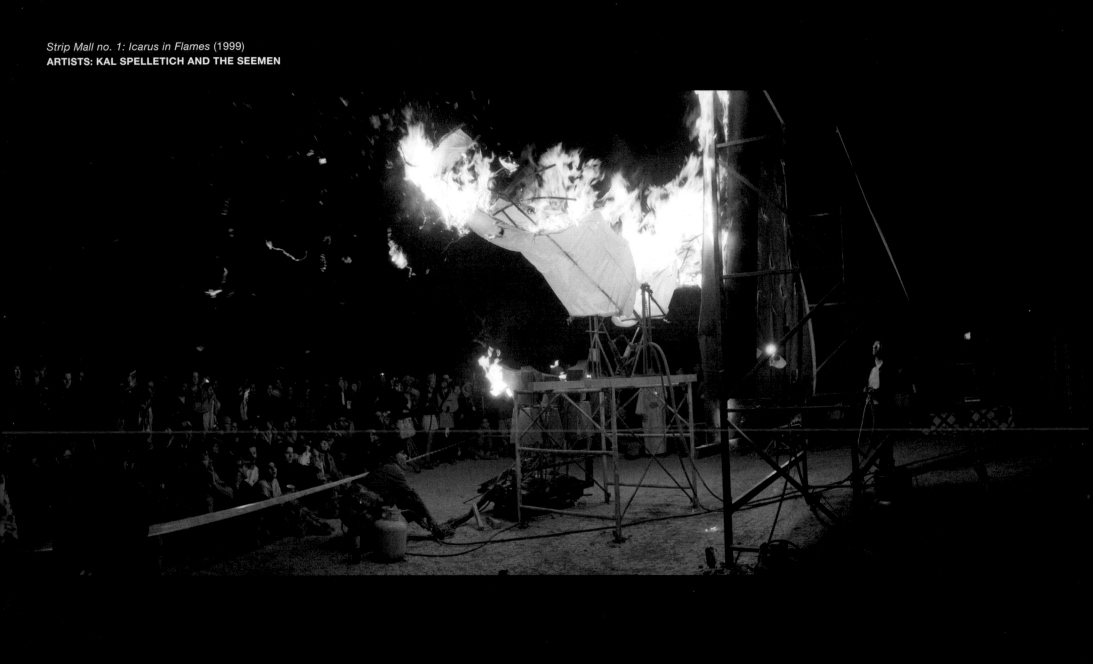

Strip Mall no. 1: Icarus in Flames (1999)
ARTISTS: KAL SPELLETICH AND THE SEEMEN

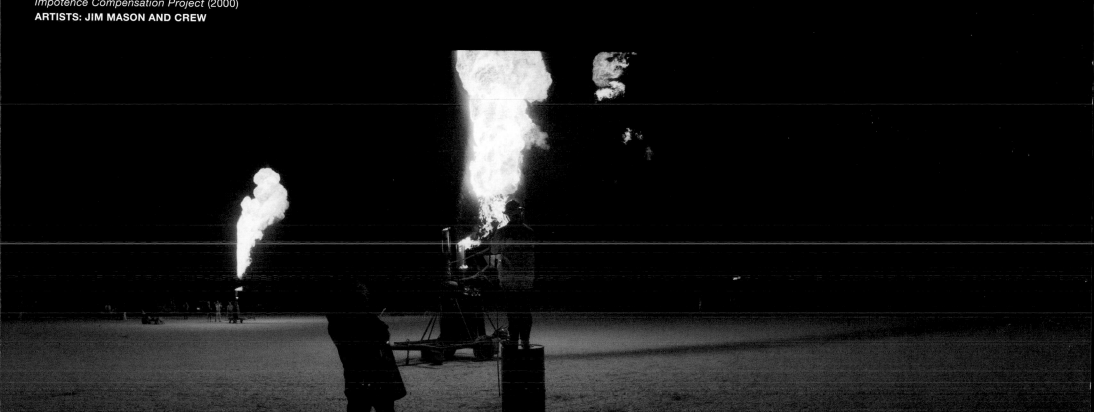

Impotence Compensation Project (2000)
ARTISTS: JIM MASON AND CREW

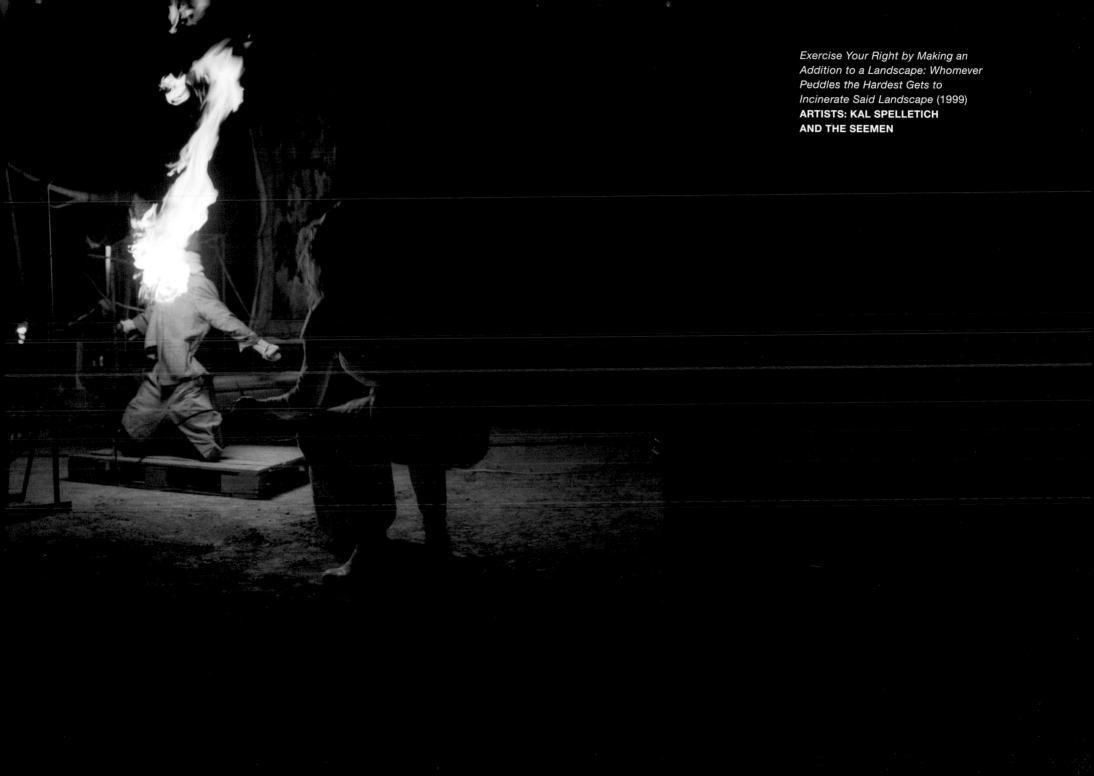

*Exercise Your Right by Making an
Addition to a Landscape: Whomever
Peddles the Hardest Gets to
Incinerate Said Landscape* (1999)
**ARTISTS: KAL SPELLETICH
AND THE SEEMEN**

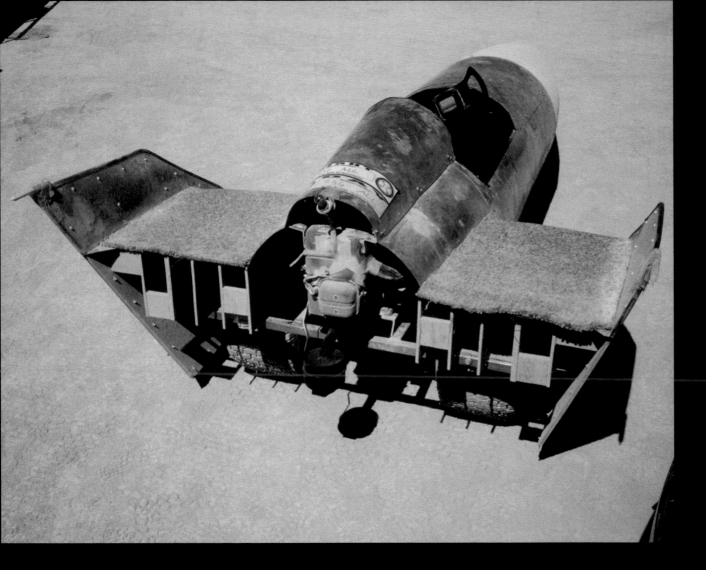

Rocket Car (2003)
ARTIST: UNKNOWN

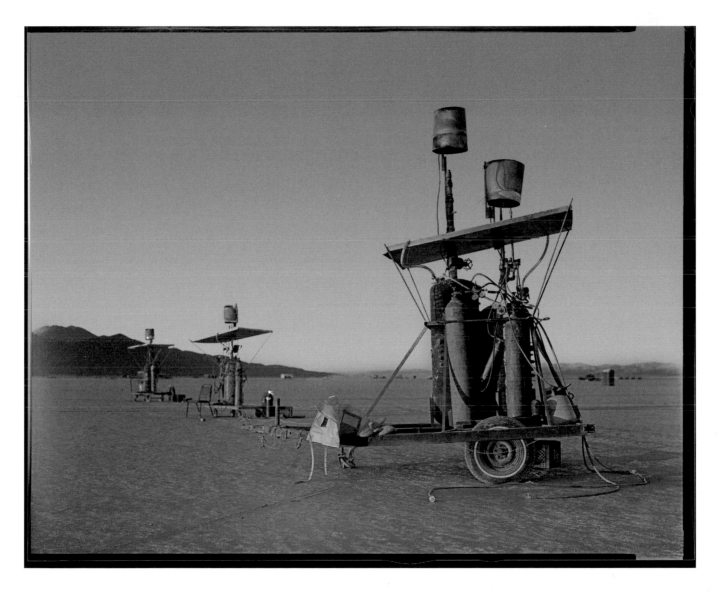

Impotence Compensation Project/Big Bertha (2000)
ARTISTS: JIM MASON AND CREW

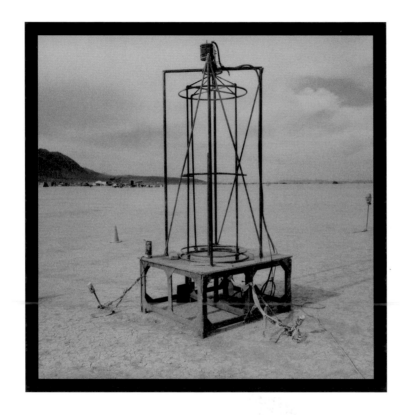

Strip Mall no. 1: Fire Shower (1999)
ARTISTS: KAL SPELLETICH AND THE SEEMEN

Right: *Rime of the Ancient Mariner* (2003)
**ARTISTS: THE LA CONTESSA CREW, A.K.A.
THE EXTRA ACTION MARCHING BAND**

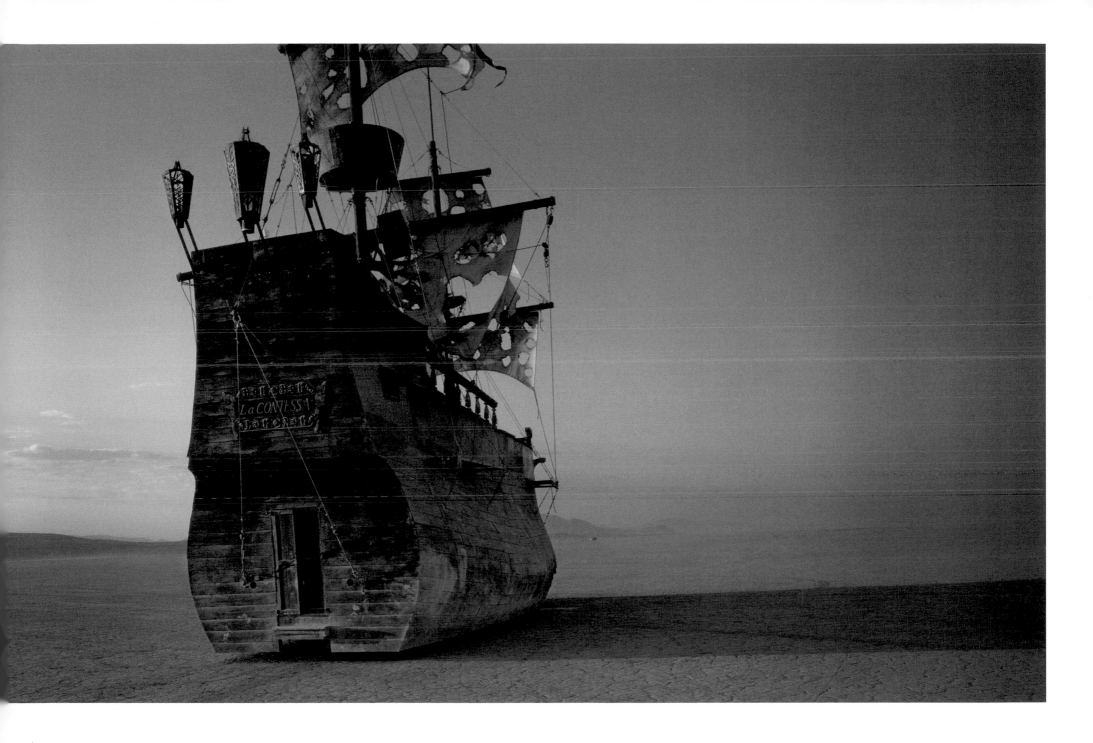

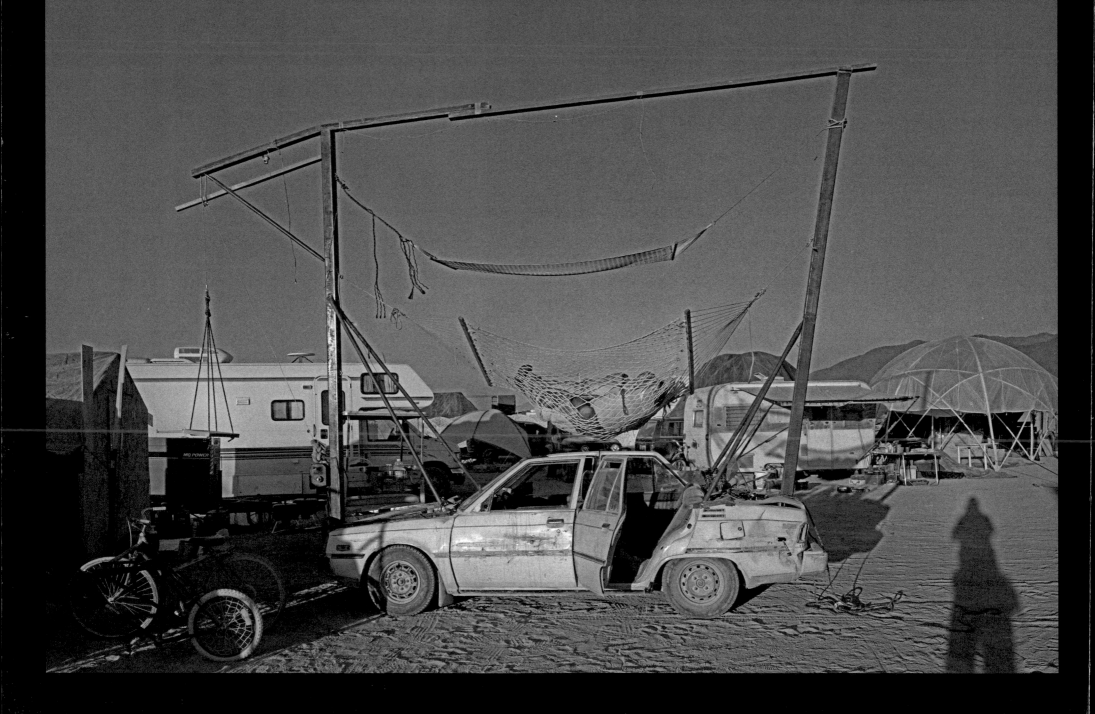

Uchronia Graffiti (2006)
ARTIST: UNKNOWN

SPIRITUAL HOME

The spiritual side of Burning Man runs counter to the work many of the artists create for the festival. The post-punk, post-apocalyptic world of machine culture lies in contrast to those that use the wide open space to "knock the rust off a year of living in the world beyond the mountains," as my friend D. A. refers to it.

I am most comfortable with feet in both camps, which makes it difficult to decide where I best belong. I'm not entirely in sync with the spiritual non-artist crowd, but not coarse enough to be part of the punks either, though I love their aesthetic and humor of expression. With them I feel a connection, a link somehow to my growing up around the family steel fabricating plant. There, amidst the daily grind of cutting and welding columns and other structural steel for buildings, my father would, from time to time, make space for local sculptors to do the large-scale work that could only be done in a plant of that size. The culture of Burning Man is hardwired into my DNA.

Most of us are jaded. How can you not be with all that has happened in the last hundred or so years: 180 million people were killed in the twentieth century alone. There's an unrelenting barrage of media and manipulation. After awhile we just tune it all out, and an annual art festival in the desert gets lost among all the other stories vying for our consideration.

However, if you are paying attention, and if you do attend Burning Man, you can have any experience you desire there. It's the same as any other situation we either find or put ourselves in. Some experience a sensory overload and they either leave early or spend the event hunkered down in their own camp feeling miserable. Others love the freedom to dress as they wish or be someone else for a week and go from one blissful moment to the next. It can feel a little capricious at times, but I like the challenge of living in the desert without any twenty-first century distractions while also having to maintain clarity of focus and just do my work among 30,000 other people.

You'll have good times and bad. That's guaranteed. It's no different than any other week in which there are emotional highs and lows. If you have a good ontological tool kit, you'll weather through it and be refreshed by your interactions and the experience. There's a fair amount of hype and accompanying skepticism about Burning Man and it's easy to understand. Many of us who experienced the Sixties have our "woo-woo" meters set low. Though a lot of compelling new and alternative ways of living and interacting came into being in that decade, most lacked the intellectual infrastructure or rigor to sustain themselves. And mainstream society put more energy into fear and resistance than in nurturing the generations that would inevitably follow. It was a turbulent time, and we were too intellectually challenged and unprepared to deal with it all.

It's different now. We've changed as much in the last twenty-five years as the previous eighty, and the development chunk before that was exponentially greater. The Internet allows us to solve problems communally regardless of physical proximity. In short,

we are able to gather, with a few simple keystrokes in a matter of seconds, the appropriate brain power that a problem requires, get what we need, and move on. The interaction takes a minimal amount of time, with little or no irritation, and is replaced by the next logical thought process at hand.

Today's technology supports new ways to interact. This is one of the rare times in history in which technology is (often) ahead of our abilities. Our capability to process information within ourselves and communicate it to others lags behind the plug-ins that are available to us. If you think something should exist, it probably already does—governments, corporations, and religious beliefs not withstanding. Once the Internet became global, people were able to lead with an ease previously unavailable.

Most of us do not think of our own consciousness as a measurable thing that develops along a timeline. Nor can we measure our personal progress with physical results. You have to stop and validate how far you've come, clearing the invalidation in the process. You also have to fight through the emotional landscape of conflicting thoughts to which we all fall victim, due to the chemical and energetic processes that bring them into being. Inevitably, we are often completely unaware that we have a choice in how we engage or disengage with our inner dialogue. When one understands this, you can start to get a sense of the lure that comes with creating art in the desert: you're free from most outside distractions, some necessary, others not, and you're surrounded by people who, for the most part, are on the same page, though there may still be some friction. It can either bring out the best in you or the worst. Properly hydrated, most people are at their best.

The next and possibly last frontier for man's exploration is an internal one. As a psychologist friend once explained, "first you have to deal with the inside before you can deal with the outside." This journey is personal and often put off or avoided (which is understandable when it comes to dealing with those aspects of ourselves that are most painful).

Some native cultures, lacking current technologies, were forced to use what was available to them, trusting and following their intuitive urges. The so-called "illegal substances" they took helped them to survive and deal with the uncertainties of life. The journey transformed them, in effect updating their "operating systems" to the next version that was required and beyond their grasp.

In the desert there are those who are out looking for some fun, and that has value; and there are those who are looking over the horizon to their unknown future, wanting communication so that they can clear the past and prepare for what life has in store for them.

The drugs and nudity get a lot of press and shape people's perceptions of the event. That's understandable. Our culture uses sex to sell *everything* inside a diminishing pretext of Victorian prudishness propped up by religious fear, guilt, and a troubled relationship between monogamy, commitment, and sexual desire. With drugs, politics enters the picture using the law as a way to deal with incongruous reality, fear, and the need to keep a handle on the wayward tendencies of the populace. Psychotropic substances are treated in the mainstream press as a malignant form of intoxication that offers no growth or spiritual renewal. This is mostly true, but the desert allows for a use of those substances that is closer to the shamanistic space used by native culture.

People come back from the Playa refreshed. They may have things in their lives that are stagnant or in need of change, but the relative safety of the community at Burning Man allows for explorations at the edge of their consciousness, (hopefully) free from the constraints of their own psychology. It can be a disturbing thing to witness, and is often what frightens lawmakers into action. Spontaneity is never welcome in the arenas of business, finance, and polite social interaction.

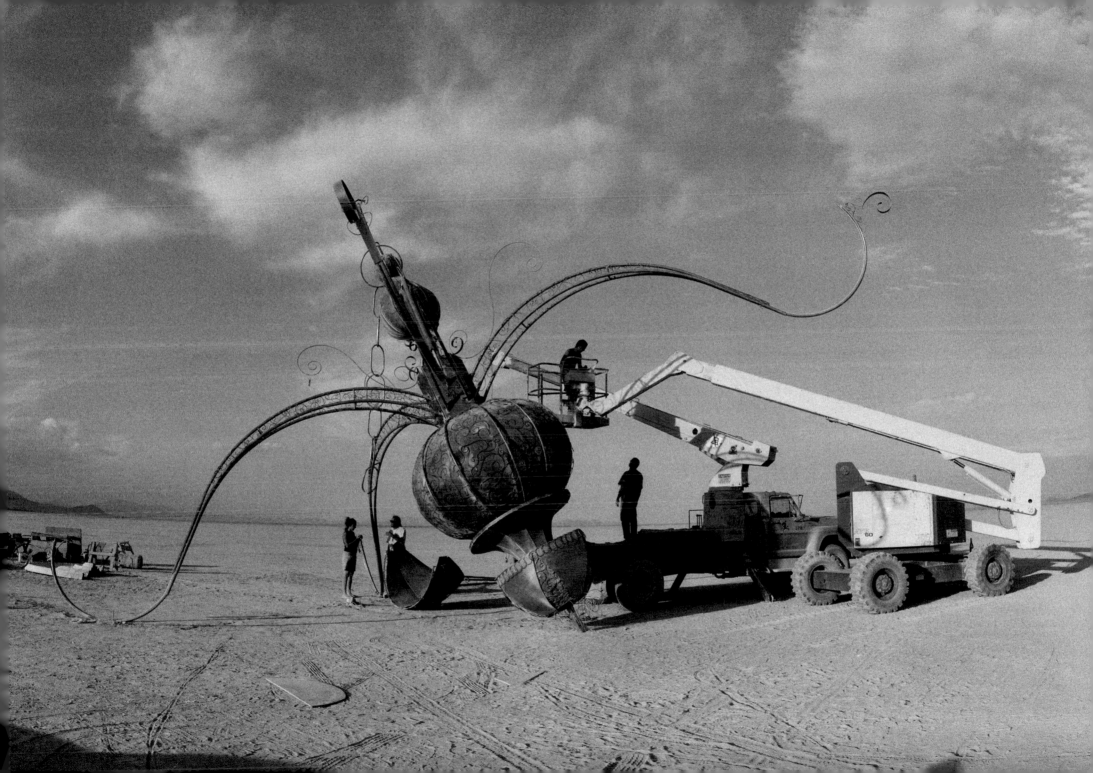

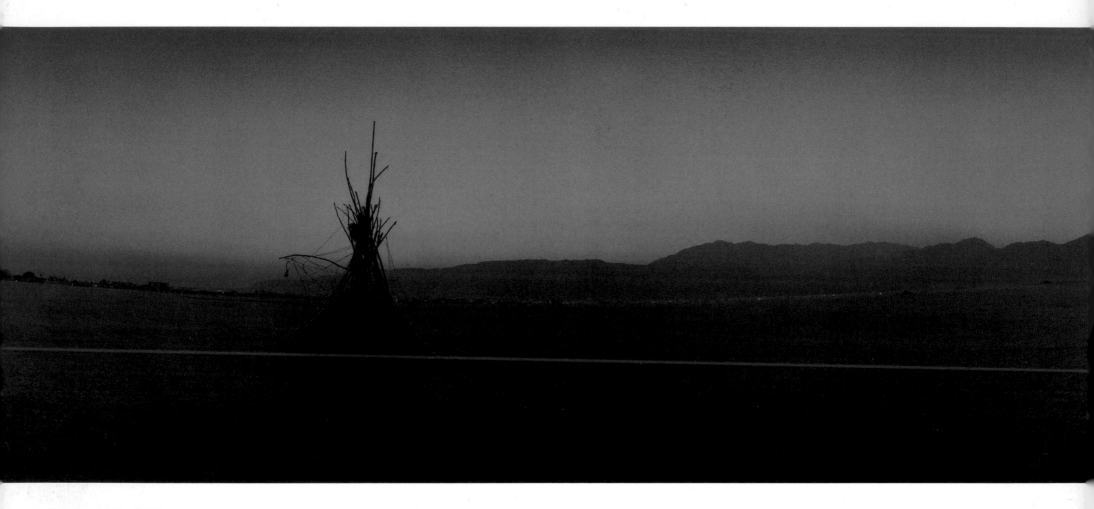

Teepee of Twigs (1998)
ARTIST: UNKNOWN

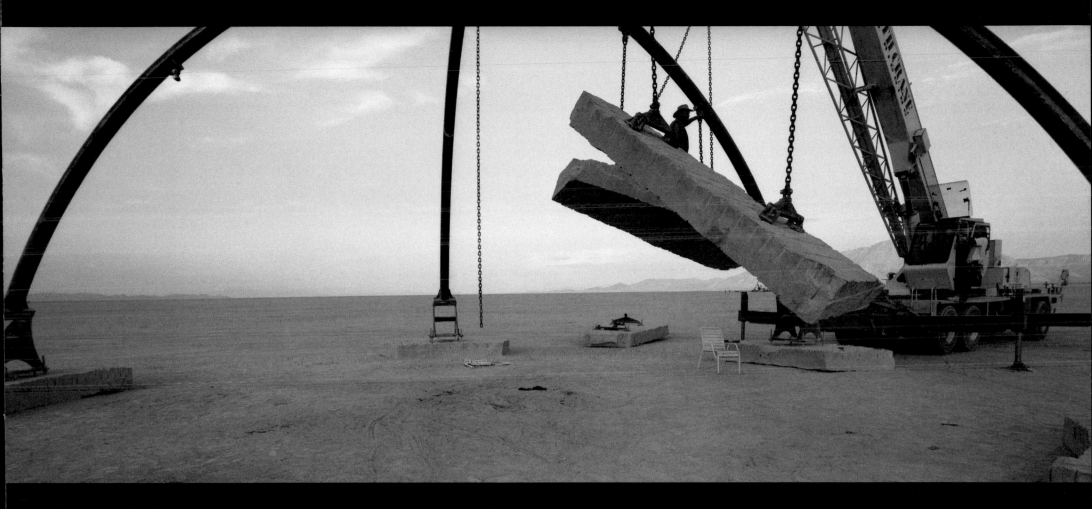

Temple of Gravity (2003)
ARTISTS: ZACK COFFIN AND CREW

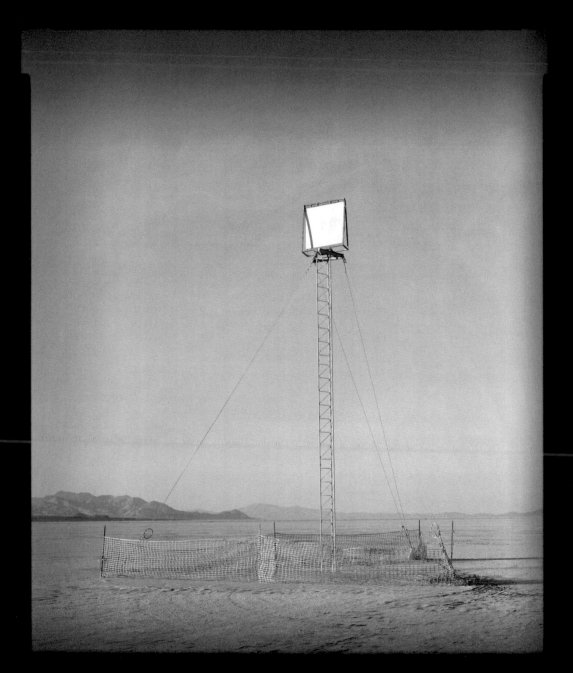

Laser Man Target Tower (2000)
**ARTISTS: RUSSELL WILCOX
AND CREW**

Opposite: *Star Wheel* (2004)
ARTIST: PAUL CESEWSKI

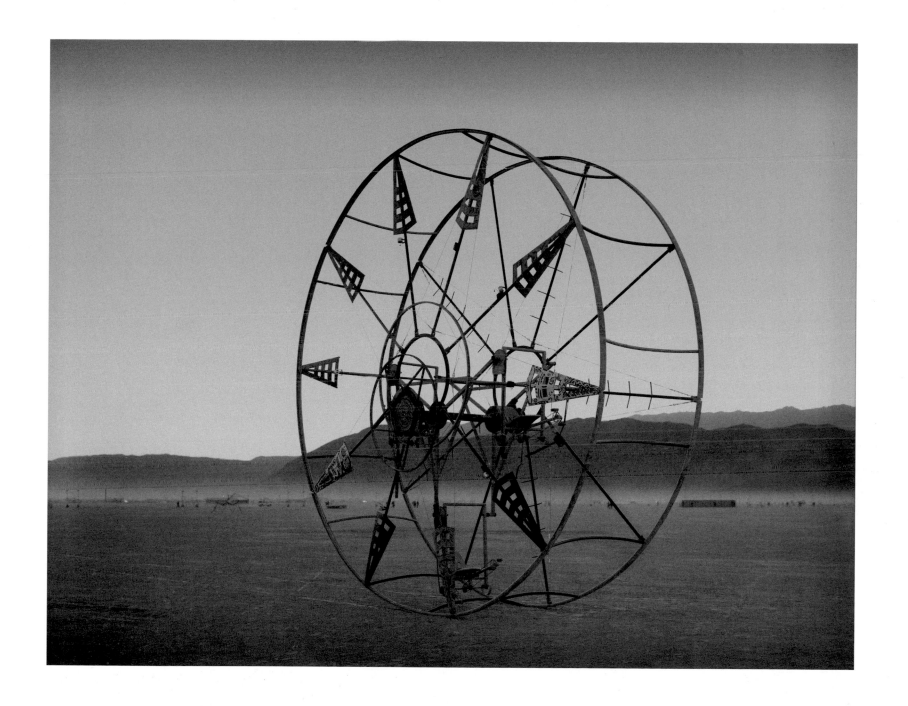

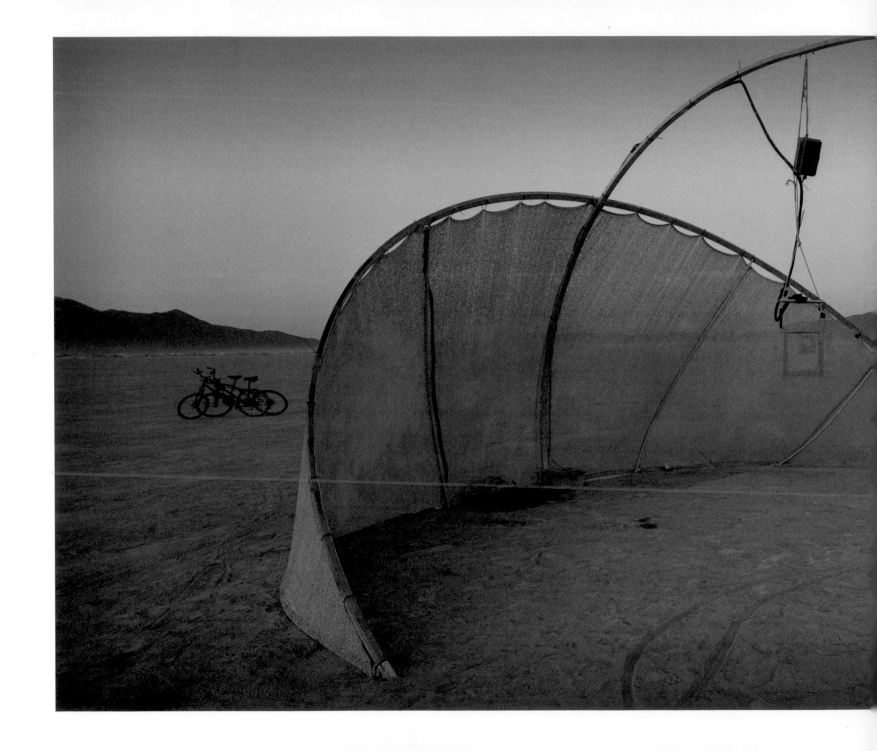

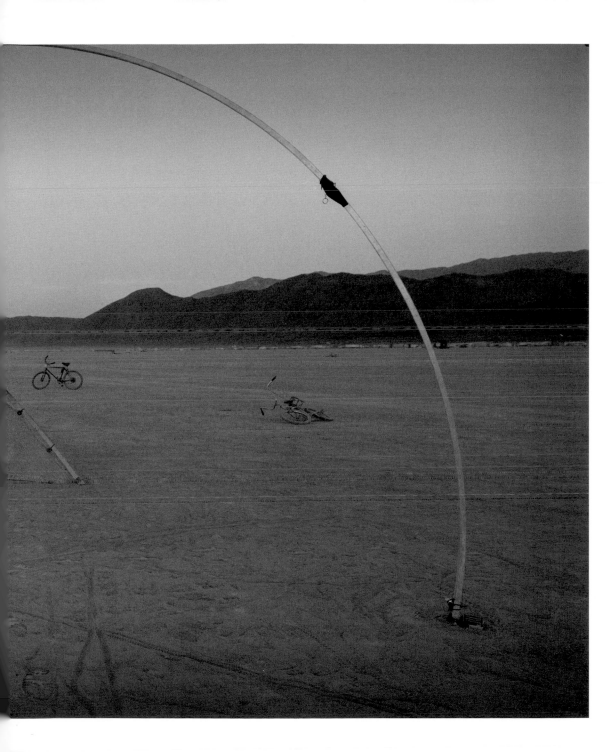

Unknown Installation (2004)
ARTIST: UNKNOWN

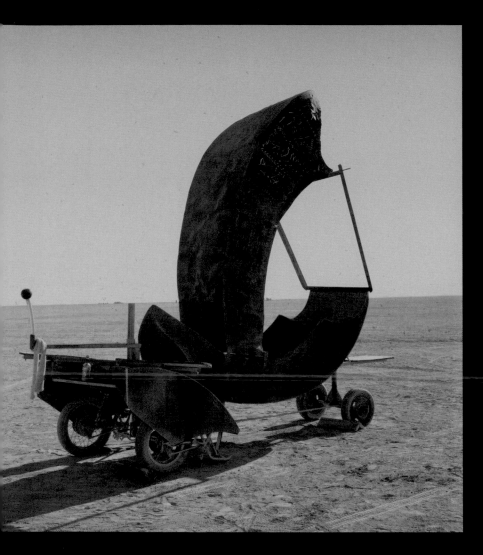

Paleo (2004)
ARTISTS: CHARLIE SMITH AND CREW

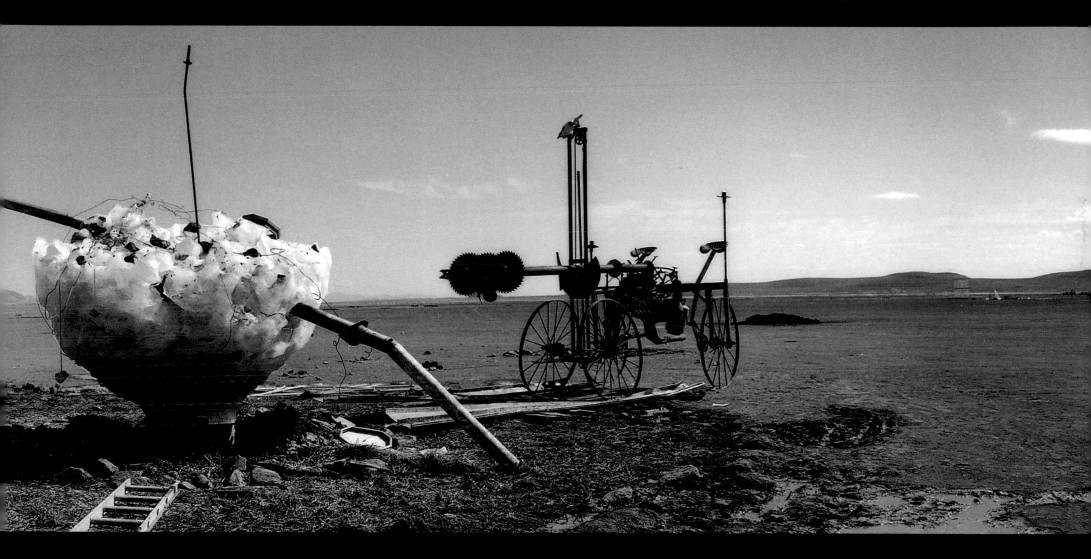

Veg-o-matic Decomposition (1997)
ARTISTS: JIM MASON AND CREW

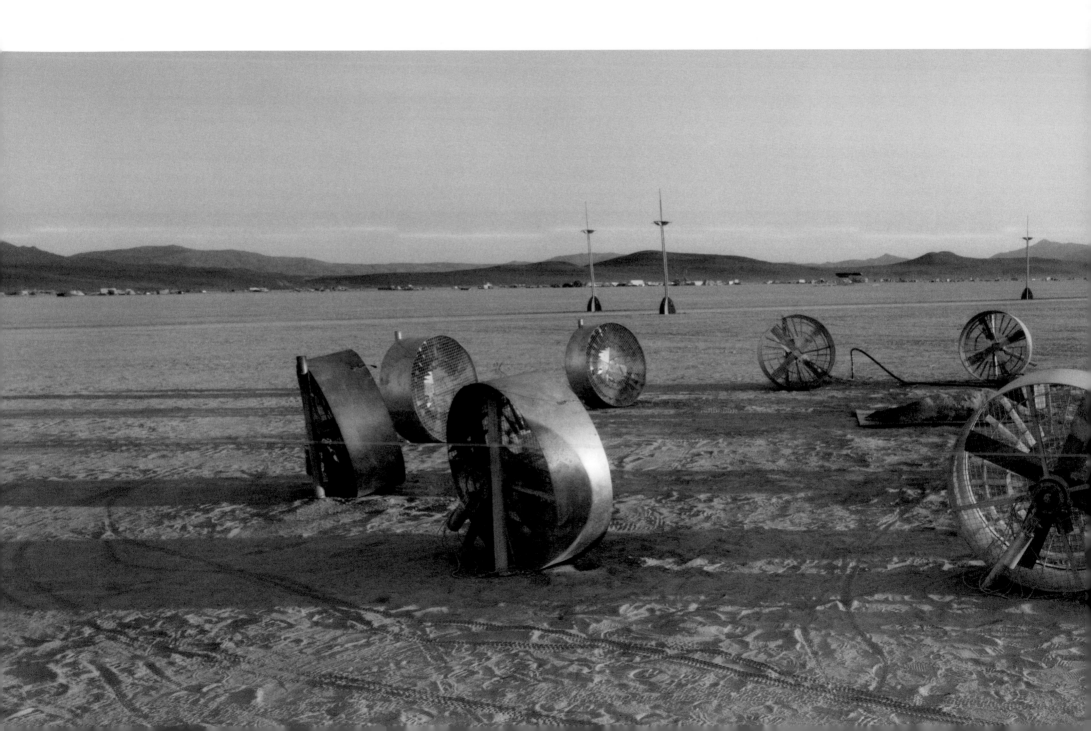

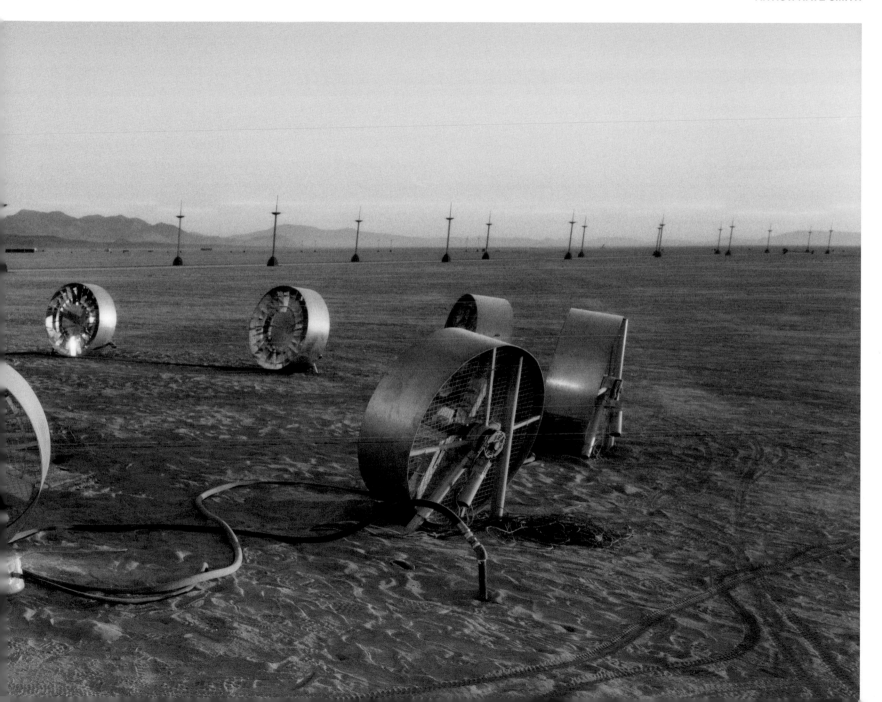

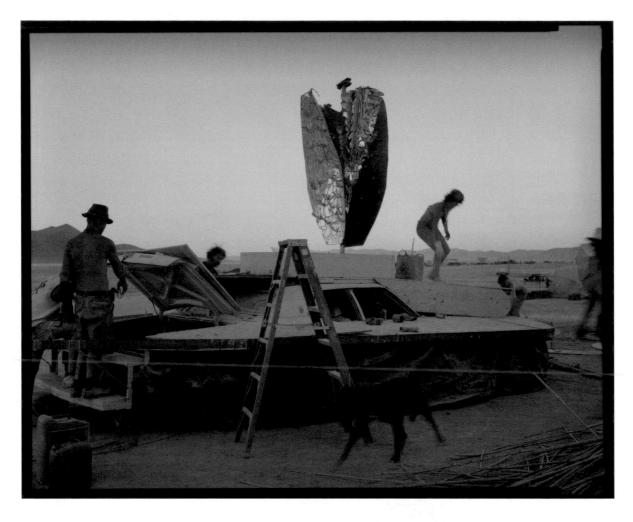

Dismantling the Comet Car (2004)
ARTISTS: ROBERT BURKE [pictured behind trunk lid]
WITH STEVE RADAMAKER AND CREW

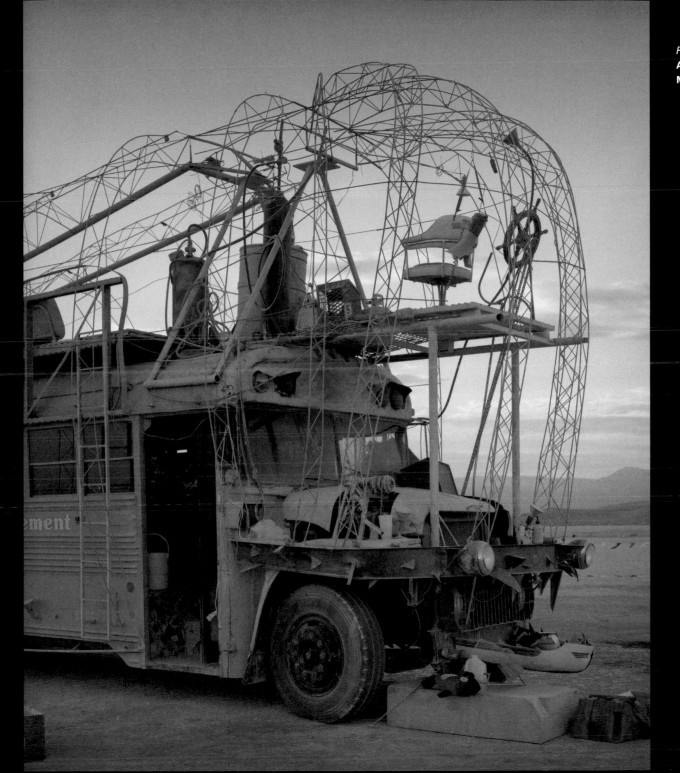

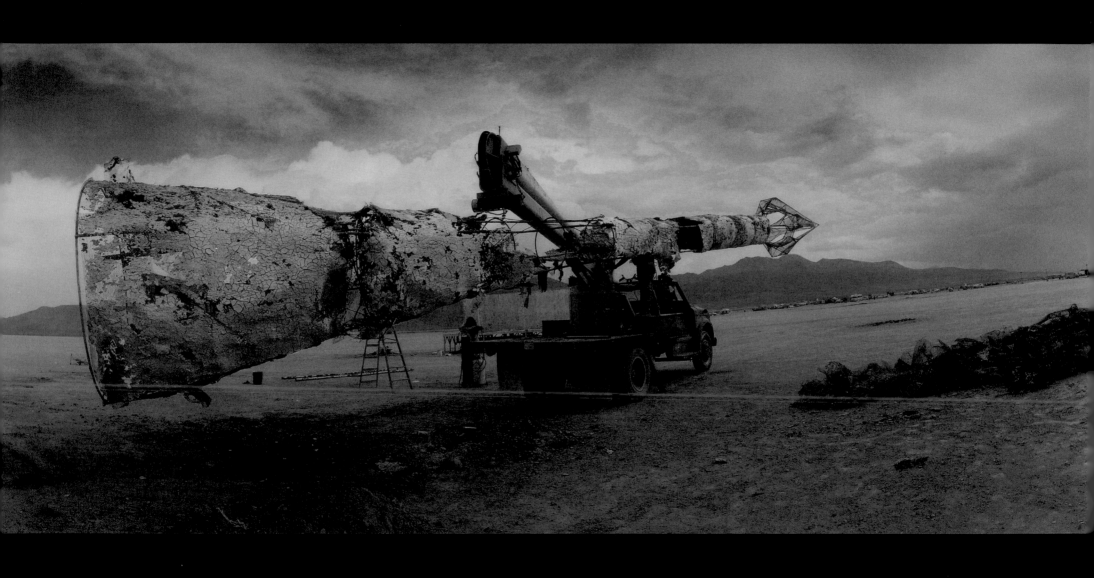

Opposite: *Temple Remnants* (1998)
ARTISTS: PEPE OZAN, MORGAN RAYMOND
[pictured], AND CREW

Chicken During Cleanup (2002)
ARTIST: CHICKEN JOHN

EXODUS

It's Tuesday morning and I'm back in my car, photographing what's left. Things are starting to fall apart. The organizing structure of the city that once provided a sense of order has mostly disappeared. The rangers are almost all gone, as are the fire and medical personnel and most of the staff. All that will soon be left are those who built the city in the first place: the DPW.

Slowly, incrementally, people will stop maintaining their camps as they feel the tug of their lives calling them back. Others will stay purposefully until tomorrow, enjoying the empty Playa and the afterglow of the event as they dismantle the larger artworks and camps.

There are a few piles of trash left that are slowly getting buried by the dust storms that move through. Some years these storms can be horrendous, lasting for days and making the breakdown exponentially more and more difficult. One year when I was working with the Hughstons and their crew on the electrical system at Center Camp, we spent hours loading cables on pallets in a storm so thick it was difficult for Lance, Senior and I to see each other as he operated the Heister, moving the pallets into the shipping containers. We finally gave up and waited out the storm in one of the old RV trailers that the DPW had provided. After a few hours, I walked back to the far end of the camp to find David Best and the remaining members of the Temple Crew passing around a bottle of wine. After sitting with them for a few minutes David said to no one in particular, "You know, if you don't like the dust, you just don't get it." I agreed, but ended up needing a GPS to find my tent.

The last loads can be the hardest: the ones you don't know what to do with, or the ones that are so messy you just want to leave them. Most large camps have some sort of evaporation pond rigged up with plastic surrounded by two-by-fours. Over the course of two to three weeks they are filled with not only water, but coffee grounds, food scraps, and all sorts of things you'd rather not deal with. They're usually the last thing to get broken down and the thing your camp will mostly likely get flagged for when the Playa's inspected.

For a community of this size, there is surprisingly little left behind. We have trained ourselves to pack everything out, but for those that literally brought everything they thought they could possibly need, the packing process can be arduous.

Everything has to go, no matter how small, and after weeks of exertion, it can often be one straw too many. People unused to physical labor leave their friends to deal with the

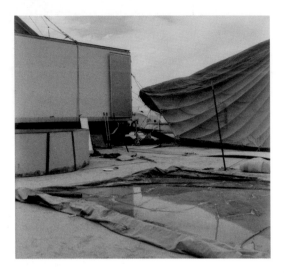

Aftermath Montage no. 2 (2003)
ARTIST: UNKNOWN

cleanup, and nerves get frayed. I was once handed a bottle of Patrón as payment for dealing with the Happyland evaporation pond as my own tent was getting buried before my tired eyes. When my lungs started to hurt from breathing in all the dust, I had to wait out *that* storm in my car, finally able to leave after dark.

The exodus off the Playa is identical to the effort it took to escape the gravitational pull of the life you left when you first came out. After weeks being in the high desert, you are not only acclimated to the altitude, lack of humidity, sun, and the influence they have on your daily rhythm, but you now have too much stuff on the ground—covered, if not buried, in Playa dust that extends up to 10,000 feet deep in places beneath your feet.

Some years I linger, photographing and enjoying the landscape of encampments that are quickly becoming relics. Some are still occupied and obviously so; others haven't officially been abandoned by their inhabitants and are quickly being buried by dust with each gust of wind.

Thirty-five to forty thousand people have stirred the surface of the desert, and any wind that blows through picks up the dust and reduces the visibility to a few feet.

Loading up an old school bus with a metal shop's worth of equipment that includes welders, torches, rigging gear, an old hot tub, and a radiator to heat it (picture a blowtorch aimed at the coils, effectively running it in reverse), aluminum water tanks, a fridge, a freezer, and a generator . . . you get the idea. In 2000 this is what the artist known as Dan Das Mann was faced with. We shared a camp with a bunch of other artists under the banner Happyland (page 54). The dust storms were their usual unrelenting selves, and more than a few of our friends who weren't used to having an overwhelmingly large amount of stuff to move were depressed by the work at hand. As we were loading the aforementioned list into Dan's bus, he said, "Let's just stay here forever. . . ." We were already halfway there.

After all you've been through building whatever it was that you brought and putting yourself into hock doing it, you now have the final insult of having to pack it all up and drive home. For many, what is normally a six-hour drive in a well maintained vehicle back to Reno, over the Sierras, and back to the Bay Area, is expanded to a twenty-four-hour odyssey of breakdowns and flats. Many have had successful years, only to roll their overloaded rigs on the way home.

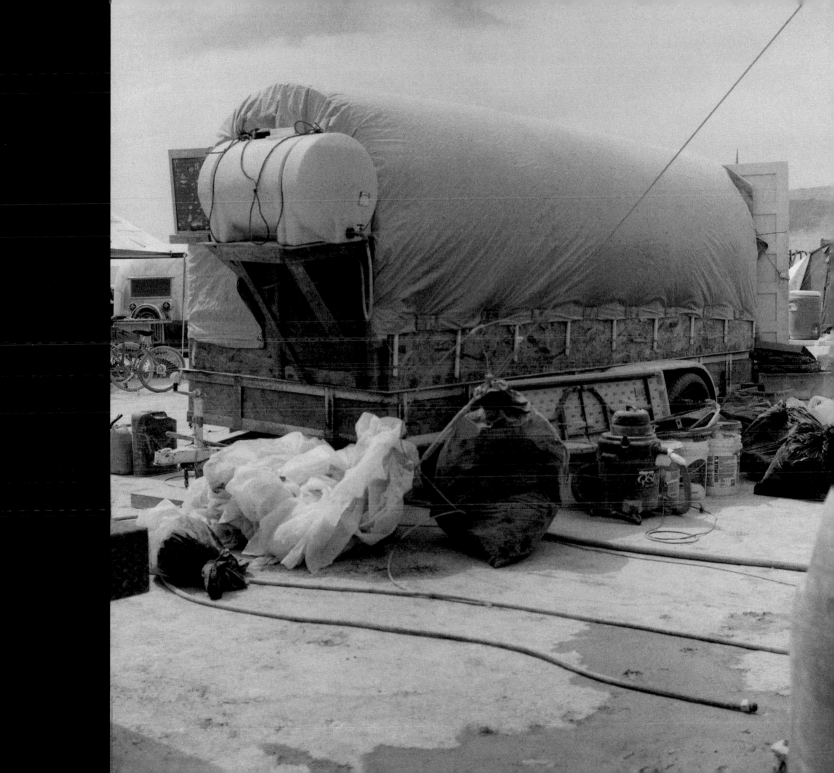

Aftermath Montage no. 3 (2003)
ARTIST: UNKNOWN

Aftermath Montage no. 4 (2003)
ARTIST: UNKNOWN

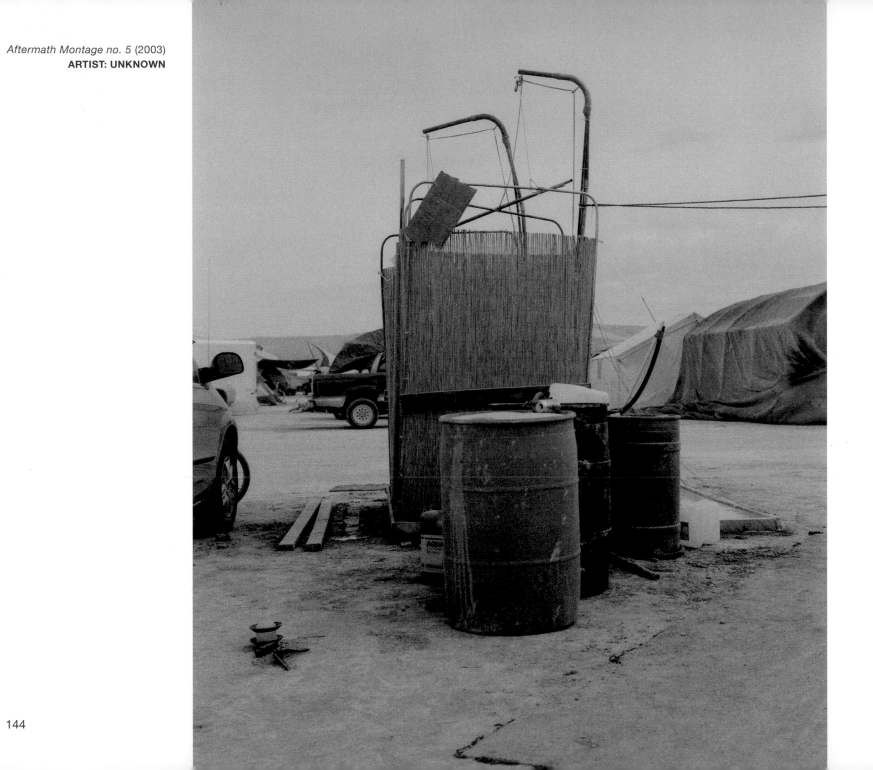

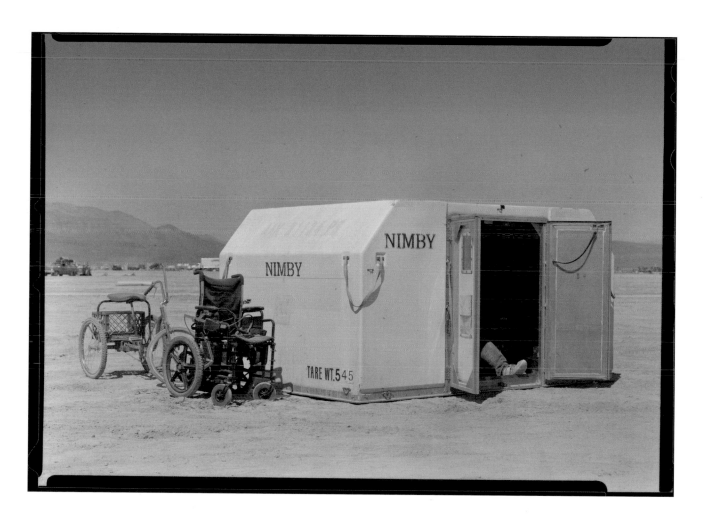

Liz Hart's Nimby Shelter (2004)

DPW VW Couch Car (2002)
ARTIST: UNKNOWN

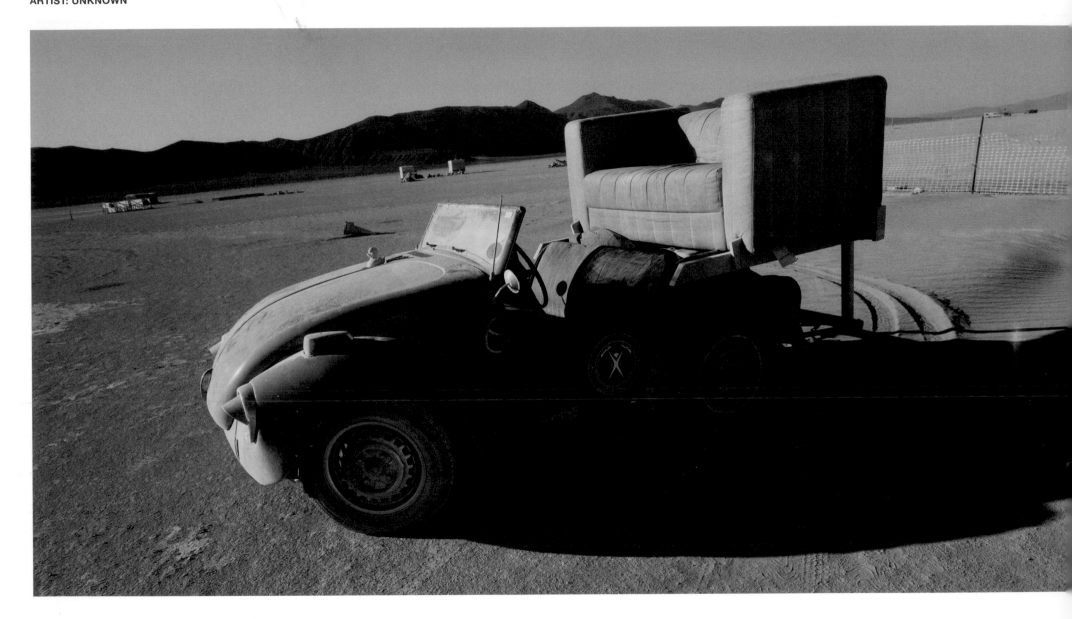

REENTRY

I drive into Reno and grab a large coffee just as I'm about to leave town and head up into the Sierras. I'm covered with dirt and Playa dust and find myself standing in stark contrast to everyone around me. I feel as if I've been on some sort of exotic adventure to an unexplored place. I've come back, with a car full of images, and I feel a contentment that I don't often feel. I've been somewhere, and done something.

The surrounding landscape of shopping center parking lots, casinos, and fast-food outlets are alien, but my resistance is down and I don't mind the ugliness the way I usually do. Instead it validates what I've been through. It was worth it. This is what I left behind. It's nice when I need it, but I haven't missed it.

The coffee tastes good and my urge to get home and see my family quickly pushes me back out the café door. It's still hot out, but I can already feel the respite that the mountains will bring. The trees will feel good and I'm glad there's still four to five hours of driving left. I need the time alone in the car to just drift along.

I usually get home right after rush hour. We live on the second floor of a small building, and everything has to come up a long flight of stairs. It takes about twenty trips, and when I'm done and everything's piled on the floor, I finally take a shower. My hair feels like a matted doll's head, and the water is a signal that I am finally home.

I haven't been home for nine days this particular trip, which is a lot shorter than the two to three weeks I used to spend out there. Nine days is a long time to be away from my family, and even longer for my wife who has had to care for our two-year-old daughter.

As I settle back into my routine, the question always remains: how can I live life more like I've just done, while continuing to accomplish what I need to for my family. Another way to put it is: how do I shift my day-to-day life more in accord with what makes me happiest. I guess that's the meaning of life in a nutshell. An "appropriate receptacle," as my brother puts it.

The event *can* linger. One year, I drove all the way home thinking about Jim Mason's boom truck. It felt strange that we come to a place as flat as a parking lot and the first tool a lot of artists need to do their work or to finish their piece is a crane.

After being home for eighteen hours and not being able to shake the thought, I hopped in my car and drove all the way back out to the desert. I arrived after dark, found the truck (broken down where Jim had to leave it), set my alarm for an hour before dawn, and woke to photograph the truck in order to capture the essence of it. (That's when the picture on pages 28 and 29 was taken.)

It began to rain not long after, and Will Roger had to evacuate his DPW crew off the Playa for two weeks, watching through binoculars as what remained sank deeper and deeper into the mud.

When I am finally home, it's as if my body has expended its energy. All I do is sleep and drift around the house in a stupor, stepping around the piles of dust-coated equipment that didn't look that dirty out on the Playa.

It'll take a month to get around to cleaning everything, and some things will never be the same. After thirteen years, my car has alkali dust inside every panel. We have an understanding.

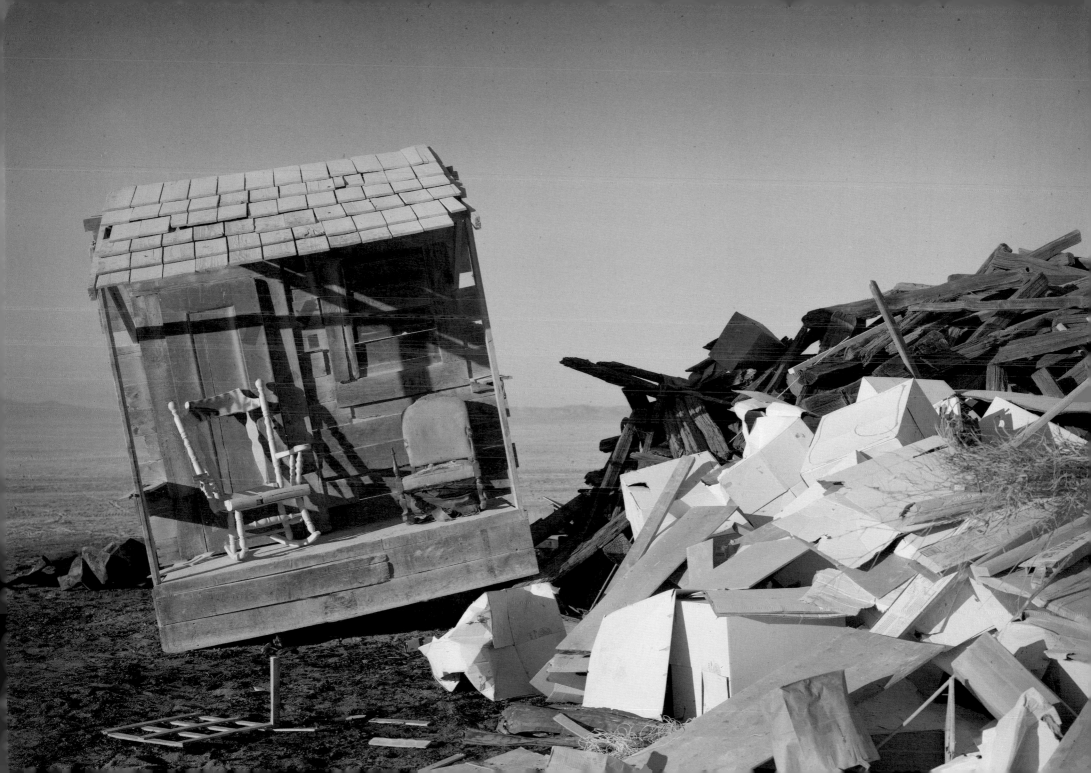

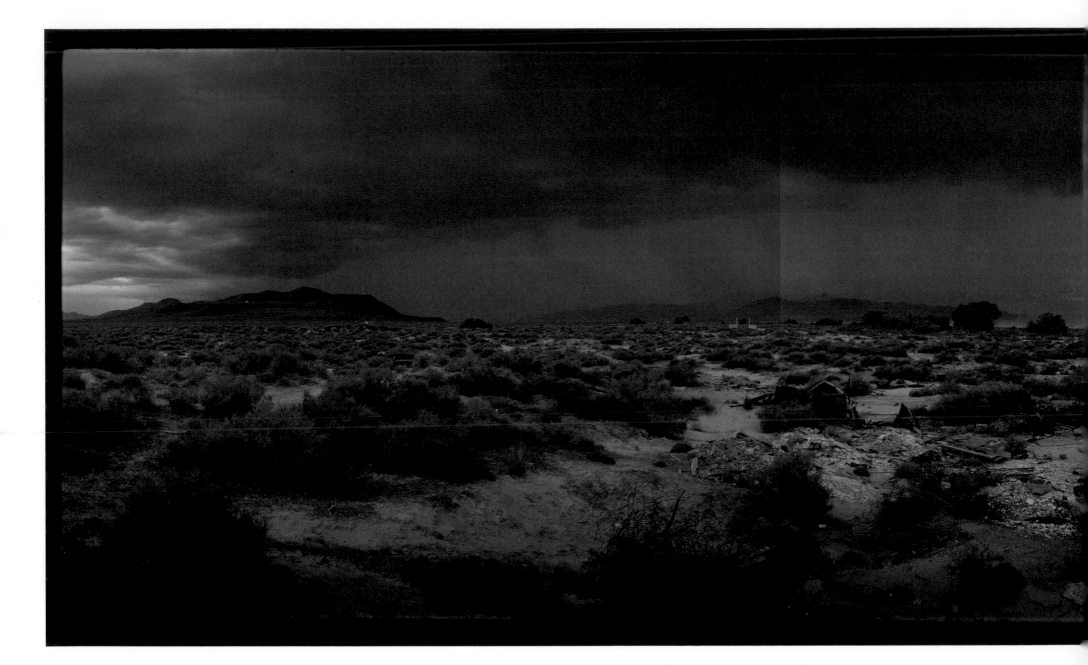

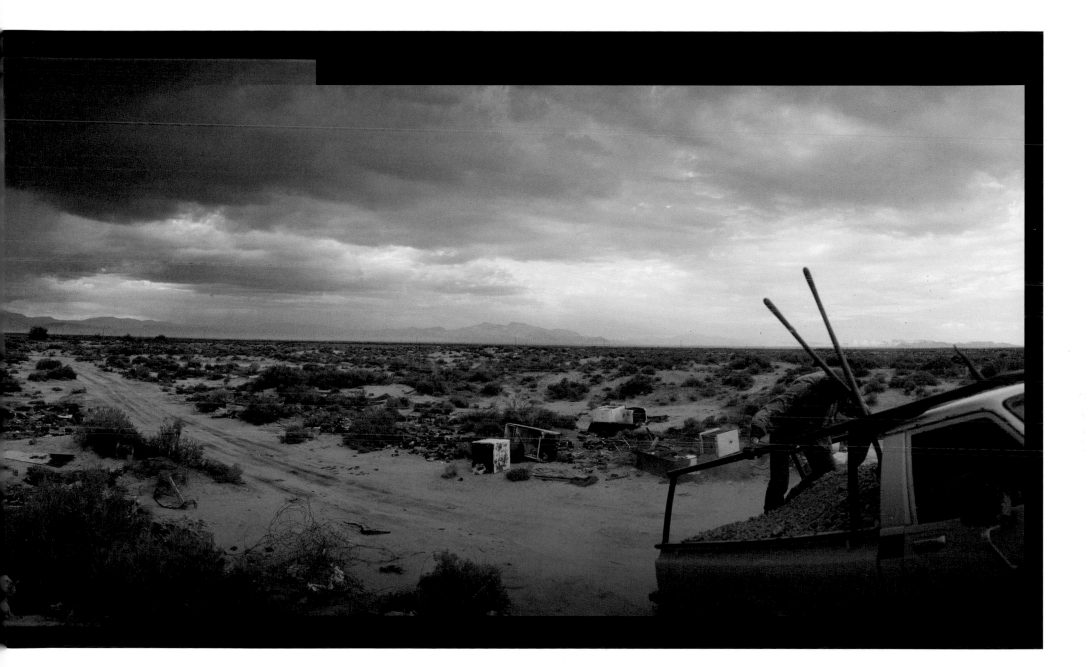

Portage (2002)
ARTIST: NESDON BOOTH

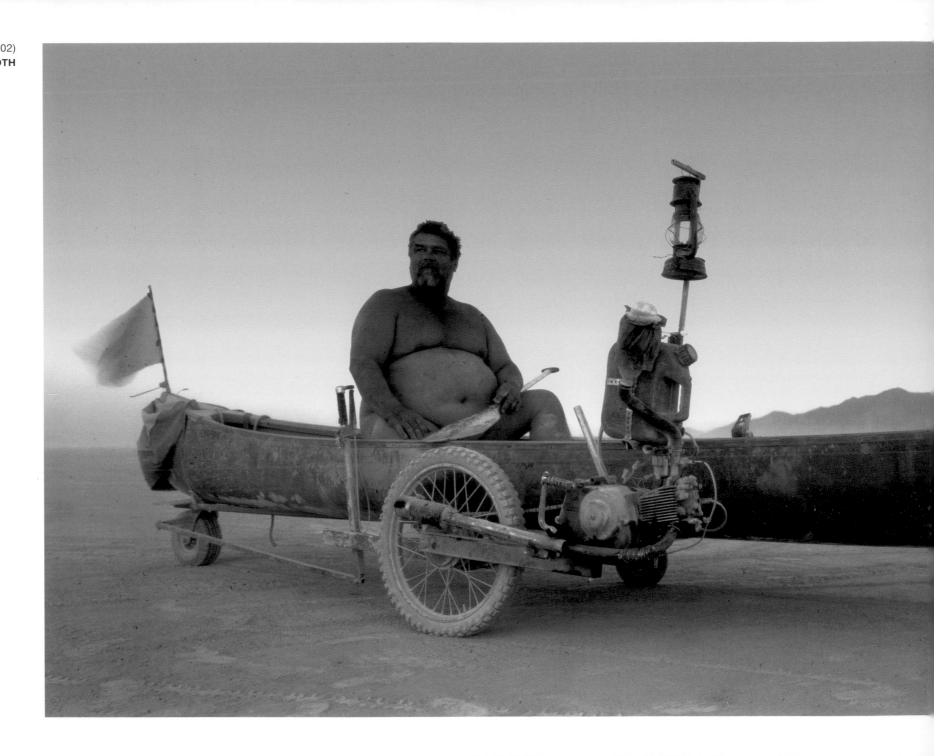

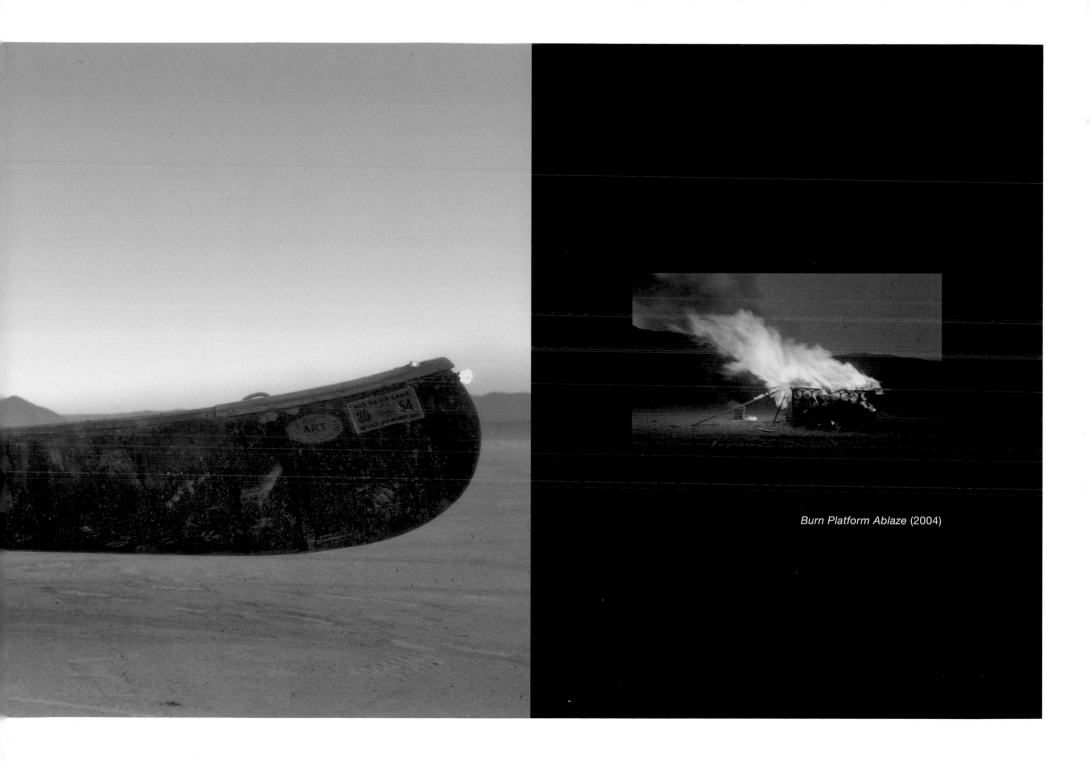

Burn Platform Ablaze (2004)

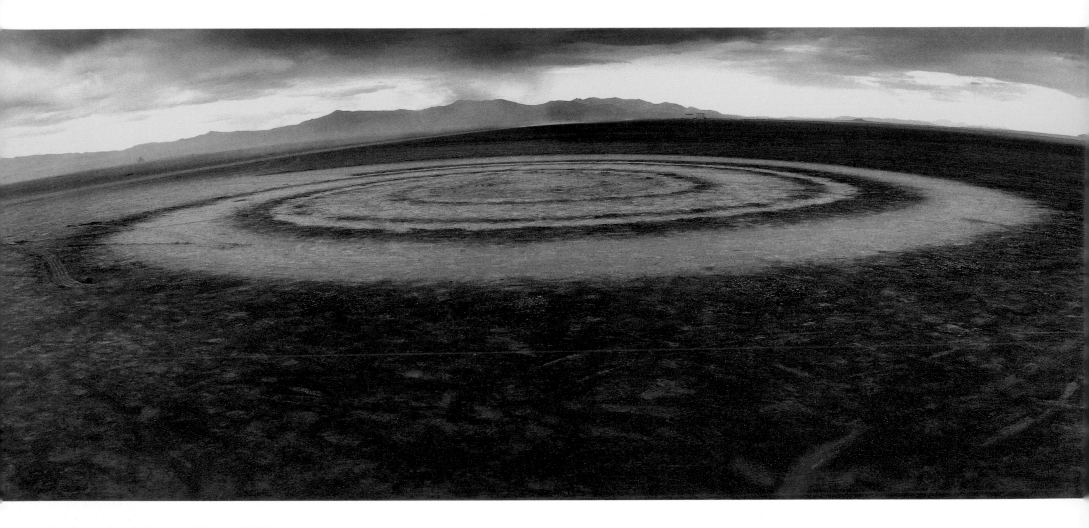

Das Ammoniten Projekt after Cleanup (1997)
ARTIST: HENDRIK HACKL

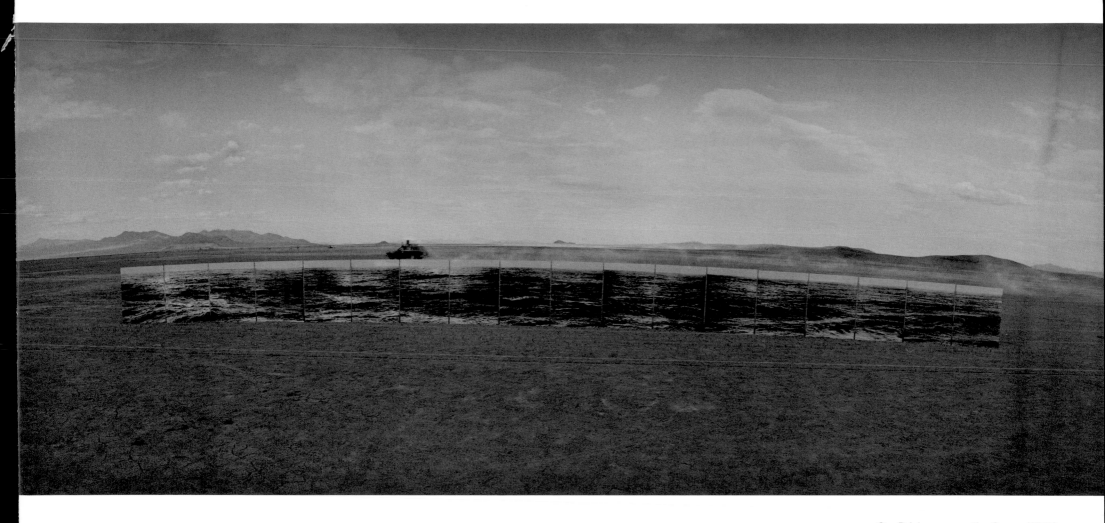

Car Driving across the Ocean (1997)
ARTIST: SHELLY HADES-VACA

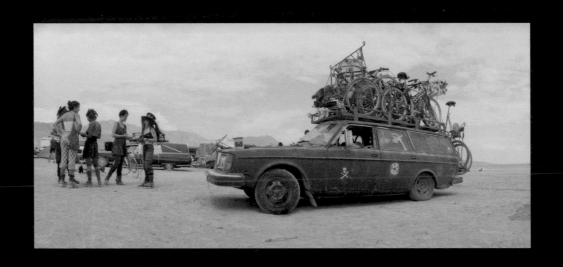

Burdened Volvo (1998)

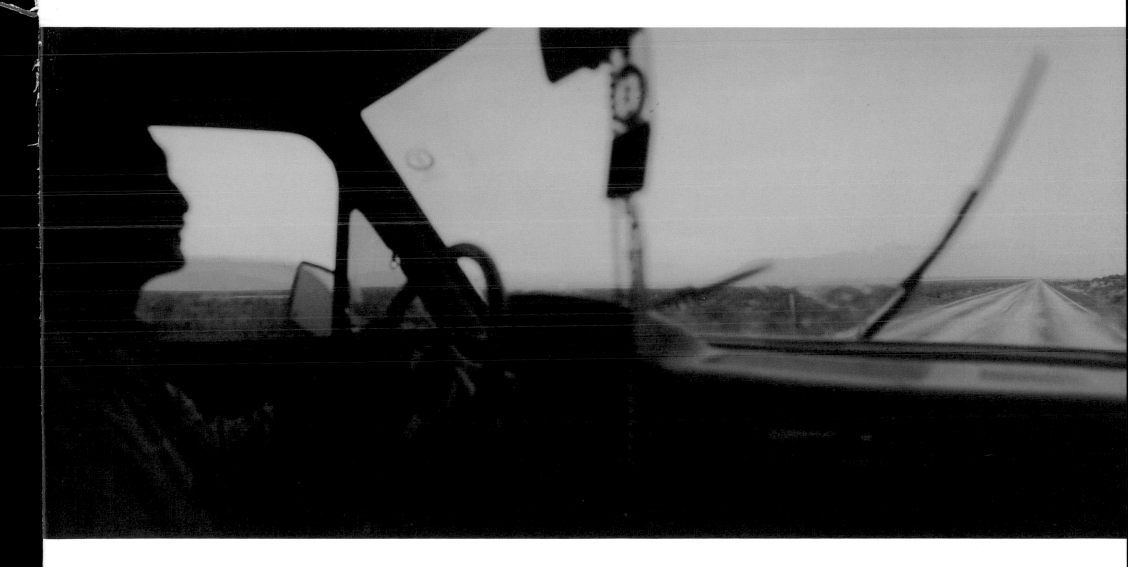

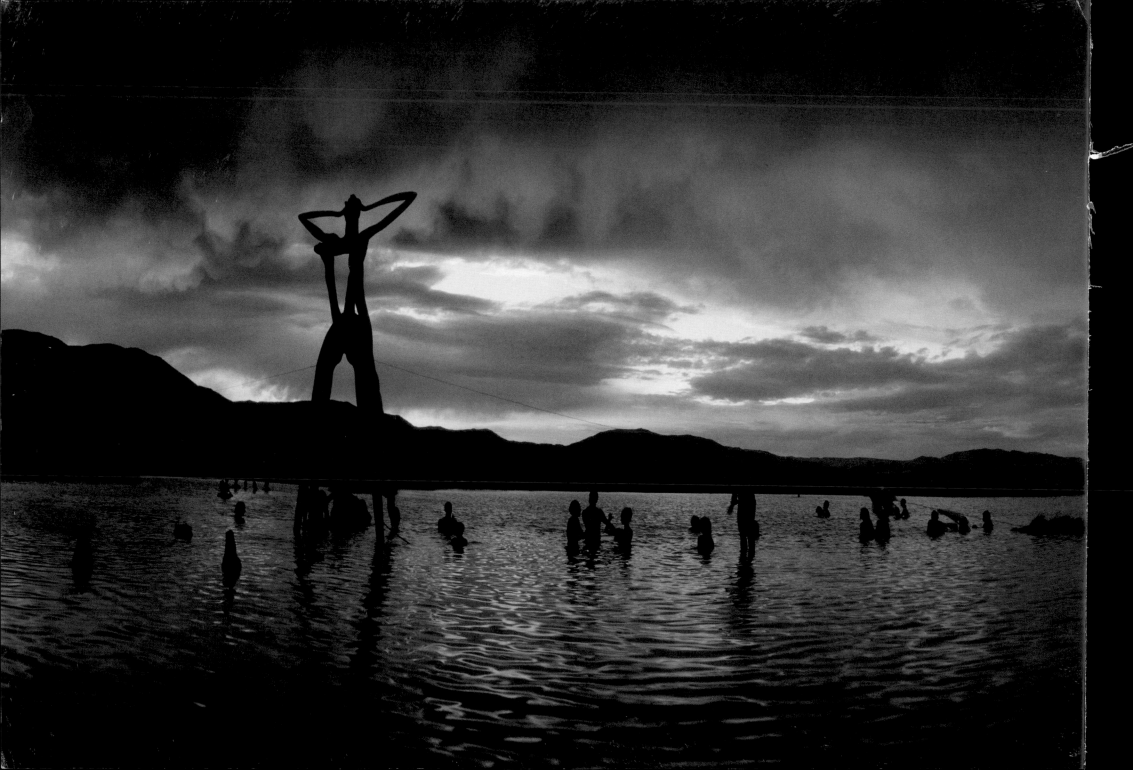

Water Woman: The Last Year We Had Access to the Hot Springs (1997)
ARTIST: RAY CIRINO

ACKNOWLEDGMENTS

This book wouldn't have been possible without the perseverance of my agent Jayne Rockmill, who was introduced to me by Bill Kouwenhoven, writer par excellence of all things photographic. As a first-time author the guidance of Eric Himmel and the [almost] eternal patience of Charlie Kochman, my editors at Harry N. Abrams, gave me the space to form new muscles, which unfortunately was always at the expense of the design team headed up by Mark LaRiviere and Brady McNamara. I want to thank the talented Travis Brown for designing the book and Jon Cipriaso in editorial for assisting Charlie in the frustrating process of dealing with my inability to hit a single deadline squarely on the head.

The support of my wife Victoria and our daughter Lucy constantly kept the emotional storm of putting thirteen years of work into a book in perspective. And my ability for hard work and perseverance comes from my parents, Suzanne and Kenneth Nash, and my two brothers, Seth and Mitchell Nash.

The dedication of the Burning Man LLC is why Burning Man continues to this day and is there for the community that supports it. They are: Harley Dubois, Marian Goodell, Larry Harvey, Michael Michael, Will Roger, and Crimson Rose. They are supported by a staff that is too numerous to list, but has my eternal gratitude and respect in making this event happen year after year in a remote and inhospitable locale, in a country that at times is more concerned with using the arts for political gain than spiritual transformation.

I am lucky to have come in contact with an interesting assortment of like-minded people over the years, and their wisdom and wry humor sustains me to this day. They are: Ray Allen, David and Maggie Best, Harrod and Les Blank, Carl Brucker, Robert Burke, Chris Campbell, Jenny Carden, Michael Christian, Simon Clark, Zach Coffin, Dan Das Mann, The Dirty Little Bitches, Brian Doherty, Joe Fenton, Fireman Dave, Michael Fratkin and Julie Lerwill, Rod Garrett, Andie Grace, the folks at Happyland (some of whom are listed here), Steve Heck, Al Honig, Michael Hopkins, Lance Hughston (senior and junior), Jerry James, Tom Kennedy, Christine Kristen, John Law, Matt Lindsay, Jim Mason, Erin MacCool, Carroll Moore, Flynn Mauthe, Dan Miller, Joy Orabella, Pepe Ozan, Tony Perez, Steven Raspa, Morgan Raymond, Chicken John Rinaldi, Dale Scott, Richard Scott, Charlie Smith, Kal Spelletich, Dominic Tinio, Lou Weinert and Charlotte Baker, and Tom Wray for allowing me to wake him up an hour before dawn for the use of his crane.

This book would fall short technically if it weren't for the fastidiousness of Jon Zax and Cathy Kronin at LotusColor in Oakland for making the drum scans from the original film negatives, and my assistant Lyra Harris for her hard work and attention to detail.

My high school English teacher Richard Curtis solidified the love of travel I inherited from my folks into an art form, and Karen Kenney Ofsink provided much needed wisdom and guidance during the darker days of this project.

I am fortunate that Daniel Pinchbeck followed his own muse to the far corners of the world in search of the next update to the human operating system, and that he gave more of his time than was required to write the introduction.

And finally, to Lightwork in Syracuse, New York, for awarding me a residency in the year 2000, to sort through where my life and this project had taken me, and the space to decide to keep going to the end. At that time Lightwork was Jeffrey Hoone, Gary Hess, Vernon Burnett, Marianne Stavenhagen, and Mary Hodges. A special thank you to Carry Mae Weems for sharing her formidable insight during that month.

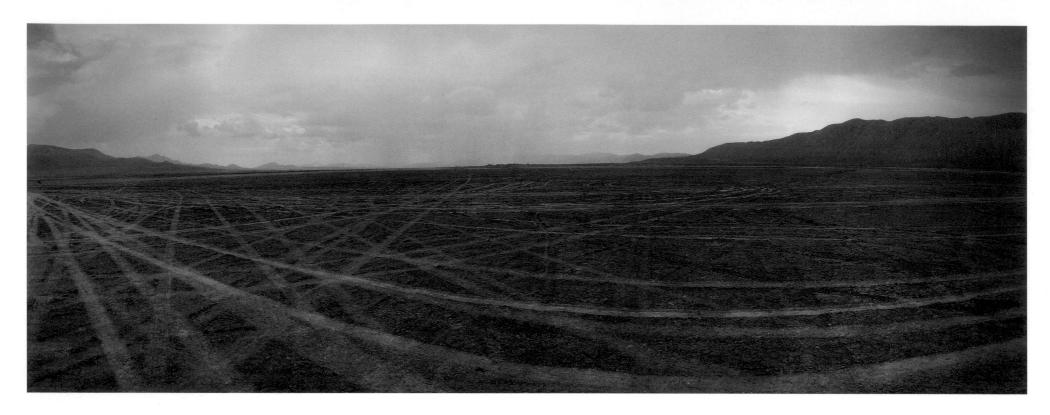

Editor: Charles Kochman
Editorial Assistant: Jon Cipriaso
Designer: Travis Brown/Method Art + Design
Production Manager: Jane Searle

Library of Congress Cataloging-in-Publication Data
Nash, A. Leo.
 Burning man : art in the desert / text and photographs by
A. Leo Nash ; introduction by Daniel Pinchbeck.
 p. cm.
 ISBN-13: 978-0-8109-9290-0 (hardcover with slipcase)
 ISBN-10: 0-8109-9290-6 (hardcover with slipcase)
 1. Portrait photography—Nevada—Black Rock Desert.
 2. Burning Man (Festival)—Pictorial works.
 3. Performance art—Nevada—Black Rock Desert. I. Title.

TR680.N338 2007
779'.9979354—dc22

 2006100748

Text and photographs copyright © 2007 A. Leo Nash
Introduction copyright © 2007 Daniel Pinchbeck

Published in 2007 by Abrams, an imprint of Harry N. Abrams, Inc.

Printed and bound in China
10 9 8 7 6 5 4 3 2 1

HNA ■■■■■
harry n. abrams, inc.
a subsidiary of La Martinière Groupe
115 West 18th Street
New York, NY 10011
www.hnabooks.com

SLIPCASE FRONT: *Th'Fuck Machine*/Ryon Gesink (2004)
SLIPCASE BACK: *Orbicular Affect under Construction*/
Chris Campbell and crew (1999)
CASE PHOTOGRAPHS: Tom Davis
FRONT ENDPAPER: *Man Lying Down*/Chris Campbell,
Larry Harvey, Dan Miller, Dale Scott (1997)
PAGE 1: *Serpent Mother*/Flaming Lotus Girls (2006)
PAGE 2: *Great Temple*/Rod Garret and Larry Harvey (2003)
PAGE 3: DPW Modified Condor (2004)
PAGES 4–5: *Heading Toward Black Rock* (2006)
ABOVE: *Black Rock City Tracks* (1998)
BACK ENDPAPER: *Man Burning* (1998)